COMMITTED TO THE IMAGE
Contemporary Black Photographers

la durée a été

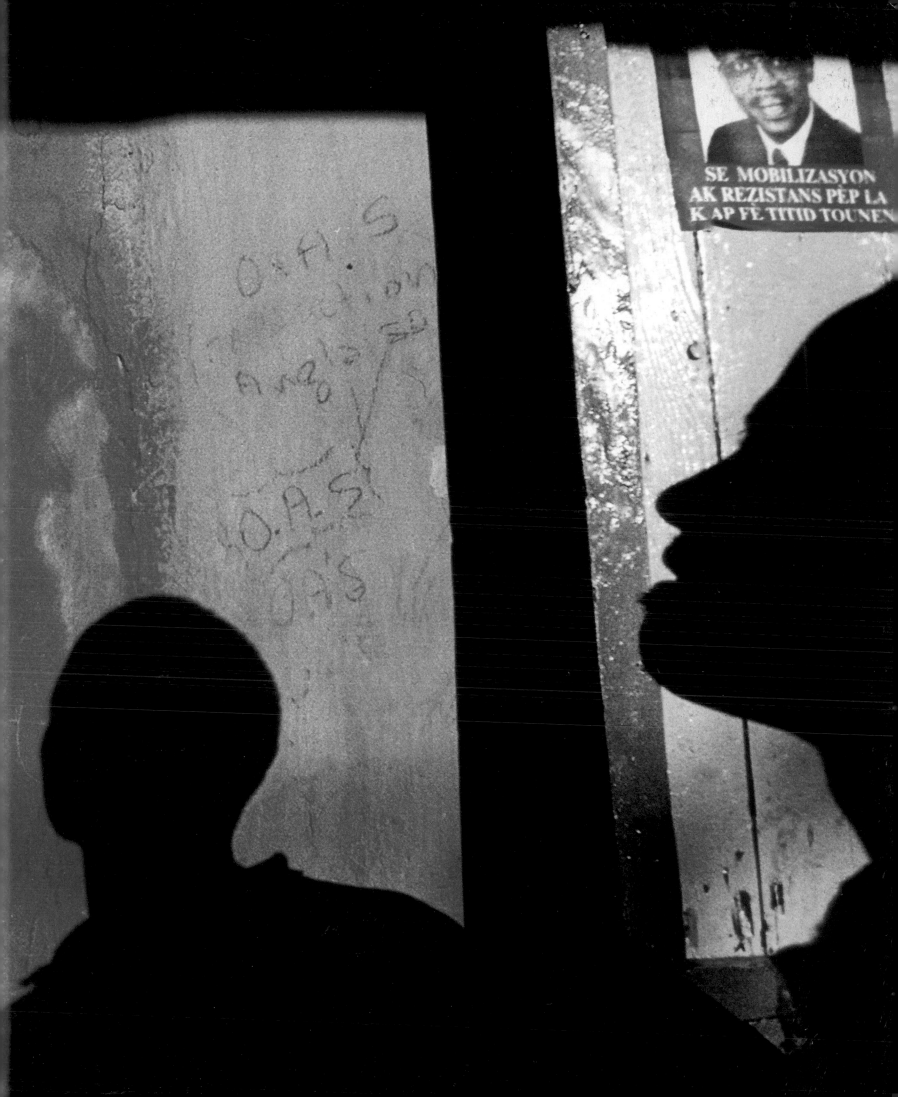

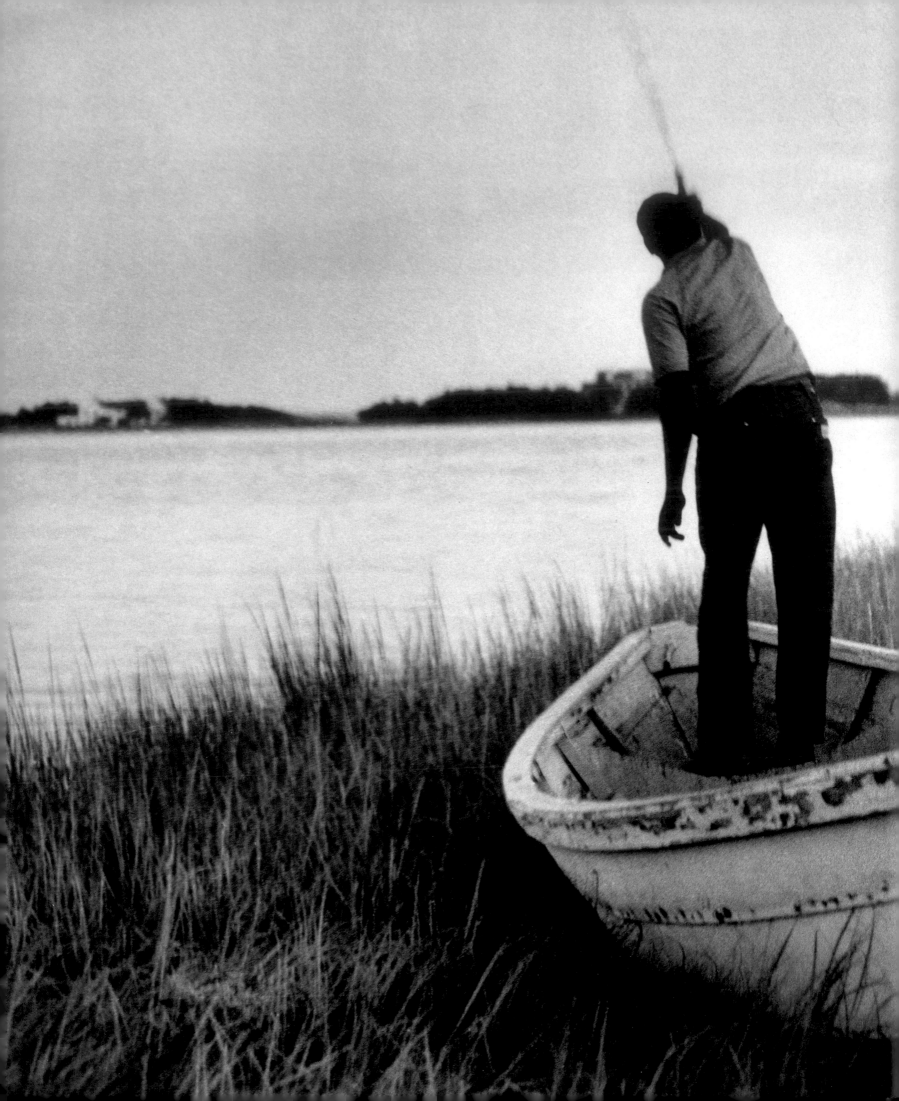

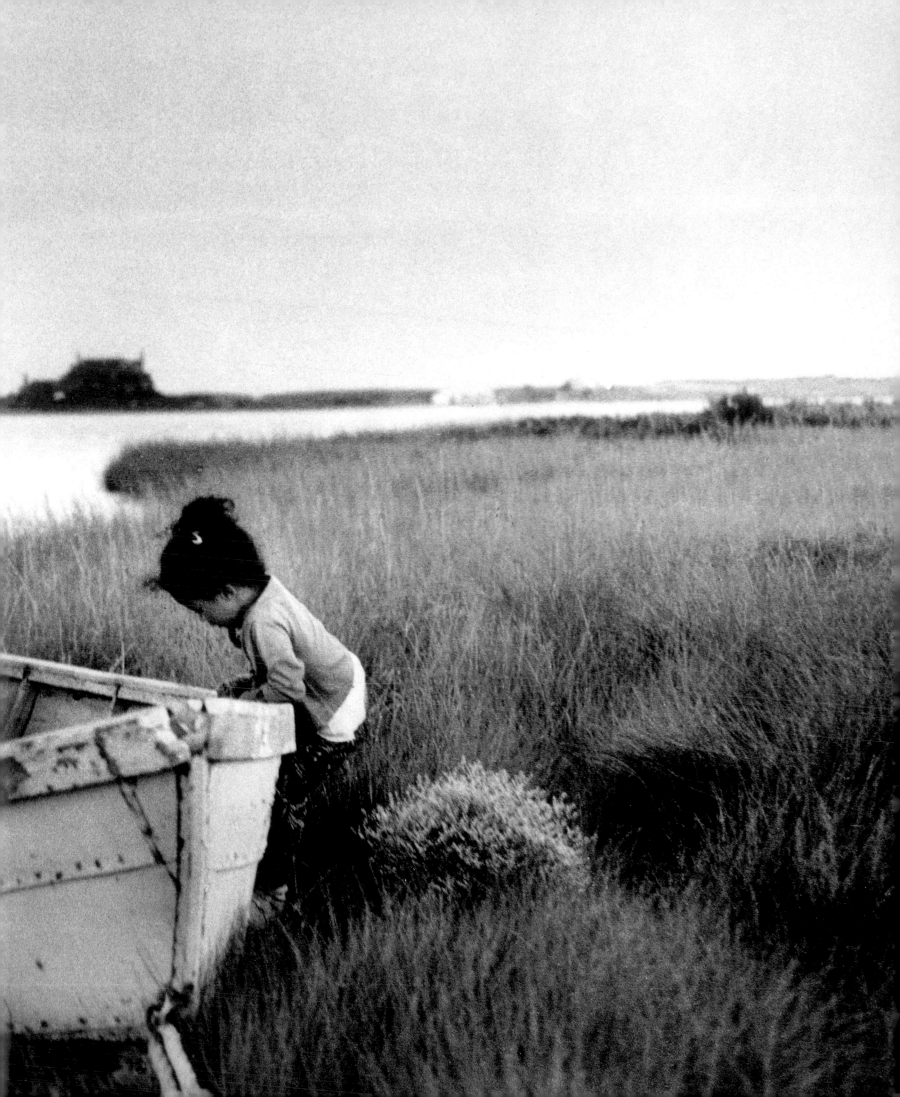

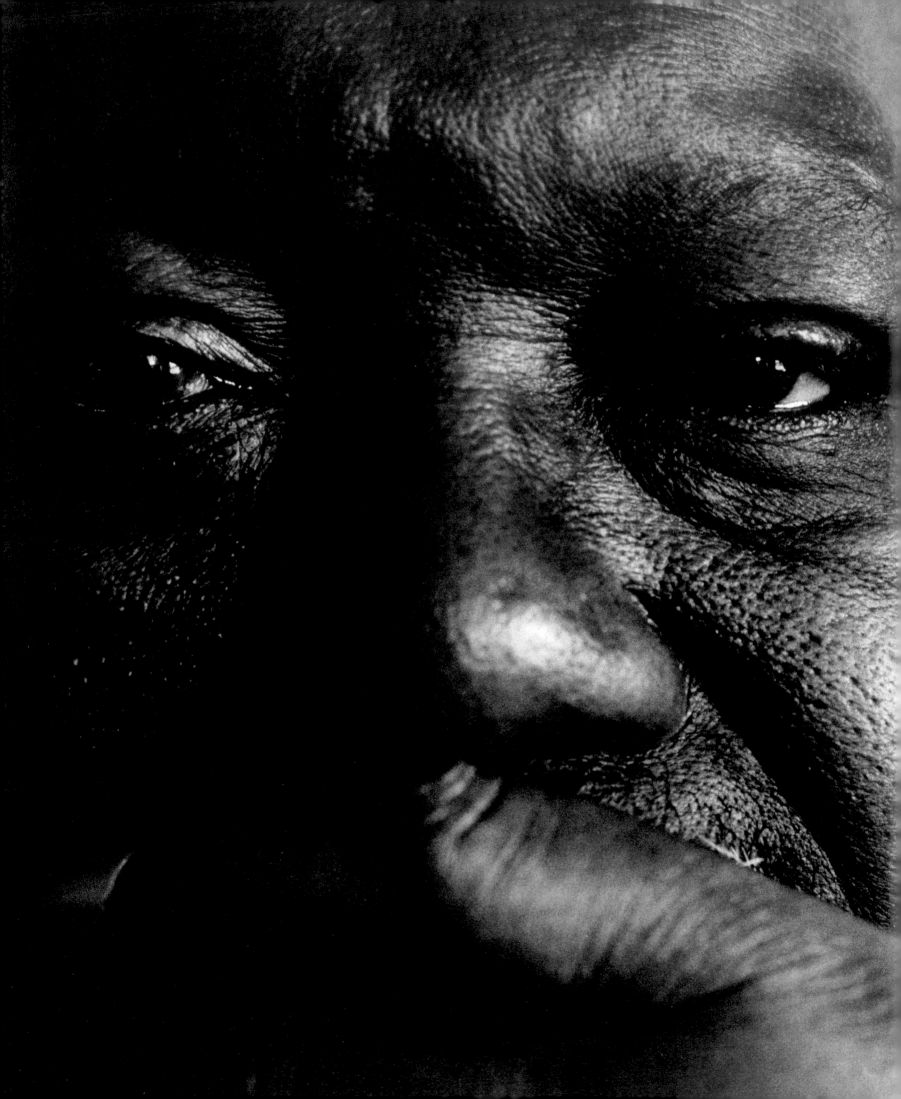

COMMITTED TO THE IMAGE
Contemporary Black Photographers

Edited by

Barbara Head Millstein

With essays by

Clyde Taylor

Deba P. Patnaik

Brooklyn Museum of Art

in association with

MERRELL

Published on the occasion of the exhibition
Committed to the Image: Contemporary Black Photographers
at the Brooklyn Museum of Art, New York,
February 16–April 29, 2001

First published 2001 by
Merrell Publishers Limited
42 Southwark Street
London SE1 1UN
www.merrellpublishers.com

This publication was organized at the Brooklyn Museum of Art
James Leggio, Head of Publications and Editorial Services
Project editors: Joanna Ekman and Abby Sider

For Merrell Publishers Limited
Editor: Iain Ross
Designer: Maggi Smith

Produced by Merrell Publishers Limited

Distributed in the USA by Rizzoli International Publications, Inc. through St. Martin's Press, 175 Fifth Avenue, New York, New York 10010

Library of Congress Catalog Card Number: 00-136092

British Library Cataloging in Publication Data
Data available

ISBN 1 85894 123 7

Printed and bound in Italy

Frontispiece: Bruce W. Talamon, *Jacob Lawrence*, 1992
(detail; see p. 211)
Pages 2-3: C. W. Griffin, *Admiration*, 1994 (detail; see p. 119)
Pages 4-5: Herbert Randall, *Untitled*, 1964 (detail; see p. 176)

Contents

Foreword

The Brooklyn Museum of Art is proud to have organized *Committed to the Image: Contemporary Black Photographers*. The exhibition presents the work of ninety-four artists who live and work in the United States and includes a wide variety of images taken over the past half century, particularly the last decade.

The photographers in *Committed to the Image* were selected from hundreds across the country. All of the artists make their living as photographers. Some are relatively unknown, some have gained local recognition, and others are considered among America's foremost photographers and have achieved international reputations. The photographs in this exhibition represent varied subject matter, with images ranging from explorations of identity and personal philosophy to documents of the Civil Rights struggle to reflections of African American daily life, culture, and cultural heroes. The selection reflects the vibrant contribution of Black photographers—as technical and aesthetic innovators, as activists and commentators—who challenge us to examine and reexamine compelling issues of race and identity in American society.

The Brooklyn Museum of Art's commitment to photography had its start in 1889, when the institution's first photography department was formed by Clarence White, who also taught photography at the Museum and began a fifty-two-year tradition of annual photography exhibitions. The Museum was one of the first to present the photographic work of Gertrude Käsebier, Walker Evans, Ben Shahn, Edward Weston, Joel-Peter Witkin, Lewis Hine, Dorothea Lange, and the photographers of the Farm Security Administration. Now the exceptional artists included in *Committed to the Image* take their rightful place in this distinguished history, which they expand and enrich.

The introductory essays to this volume were written by Clyde Taylor, professor in the Gallatin School of Individualized Study and the Africana Studies program of New York University, and Deba P. Patnaik, a writer and critic who has taught at the University of Michigan and Oberlin and has written widely about photography. I extend my thanks to them. I would especially like to thank the exhibition's curator, Barbara Head Millstein, and

the many members of the BMA staff whose professional expertise and commitment were integral to the success of the exhibition and catalogue.

For the ongoing support of the Museum's Trustees, we extend special gratitude to Robert S. Rubin, Chairman, and every member of our Board. Without the confidence and active engagement of our Trustees, it would not be possible to initiate and maintain such a high level of exhibition and publication programming as is exemplified by *Committed to the Image: Contemporary Black Photographers.*

Arnold L. Lehman

Director

Brooklyn Museum of Art

Preface and Acknowledgments

For more than twenty years, I have wanted to organize an exhibition of Black photographers working in America. Twenty years ago the significance of such a show would have been obvious in that few exhibitions by Black artists were being done. Now the importance of the undertaking is its celebration of so many fine Black photographers working in journalism, fashion, and other fields. However, Black photographers are still underrecognized; few have won the renown they deserve.

The process of choosing the artists for *Committed to the Image* was carried out by a committee consisting of three African American professional photographers and myself. The photographers on the committee represent three different approaches to the photographic image. Anthony Barboza, a portrait, high-fashion, and press photographer, takes narrative and highly imaginative images. Beuford Smith has made a living in location photography and journalism, and has been a working street photographer as well. Orville Robertson, a portrait and street photographer, is also the publisher and editor of the journal *Fotophile*.

Each of us spent more than two years reviewing hundreds of slides and prints, all of a professional standard, that came from twenty-two states. Each photographer's work was evaluated with regard to originality, standard of printing, and social or historical significance. The standard of quality was exceedingly high. We looked for the strongest and most challenging ideas as well as the most moving, beautiful, or, in some cases, amusing images. I am sure that we have overlooked some notable artists; there were also a few who declined to take part in an exhibition devoted exclusively to African American photographers.

Most of the photographs in the final selection date from the 1980s and 1990s, but there are also images from previous decades, going back to the 1940s. Some evoke the Freedom Marches, bebop and Dixieland jazz, and many legendary athletes, performers, and political figures of the past and present. The prints range from black-and-white and chromogenic to digital and computer-generated. Their sizes vary from 11 by 18 inches to as big as printable. Together, these wide-ranging images represent a group of photographers of rich and diverse talents.

Many people provided invaluable assistance to this project. First, I would like to thank Arnold L. Lehman, the Museum's Director, for his vision and sensitivity to the importance of the exhibition at this time in the history of American photography. Ellen Reeder, Deputy Director for Art, provided wise advice and encouragement. I also thank Judith Frankfurt, Deputy Director for Administration, for her support and helpful suggestions. For her unerring attention to the logistics of organizing the works of the photographers, whose contributions came from all over the United States, I am most grateful to Hannah Mason, Exhibitions Manager. I would also like to thank Kit Smyth Basquin, research associate for the project, who compiled the biographies and artist statements for the catalogue. Elizabeth Reynolds, Chief Registrar, completed with calm vigilance the complex task of overseeing the exhibition prints as they were received. Dara Sicherman, our Departmental Assistant, smoothly coordinated information between artists and Museum staff members. I am also grateful to Joanna Ekman, Editor, and Abby Sider, Associate Editor, who prepared this volume for publication. Dean Brown, Chief Photographer, oversaw photography of the exhibition prints for reproduction in the catalogue. I also extend thanks to Charles Froom, Chief Designer; Sally Williams, Public Information Officer; and Sallie Stutz, Vice Director for Merchandising.

And, finally, I wish to thank all of the artists for their wholehearted cooperation with this venture and, especially, for their outstanding and memorable contributions to the exhibition.

Barbara Head Millstein
Curator of Photography
Brooklyn Museum of Art

Empowering the Eye

CLYDE TAYLOR

"Black" photography stakes out a novel terrain within modernity. From its beginning, photography has made itself the art of surprise, washing our eyes to newly naked perceptions. The camera's eye has surprised us with revelations of poverty, pomposity, shy wistfulness, inhumanity, and sublimity. Beyond the Peeping Tom starkness of fragile humans caught in the act of trying to escape their mortality, Black photographers often catch a further glimpse of the unexpected. For the Black face, as a visual representation, has long had a way of circling around the corners of our awareness with an extra something—charged with mythic energy, a familiar strangeness, an everyday exoticism. Its image still registers as a marker of difference, just as its color has been seen as a marker of race. And for some in our racialized society, clearly this face raises a pause, reorganizes emotions, or demands an attitude reality check. Black photography as represented in *Committed to the Image* therefore unsettles the comfort zone of idealized American society. As it confronts us with this challenge, the present exhibition testifies to the liberation of the Black gaze.

African American writing carries the mark of an ancestry forbidden to read or write, sometimes on pain of death. Photographers out of Africa know a similar burden—the imperative upon their ancestors not to look in the eye those who would overlord them. The anguish of the Civil Rights movement escalated when a fourteen-year-old boy from Chicago glanced with unguarded attention at a southern housewife and was murdered and mutilated in return. In the terms of the southern White-supremacist code, he was guilty of "reckless eyeballing," a charge that could land a person before a judge—or a lynch mob.[1]

One of the exclusive entitlements of the propertied class was the gaze. The disenfranchised were fixed at the receiving end of the right to scrutinize. Come the mid-twentieth century, a shift takes place. A recurrent academic joke tells of a European anthropologist looking through his telescope to research "primitive" customs when he discovers an African anthropologist peering through his own telescope and taking notes on him. "Today," wrote Jean-Paul Sartre, introducing a volume of poems from the Negritude movement of the 1930s and

1940s, "these black men have fixed their gaze upon us and our gaze is thrown back in our eyes."[2] But the camera's eye, when controlled by Black photo-artists, has more often been intrigued by images of Black people. Even this self-composed "eyeballing" might have been judged "reckless" in the more obvious times of the White-supremacist empire.

For the longest time Black photography was indentured to the need to document, hoping to bear witness to the profound story of the African Diaspora otherwise denied in the narrative of civilization. But it was finally in the context of the Civil Rights movement that Black photographers ascended the stage of national attention. The gripping photo that punctuates our memories—a Vietnamese girl-child running naked from a napalm attack, an American flag speared into the belly of a Black lawyer at City Hall Plaza in Boston during an antibusing demonstration, "John-John" saluting the funeral cortège of JFK—also carries the power to rearrange the furniture of our social imagination. Through startling, gritty images, African American photographers seized the moment of the Civil Rights struggle—the sterling moment of heroism in American experience over the last half of the twentieth century—to establish their presence and cover themselves with glory.

Since that historic and heroic moment, the significant evolution of Black photography has been its move closer to the mainstream of the art world, and the art world's movement toward it. This exhibition, as a reflection of that evolution, offers evidence of the complex interaction between these two domains of cultural perspective, both shifting with the winds of social change, each showing the other a continually altering face. A dance is taking place before our eyes, whether a stately minuet or a raucous hip-hop breakdown. The stakes are high in the drama being played out, with hidden histories springing abruptly out of closets, new alliances disturbing old ones, and the vocabulary of cultural meaning on a roller-coaster ride without tracks.

"Post–Civil Rights" is usually a catchphrase for a wholesale retreat from commitment to careerism, from group solidarity to egocentric consumerism. The end of the Civil Rights moment presented a turning point, marking the decline of a stirring role of great relevance, but also the gain of new opportunities to explore in an art scene notable for its abundance of new resources and tolerances. In this new space, in-the-moment action photographers like Shawn W. Walker and Ernest C. Withers found the license to convert themselves from documentarians to artists, following the creative impulses that urged them to take up the camera in the first place. When photography was considered beyond the privileged arena of "art," Black photographers got little recognition; now that photography has come to be considered seriously as an art form, Black photographers are not only recognized, but for the first time are getting the opportunity to have their work regarded as art. And the

photographers have responded with flair, alacrity, and an intensity that may owe something to the smoldering embers of the excitements of the 1960s. This exhibition is proof that the capacity to seize the moment of burning significance is very much alive and has found ever-widening scope for play. For as we stand back and look, we cannot miss the fire that glows under these images, a fire kindled by passion on both sides of the lens.

The entrance of Black photography into mainstream venues presents us with new marvels to behold. It offers us the shock of the new, the shock of modernity. What might have been suspected, hinted at in the brilliance of James VanDerZee, is that the artistically photographed image of people of Africa is one of the magical offerings of the modernist transcendence of the traditional. At the end of the twentieth century, the century of modernism, the photographic Black image manifests itself as another chapter in the history of modern art. This new episode arrives ambiguously, echoing the modernist past at points, and at others nudging us toward redefinitions of the modern altogether.

As an apparatus, the camera is in technological collusion with Black photographers' ability to subvert—to undermine not only routine dullness, but the classical Western notions of truth and value. Photography interrupted a world where the luxury of seeing one's image reproduced was reserved for the rich. Today, with throwaway cameras, the personal image is within reach of everybody in the overdeveloped world. Here in this exhibition are faces that once had little hope of seeing their likenesses except in the caricature of a poster describing a runaway slave.

The high-art aspirations of photography have to cope with this democratizing potential. Unlike easel painting, the photographic image always threatens to drag the object back from the aestheticized gaze into real, everyday life. African American photographers have used this duplicity to play a game where the observer is in one instant entranced by the felicities of form, composition, lighting, and color, only to be jolted in the same nanosecond by a restless psychosocial revelation to which these formal qualities play a sometimes bracing counterpoint.

If the visual spectacle of Civil Rights action caught on film made its mark by focusing brutal national contradictions, this later art photography engages a social field full of subtler ironies. Hence, the iconography framed in this new work always has at hand the play of ploy and the ploy of play. It projects images that appear one way to the homogenizing eye but then bounce back shadows in return. This shadowy world turns out to be a parallel universe beside the prefabricated spectacle, complex where the regimented eye is reductionist; empowering where the other is deflationary, nostalgic, or paternalistic; coherent where the other is fragmentist; offering explanation instead of divertimento.

Once the pressure of social-protest duties lifted somewhat, Black photographers scattered in all directions. But lest we overstate the case, there was real diversity and artistry among Black photographers long before the era of marches and police dogs in Birmingham. Here in this exhibition, the presence of pictures of jazz musicians from the 1960s, like Chuck Stewart's *Eric Dolphy* and *John and Alice Coltrane*, caution against the reduction of all photography of that period to one note (pp. 204–5). The division between protest and non-protest expression is far less pronounced to those who live daily with the question of social justice than in the theoretical frames of the art world.

In Jules Allen's shot of police smothering a youth identifiable only by his sneakers, we find continuity with the action photos of Civil Rights demonstrators being brutalized, with the dogs of Birmingham here replaced by uniformed agents of the law (opposite). Maybe the lesson is that the Civil Rights movement is still with us, with its concerns sometimes modulated among other interests. Examining these images can offer an exercise, a game, the search for the ploy. Notice the point of ironic commentary, often social in nature, like the "Alive with pleasure" commercial slogan over the bustdown captured in the Jules Allen photo just mentioned.

These ironies are not always so explicit, nor always social and political. Sometimes there is a residual reflection of the classical Western world against which an image of repressed meaning is breaking forward. And this connection with the classical bourgeois worldview may be in the spirit of artistic collaboration or resistance, a fun echo or a satirical quotation. Some of these photographic impressions simply notate an unencumbered, self-possessed way of the Black subject's being in the world, with the subtler irony located in the understanding that this fruitful existence is an anomaly before the sour predictions of social policy. Other works refuse social and historical reference altogether in favor of the intuitions of the eyeballer's cosmopolitan individualism, as in the abstraction of photographs by Herb Robinson (p. 184), the architectural compositions of Albert R. Fennar (p. 96), or the nonfigural expressionism of Shawn W. Walker (p. 214).

What is memorable about this mass of work is the way the photographers spread out across the range of artistic possibilities. They overlap in the modes and genres that they undertake, but always with great individuality, each distinguishable from the others. Their work extends from social realism of undeniable power to many of the motifs and genres of Arthistory (which is the self-image of Western imagination),[3] as well as the history of African American visual art. There is playful symbolism in Coreen Simpson's work (p. 198). There are photo memorials like Lonnie Graham's (p. 112). The homey sentiment of Toni Parks's cherubic children is countered by the gritty angst of children at risk in the pictures of Eli Reed (pp. 170, 178). Anthony Barboza's meditation on Black youth as sacrificial victims of the media puts into play the alienation mixed with involvement characteristic of

Jules Allen, *Untitled*, 1987 (detail; see p. 47)

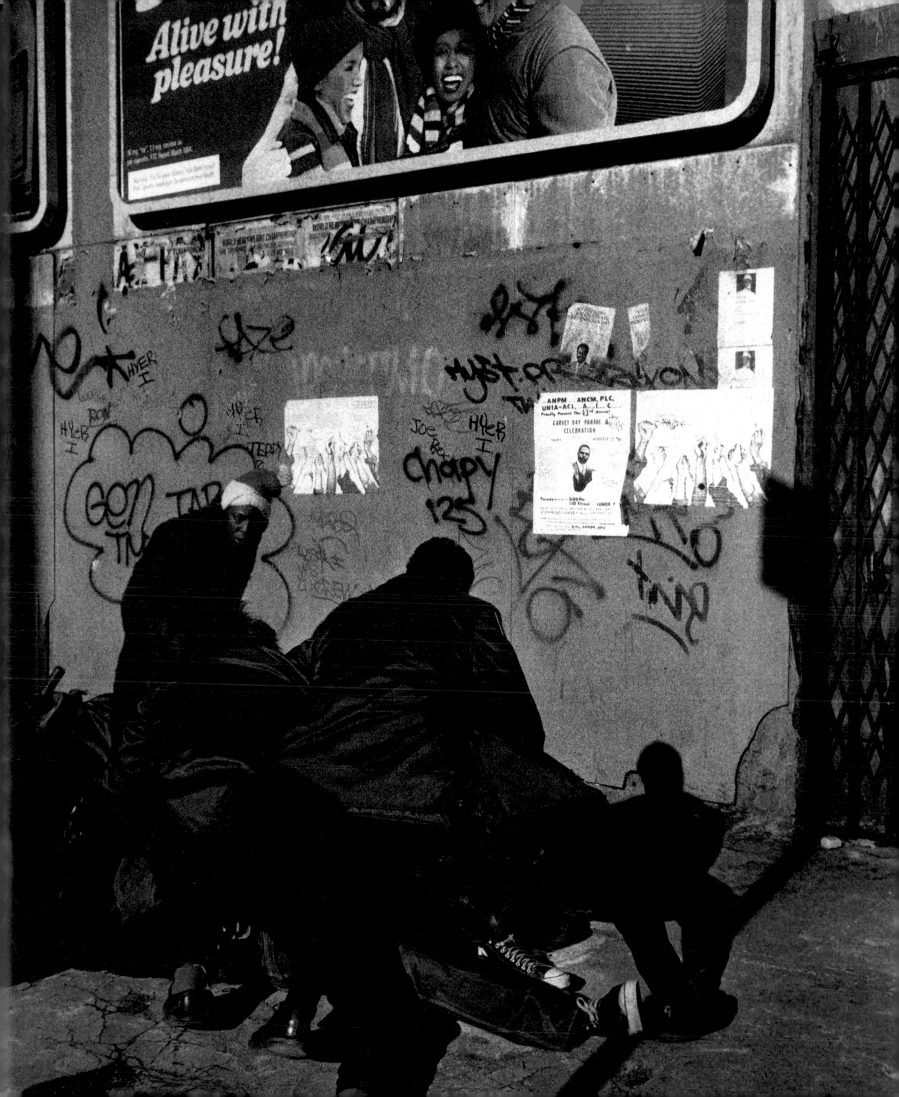

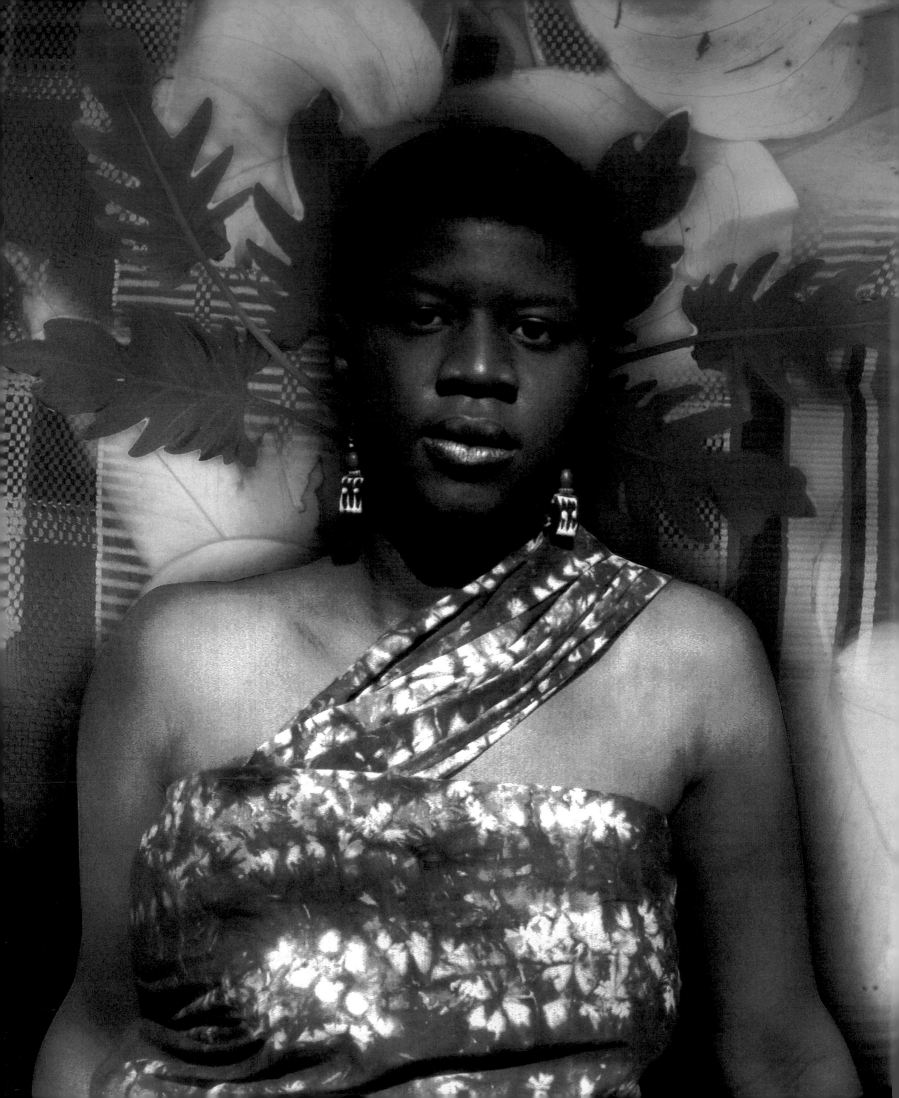

much Conceptual and installation art (p. 48). There are surreal interiors; while the dense frame of Charles Martin's evocations of carnivalesque Brazil echoes Cubist multiplicity or the neo-Baroque of Mexican muralists (p. 150).

Some of these depictions capture scenes that look strangely off-balance, like structures that appear to stand without means of logical support. Looking at Jim Collier's layered image of an impoverished but highly textured dwelling or Albert R. Fennar's mysterious yardscape, *Chet Cole's Farm*, we are challenged to recognize what we "see" (pp. 79, 97), as with deconstructionist architecture by Frank Gehry or certain pieces of Conceptual art. The faces of Black youth in Beuford Smith's pieces are collaged and disturbed by scrims of detritus and menacing iconography that produce an unsettling but appropriate poetry to represent a generation for whom hip-hop is both an artistic release and a sign of extremity (p. 200). There is a continuous stretch of images that reaches past naturalistic realism into the many venues beyond the merely "photographic," as that term was used in the nineteenth century, in negative comparison to painting. The black-and-white figure against a tropically colorful background in Fern Logan's *Earth Goddess* intimates a magical realism shared in Albert Chong's *Justice Variant with Eyes of Cowrie*, among others (opposite, p. 69).

This exhibition registers a seismic shift. The work of these photographers seems to reverberate, echo, and dialogue with Arthistory, expressing the intimate self-consciousness of "minority" perspective. Arthistory's legacy of arrogance places it in an awkward dilemma, now that its highly evolved vocabulary is being used to express alien thoughts in a patois once held up as a symbol of unworthiness.

So the former outsiders invade the halls of Arthistory. It wasn't supposed to be like this. Arthistory prided itself on certain gestures and images, precepts and practices, that harmonized with its host audience. Now the formerly excluded are half inside, half out, using the same gestures, devices, and references that Arthistory considered its own, its signatures. Suddenly, with the introduction of the faces and ideas of these emergent artists, traditional looks and attitudes take on a different, ironic flavor.

After many in-your-face encounters with difference, Arthistory now begins, ironically, to understand the vernacular of the paganized. There has been an erosion of exclusivity. The banker's daughter sings along with rap lyrics. Arthistory gets a nervous rush as it thrills to the radical hipness of this new expression. How much longer can it hold its privileged position together? A bit anxious about its virtue and honor, but titillated by the novelty, Arthistory invites the newcomers into the main wing.

What does it mean that these echoes of art motifs in Black photography carry so many overtones of the civilizing art world? Is this a sign of assimilation and capitulation? Before the twentieth century, the interaction

Fern Logan, *Earth Goddess*, 1997 (detail; see p. 144)

between these two worlds was exploitative and unilateral, but the exchange has become less and less one-sided. The encounter is now two-way, as it was when Pablo Picasso and the Cubists surrendered to the hypnosis of African sculpture. The two ends of this dialogue echo each other and at points come into primary contact and inseminate each other.

In *Committed to the Image*, this dialogue with Arthistory is sometimes delicately ambiguous. Gary Jackson Kirksey's image of the elderly middle-class Black couple in raincoats echoes *American Gothic*, but with the pity of the original replaced by awe that these survivors are here at all (p. 141). There is more than one Black woman's nude back in this exhibition, and we may accept the invitation to enjoy the absence of whip scars there. Pathos enters the dialogue with Western self-regard in LeRoy W. Henderson, Jr.'s reflection of a pensive young balle-rina—where the blackness of her face and arms highlights the whiteness of the neoclassical wall sculpture in the background (opposite). Here the irony includes the way the figures in the frieze look upon the girl almost in mockery. "Get out of there," I almost want to shout at her, "Can't you see the danger?" Is she not, even with all her determination and character, caught in a historical bind that recalls the little Black girl surrounded by Federal marshals on her way to integrate a school in Norman Rockwell's famous painting? And yet, sacrificial lamb that she may look to be, we know that beauty from experience, now, and the resilience that will carry her through and maybe turn those frozen sculpted leers into welcoming smiles.

Other artists speak of an imaginative framework outside of Arthistory. This "outside" set of possibilities is implied by the many references to Africa in this exhibition—one of the distinctive marks of this body of work and its era. Carrie Mae Weems's witty architectural still life (is it a Sahelian doorway in Mali or Senegal?) insinuates a version of African womanhood (p. 216). Throughout the exhibition, cowrie shells abound, and brilliant robes and head wraps evoke ancestry. Africa is summoned in these photos without the sardonic distance brought to it in Cubist and other Euro-modernist references. In place of condescension or voyeurism, there is a sense of tri-umphant identification. But here again, the individuality of the varied approaches to Africa as subject demands respect. Dr. Juma Santos's ritual memories meditate on an Africa that is much about the business of being African for itself (p. 190).

These visual philosophers, being ambitious people, usually sign the contract with Western art theory, but then, likely as not, they break it. Among the fragments of these breaks is an abundance of spirituality not easily located in the modern Western tradition. There is less fear of invoking gods outside the Christian pan-theon. One finds in these photographs quantities of belief, reverence, and devotion. These photographers and human subjects occupy a different historical position from the more jaded elite of the fashionable art scene.

LeRoy W. Henderson, Jr., *Untitled*, 1993 (detail; see p. 126)

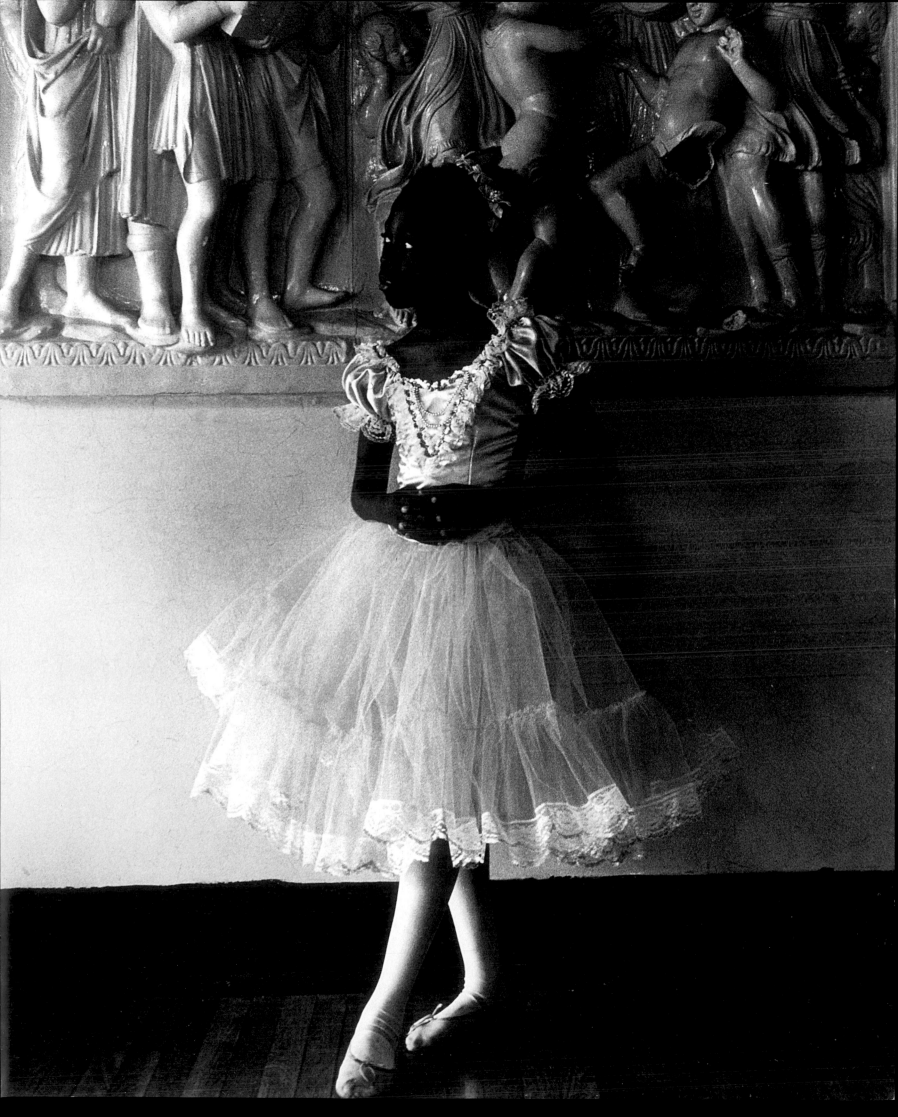

The self-cannibalization of the Western art world, where movements and art styles battle with each other to claim the only great or relevant tradition, has led its followers to deadness of spirit—and proud of it! The artists in *Committed to the Image* cannot be blamed for asserting a perspective still able to sustain the idea of tragedy, desire, and love, while these ideas seem like sentimental pap to those for whom such feelings have been evacuated.

Some of these spiritual reference points show up here in photographs that almost look like family-album materials, as in the family dramas and *tableaux vivants* of Gerald Cyrus (p. 86). It has been observed that the decoration of some households—not only among African Americans—features objects grouped in ways that compose a kind of altar. It is more and more common to find such corners and spaces in households of African Americans, sometimes including banks of family photos. More than a few of the images here reflect this pride of heritage. Some recall the walls of respect erected in the 1960s and 1970s, those neighborhood murals celebrating the heroism of the tribe. So the charisma found here conveys a spirituality that is an ethno-spirituality. The note of celebration is also sounded by the many photographs of Black women whose beauty carries the sweeter sting of emerging from a history of being maligned. Delphine A. Fawundu's nude on a bathtub, *Patiently Waiting*, with the shock of exquisite Black loveliness set against a stark white background (p. 95), is only one of several photographs that recall the work of Black American painters and sculptors, in this case, Eldzier Cortor.

So there is an air of triumph in this exhibition. It comes out of the impact of the whole, the cumulative impression of highly individualized contributions. Altogether, this exhibition represents the empowering of the eye. Seen as a group, these images do not encourage despair, fear, and loathing, as have several recent exhibitions of Black art and imagery that catered to fashionable nihilism.[4] There is compassion for the human in these works. They are missing the self-corrosive, trendy "transgression" insisted on by many curators and critics, perhaps in part because the photographers themselves submitted work they wanted to represent them on this occasion. Maybe the pieces were chosen to reflect inner selves, as well as what the photographers wanted to project outward for social reflection.

The triumph in this work, as well as the capacity for triumph—the ironic sense of belief in oneself that we find profusive among the very people least likely to afford such sentiments—is part of a larger irony in cultural history. Those who have been cast in the role of "pagans" to the civilizing mission emerge as caretakers of a parallel version of modernist expression that embraces life-affirmation, while the official modernism of the gatekeeping institutions is being deflated in revisionist reassessments.

Is this parallel modernism a manifestation of an alternative history, another world? Do we not see these photo-artists reveling in the joy of capturing this extravagant difference that refuses to be other than it is, despite the cost—as in the neo-Africanism of Suné Woods's Diasporan family portrait, *Moses and Rongee Tjiriange* (following pages), or Vernon Reid's eerie, *vodun*-evocative "still life," *Two Figures with Gold Bar*, a curious, off-balance image that he caught in the window of a Paris shop (p. 181)? Black art and imagery of the caliber presented here gain power from their capacity to *haunt* the dominant cultural position.

This exhibition puts us in a fortunate, intriguing, and perhaps transitional place. We have the satisfaction of seeing Black photographers alight on this momentary point of accomplishment, past any question of legitimacy as creators, and with infinite possibilities in front of them. The genius displayed here allows us to embrace African American photographic expression as another fully empowered force, along with Black music, dance, poetry, fiction, theater, painting, and sculpture, that contributes to the revitalization of American and world culture. The moment is ripe. But this is also a moment of blurring of lines of perception, and reception of art of all sorts and sources—elitist work blends with pop, outsider art mixes and mingles with choice gallery venues, media collide and cross. In this blurring of lines, the openness of the art scene gives space to an identity-based Black art whose attachment to its roots is the particular source of its power. At the same time, that scene exerts equal pressure to diminish Black identity. The arrival of Black photography as sampled here is just in time to enter into this latest phase of a complex dialogue.

NOTES

1. Emmett Till was tortured and murdered in Money, Mississippi, in 1955 for violating local racial codes by allegedly making advances toward a White woman. The photograph of his mutilated corpse in an open casket—which was published in *Jet* magazine—is believed to have been a spark in the developing Civil Rights movement. For a fictional exploration of reckless eyeballing, see Ishmael Reed's novel *Reckless Eyeballing* (New York: St. Martin's Press, 1986).

2. Jean-Paul Sartre, *Black Orpheus*, trans. S. W. Allen (Paris: Presence Africaine, 1976), pp. 7–8. Originally published in Léopold Sédar Senghor, *Anthologie de la nouvelle poésie nègre et malgache de langue française, par Léopold Sédar Senghor, précédée de Orphée noir, par Jean-Paul Sartre* (Paris: Presses Universitaires de France, 1948).

3. I use the term *Arthistory* to indicate the institutionalization and control of knowledge about the world's cultural work, maintained through an inbred or very limited academic conversation. Arthistory's judgments must remain suspect because of the narrow range of its sympathies and allegiances.

4. The leading example would be *Black Male: Representations of Masculinity in Contemporary American Art* at the Whitney Museum of American Art, October 1994; other examples include the representations of Black men in Robert Mapplethorpe exhibitions, and the "neo-coon" art of Kara Walker.

(overleaf) Suné Woods, *Moses and Rongee Tjiriange*, 1998 (detail; see p. 226)

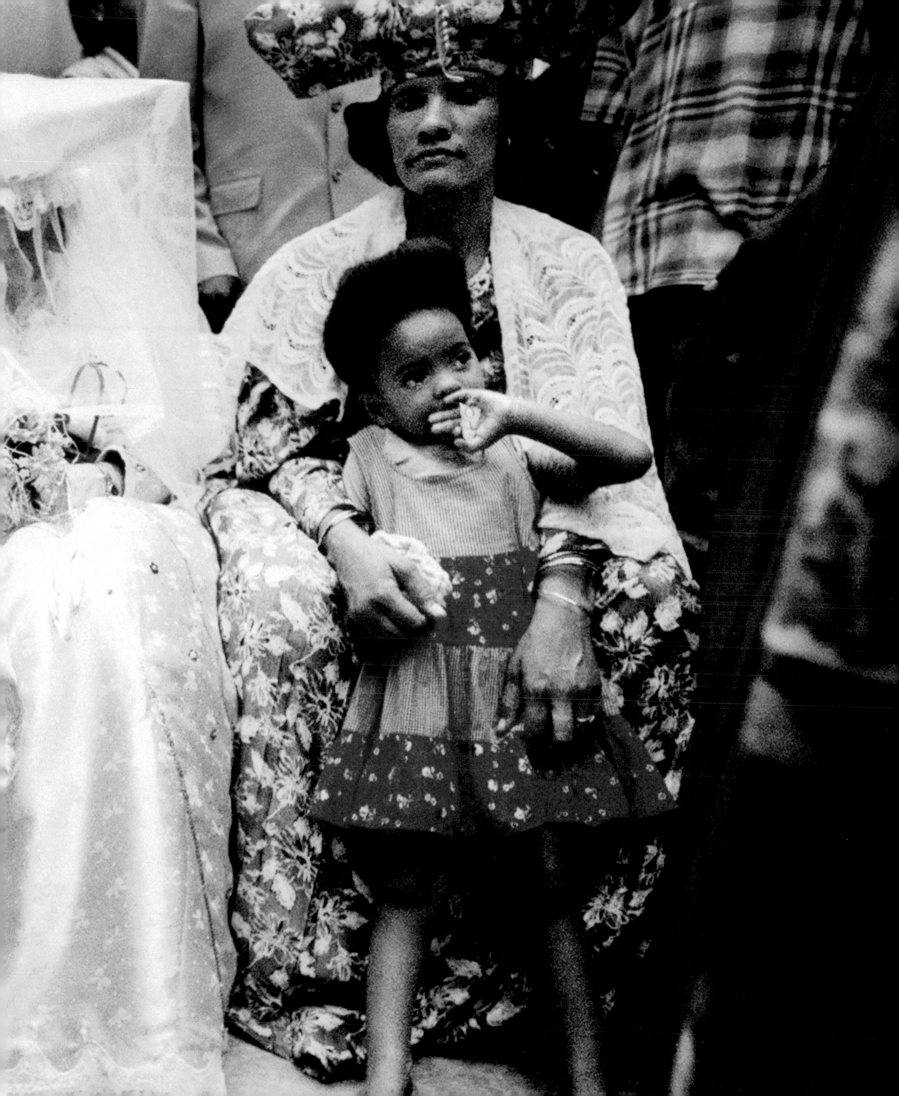

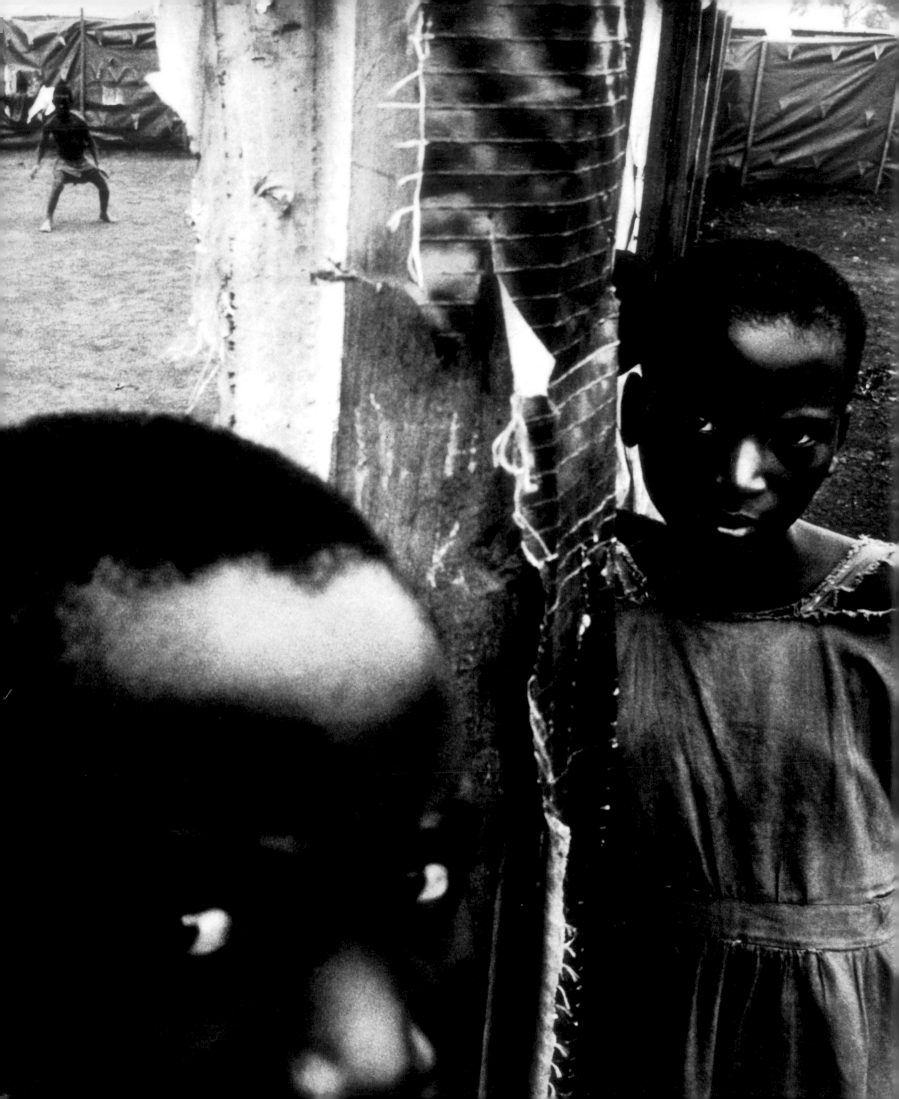

Diasporic Double Vision

DEBA P. PATNAIK

I love light. Light confirms my reality, gives birth to my form.
Ralph Ellison, *Invisible Man*

I gotta world I'm making in my own image.
Ntozake Shange, *A Photograph: Lovers in Motion*

The story of the Negro in America is the story of America.
James Baldwin, *Notes of a Native Son*

The story of the African Diaspora in America and the violation and brutalization perpetrated against Black people for centuries needs no retelling. Denied all basic human dignity and rights by the dominant society, both individually and institutionally, African Americans were long treated in the art and literature of the dominant culture with mockery and contempt. Their portrayal, to put it mildly, was gross beyond reason and reality. In truth, African Americans have themselves made original and enormous contributions to music, literature, and the visual arts. Since the nineteenth century, they have used the camera with telling import, not only to memorialize their subjects, but to preserve with integrity the self-image of Black life and community, while refuting racist imagery.[1]

From the very beginning of the history of American photography, Black photographers have played a noteworthy and active role. Artists such as Jules Lion in the 1830s, the Goodridge Brothers in the 1850s, and, later in the century, Harry Shepherd, James Ball, Henry James Lewis, Addison Scurlock, A. P. Bedou, Mary Warren, and Mary Flenoy, to name but a few, have left behind a robust legacy in their daguerreotypes, portraits, landscapes, and documentary views. Hamilton Smith's Boston, P. H. Polk's Alabama, James VanDerZee's Harlem, and Roy DeCarava's jazz images are remarkable contributions to the history of photography. The multitalented Gordon Parks's prodigious corpus is an outstanding achievement. Polk, Parks, and DeCarava have inspired and influenced

generations of American photographers, especially African Americans. The accomplishments of these and many other Black photographers have continued despite decades of "*de facto* segregation in the field," to quote A. D. Coleman, writing on DeCarava in 1970.[2] *Committed to the Image: Contemporary Black Photographers* is a fitting testament to the dedication and genius of contemporary Black photographers in America.

An exhibition of this nature raises challenging issues and questions that are at once sociopolitical, ideological, and aesthetic—for these perspectives are fundamentally interconnected with regard to "minority" artistic expression, particularly in the context of American history, culture, and practice. Why talk of Black photographers as separate from other American photographers? Do shows like the current one betray a kind of "ghettoization"? How valid is the notion of "Black photography"? Is "Black aesthetics" an identifiable and a justifiable concept? I will attempt to address these questions briefly, but first it will be useful to survey quickly the undeniable part that African Americans have played in modern American photography.

For more than half a century, Gordon Parks and Roy DeCarava have produced an extraordinary body of photographic work of great technical and artistic quality in portraiture, landscape, fashion, documentary, and experimental genres. In 1955 DeCarava published his *Sweet Flypaper of Life*, with the distinguished poet Langston Hughes's moving narrative. It is a compelling interpretation and documentation of Black urban life and experience. With DeCarava's guidance, the Kamoinge Workshop was founded in 1963 in New York. The original group consisted of Lou Draper, Albert R. Fennar, Ray Francis, Herman Howard, Jimmie Mannis, Herbert Randall, Herb Robinson, Larry Stewart, and Calvin Wilson. Later Anthony Barboza, Adger W. Cowans, C. Daniel Dawson, John Pinderhughes, Beuford Smith, Ming Smith, Frank Stewart, and Shawn W. Walker joined the group. The Kamoinge Workshop's goals included support for practicing artists, enhancement of knowledge and skills in the medium, encouragement of aspiring photographers, and positive and truthful representation of Black life, culture, and community. Camera 35 was another organization started in New York in the 1960s. Along with New York, cities like Atlanta and Chicago became centers of considerable activity among African Americans in the field of photographic arts during and after the decade. In the early 1990s Zone III Photography Workshop and Sistagraphy (for Black women) were established in Atlanta. From these groups, many prominent photographers have emerged, some of whom are included in the present exhibition. Between 1973 and 1980 *The Black Photographers Annual* published four impressive issues that showcased many established and budding photographers.

Yet, the burgeoning work and activities of Black photographers attracted scant attention from non-Black critics, museums, and galleries. (Only in the last twelve years or so have a handful of them received some recognition from museums such as The Museum of Modern Art in New York, the Albright-Knox Art Gallery in Buffalo,

and The Corcoran Gallery of Art in Washington, D.C.) The Studio Museum in Harlem, however, has valiantly continued to support them from its inception, as has the Anacostia Museum in Washington, D.C. Books on the history of photography and photo-criticism by non-Black writers (with the exception of A. D. Coleman) hardly mention them, as if in a conspiracy of benign neglect. As yet, Aperture's Masters of Photography series has not included even such eminent artists as Gordon Parks and Roy DeCarava, with their solid international reputations and contributions to American photography.

In the face of manifold forms of neglect, misrepresentation, and denial of opportunities and resources, Black artists have prevailed in formulating an authentic and meaningful alternative artistic response to American society and culture, their own experience, and the world at large. Galvanized by radical cultural and sociopolitical events such as the Civil Rights movement and the activities of the Black Panther Party and the Student Non-Violent Coordinating Committee, they have shaped an important space and culture. This reality is not a matter of "separatism," especially considering the prevalent exclusionary practices and hegemonic attitudes of the dominant culture and society and their market. Nor is it a question of "ghettoization." By and large, non-Black American photographers have depicted Black life and community in a pathetically narrow fashion, producing only images of squalor, poverty, and decadence. Individual portraits of Black Americans have suffered degrading stereotyping and eroticization. In contrast, Black artists provide an image of Black life and community as multidimensional and self-sufficient. Thus, this exhibition includes portrayals of working mothers, wood-carvers, boxers, musicians, children dancing and laughing—as well as their homes, yards, and family and social gatherings in both rural and urban settings in America. The photographs of Jules Allen, Gerald Cyrus, LeRoy W. Henderson, Jr., Gary Jackson Kirksey, Fern Logan, Jeanne Moutoussamy-Ashe, and Eli Reed, for instance, exemplify striking imagery and craft that challenge stereotyping and reflect the richness and diversity of Black life, community, and experience. Don Camp's handmade casein-and-earth-pigment monoprint portraits are inventive and metaphoric (p. 62). Hugh Bell's portrait of Billie Holiday is vivid with poignant dignity and realism (p. 52). Free of sentimentality, valorization, and condescension, images of beauty and power abound in the work of photographers like Donald L. Bernard, Faith Goodin, and Frank Stewart. In their compositional intelligence and tonal and textural complexity, the photographs of Jim Collier, Roland L. Freeman, Leslie Jean-Bart, and Marilyn Nance convey an immediacy of feeling and a sense of location and time with irony, humor, and social commentary. In the field of photojournalism, Black photographers from Gordon Parks to Ernest C. Withers have carved out a place of distinction.

Unlike ethnographic or predisposed journalistic types of photography, the work of Black photographers particularly illustrates connections among the "subject," the artist, the community, and the viewer. In treating

the photographic subject—be it an individual portrait, a neighborhood bar, or a family or street scene—Black photographers have tried to formulate a critical social basis for their art by using modulated forms and tones and unusual angle and perspective, combined with narrative and graphic art. This sensibility, I propose, directly flows out of the tradition of jazz and blues, which has been an underlying influence in Black aesthetics. Ralph Ellison maintained that "jazz impulse" and "blues impulse" shaped the literary tradition of Black writers from the very beginning.[3] Not only have these two impulses given a unique authenticity, voice, and texture to the literary works, but they have also infused African Americans' aesthetic and intellectual approaches to the Black experience of displacement, oppression, and misrepresentation in America. In their modulated tones and forms, encoded social implications, and improvisation, jazz and blues create a polyrhythmic structure of interrogation, affirmation, and reconnection with the community's shared history, experience, and destiny. From the writings of Charles W. Chestnutt and Zora Neale Hurston to those of Ralph Ellison, Ishmael Reed, and Alice Walker, this sensibility is manifest. Among the painters, Romare Bearden, Jacob Lawrence, and Adrian Piper, for example, incorporate these structural and aesthetic features in their work.

The use of series in the work of Black photographers is an aesthetic strategy that is informed by blues and jazz impulse. Each individual image in a series is autonomous and complete yet reinforces the narrative structure and form of the whole—like a phrase in jazz. This mode is clearly evinced in series such as Beuford Smith's Hip-Hop Poster, Anthony Barboza's Black Dreams / White Sheet, Cowans's Shadow Light, Pinderhughes's Pretty for a Black Girl, or Delphine A. Fawundu's Black Love.

In my view, the jazz and blues impulses animate the work of Black photographers and also engage them in critiquing the American experience and history of misrepresentation and in expressing a new vision. The commentary and interpretation are in the manner of "call and response" of Black oral and musical traditions. One could reasonably argue that if the imagery of VanDerZee, Polk, Parks, and DeCarava provides a communal and historical context (call), the work of the younger generation of photographers, in defining their selves and their subjectivity, and validating their experience, constitutes a response. Anthony Barboza's and Shawn W. Walker's portrayals of the Black experience and the myth of the American Dream are heightened by dramatic irony and intensity. One notices in them, as with many other images by contemporary Black photographers, a mythopoeic imagination and subtle improvisation at work. As it emerges out of existing contradictions and conflicts in American life and society that pertain to issues of race, class, and identity, art becomes a way of naming, seeing, and changing the world for Black artists.

Albert Chong and Carrie Mae Weems have masterfully organized these tensions and dynamics in their work.

Ernest C. Withers, *Dr. Martin Luther King, Jr., Confronted by Police at Medgar Evers's Funeral, Jackson, Mississippi,* 1963 (detail; see p. 225)

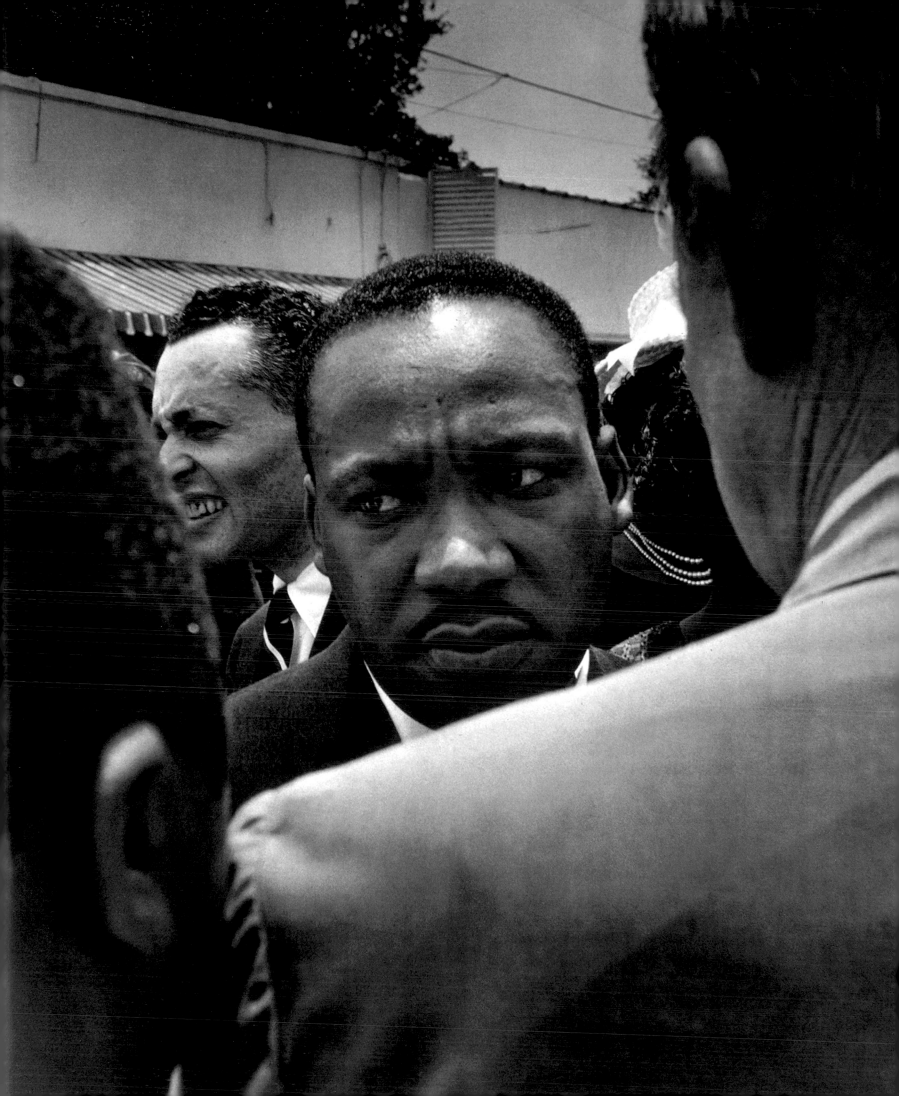

Their use of autobiography and self-image is far more stimulating and intricate than that of their non-Black counterparts. Chong's fabulous fabrications combine disparate materials and elements with drama and poetry. He transmutes the conventional method of photographing through a ritualized process of improvisations. Juxtaposing the secular and the religious, the concrete and the magical, and memory and fantasy, he invests his images with iconic symbolism. Weems, a most innovative, intellectually challenging, and technically skilled artist, redefines and extends the boundaries of the photographic medium to project a dialectic of ideas, beliefs, and assumptions about social constructs of gender, race, and identity. In the Africa series, for example, she uses architecture metaphorically to probe gender issues, as well as the colonialist psyche, while she captures the beauty and grandeur of the African cultural and artistic heritage (p. 216). It is a mordant comment, devoid of spurious emotion and didacticism, on the Western world's attitude toward and image of African and Black culture, history, and heritage. Incorporating folklore, dialect, and words from the blues, Weems's imagery is vibrantly expressive and provocative in its starkness and economy.

It is pertinent to recognize how many Black photographers have spent extended periods of time in Africa and other parts of the world of the African Diaspora, and to acknowledge the distinctiveness of their imagery and interpretations. From Chester Higgins to Charles Martin to Carrie Mae Weems, the artists address issues of displacement, roots, and reappropriation. In general, contemporary Black photographers reject the notion of the camera as a neutral, objective instrument in the service of art for art's sake. Through the use of the medium to rediscover and redelineate their history and that of America—"excavating history," to borrow from James Baldwin—the photographers have created a countermyth, forcefully revealed in the work of such artists as Barboza, Chong, Walker, and Weems.[4] The countermyth is rooted in the very experience of the Diaspora—both in America and in the world—and has evolved from a potent historicization of Black life, culture, and experience. Henry Louis Gates, Jr., suggests that Black literary artists "wrote themselves into being."[5] In the same vein, it could be said that Black visual artists composed and projected themselves into being through their image-making and imagery. Commingling social, political, historical, spiritual, and personal themes with conceptual and metaphoric significations, Black photographers have creatively transformed what W. E. B. Du Bois called the African American's "double-consciousness" of being "an American, [and] a Negro."[6] They have forged a double vision, which encompasses African American history and the history of America with all its contradictions. This perspective has given a dynamic context to the photographic manifestations of their individual and collective experience. And with this insight, they have discovered new possibilities for continued, vital contributions to the art and culture of America.

The work of Black photographers is significant not only for its conceptual and ideational content, but also for its aesthetic and technical range, quality, and experimentation. The works in *Committed to the Image* run the entire gamut of genre—from documentary to portrait to abstract imagery—and technique—from Polaroid transfer to photomontage to digitalization. Adger W. Cowans's talent in manipulating light for abstract imagery is absorbing. Delphine A. Fawundu's *Patiently Waiting* is an exquisite image both in suggestiveness and technique (p. 95). The high contrast of the woman's shining black body against the white bathtub and walls, the framing of the whole image, and the precision in composition display Fawundu's acute sense of visual architectonics. In the Yo Mama series, Renée Cox makes an emphatic statement about Black womanhood and motherhood with frontal-angle shots and staging of human figures. Herb Robinson's abstract color compositions are evocative and symbolic, while Mel Wright's use of color illustrates subtle and suggestive tonalities. Lonnie Graham shows a keen ability in organizing objects and space to create a sense of mystery. John Pinderhughes elegantly uses technique to produce captivating images. His panoramic landscape is a lyric in color and attests to his mastery of tone, texture, and mood (pp. 172–73). In his recent color work (not included in the exhibition), Gordon Parks has pushed his earlier experimentation to higher flights of poetic imagination, musical improvisation, and surrealistic evocation. With its very limited sampling of the current exhibition (in which work by DeCarava, Lou Draper, Dawoud Bey, Lorna Simpson, and Ming Smith is absent), this essay can only hint at the range and quality of the Black photographer's art and craft. The diversity in subject matter, imagery, and treatment of the photographic material—which squarely exposes the mistaken assumptions about specifically Black subject matter or "Black photography"—is matched by the resourcefulness in technique and genre.

The concept of "signifyin" (or "signifying"), I believe, underpins the aesthetics of many Black photographers' work. Signifying, in the context of Black culture, is a unique and expressive and communicative mode with a variety of applications and meanings. It is a trope that subsumes, according to Henry Louis Gates, Jr., "several other rhetorical tropes including metaphor, metonymy, synecdoche, and irony."[7] It grew out of tales of the Black mythological figure of the Signifying Monkey during slavery in the nineteenth century and variously figures in Black songs and literature. Although the precise origin of the Signifying Monkey cannot be determined, its role as a trickster and an agent of subversion is universally articulated in folktales and literary works of Black culture. Its method is to turn and twist by language and gesture to interrogate and expose the other side, as the Monkey does to the Lion in the original tales. Signifying is a multilayered symbolic system of expression and meaning—a mode of figuration that functions simultaneously at several levels—ironic, factual, and metaphoric. Roger D. Abrahams explains this unique form of Black discourse: "It can mean any number of things; . . . it certainly refers

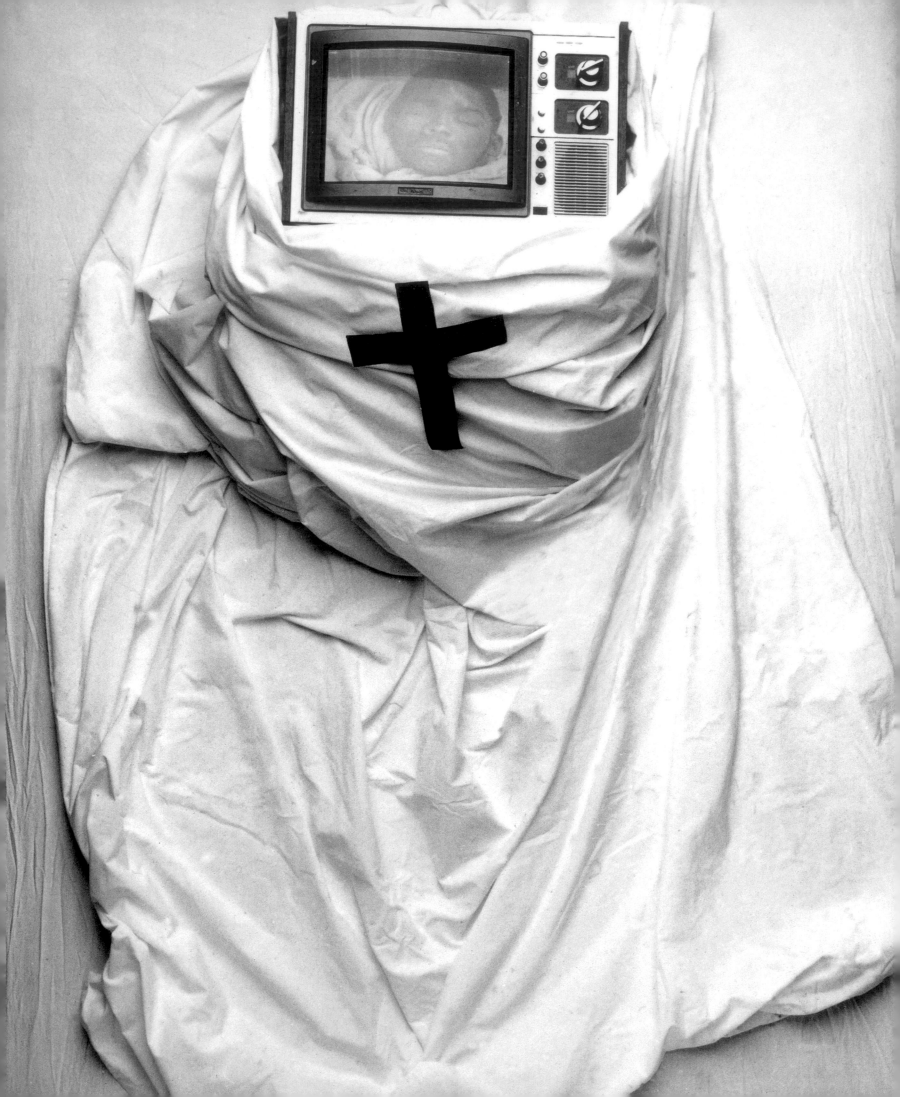

to the trickster's ability to talk with great innuendo, to carp, cajole, needle, and lie.... It can mean making fun of a person or situation...."[8] And, in the words of Claudia Mitchell-Kernan: "The Black concept of *signifying* incorporates essentially a folk notion that dictionary entries for words are not always sufficient for interpreting meanings or messages, or that meaning goes beyond such interpretations.... What pretends to be informative may intend to be persuasive...." She further elaborates: "The apparent significance of the message differs from its real significance."[9] She finds indirect intent, or reversal in apparent significance, and metaphorical reference critical to signifying. An aesthetic principle and strategy of irony, parody, reversal, indirection, argument, and persuasion, signifying is totally integrated in Black expressive and communicative forms.

This aesthetic strategy is conspicuous in the work of Black photographers, and recognizing it enhances the impact of their imagery and our appreciation of their artistry. Coreen Simpson's two images in the exhibition are riveting examples. The photograph from her Sky Portrait series—with its stereotypical associations evoked by the watermelon, white lips and palm, and blackened face—is an obvious allusion to minstrelsy (p. 198). Read in the context of the history of minstrelsy in America, with its blatant stereotype of Whites performing in blackface, the image acts as an ironic inversion. The jestful entertainment turns into a subtle, coded mask-act; and the comic drama becomes a symbolic mode of exposure and critique. The jester, like the Signifying Monkey, is a trickster and typifies a subversive figure, whose symbolic language, as in the case of blues and spirituals, is especially transparent to the Black community. Simpson's juxtaposition of the watermelon and the pair of antennae, which is a receiver and transmitter of images (both racist stereotypes and real portraits), is a brilliant stroke of parody, irony, and subversion. Like Simpson's imagery, Anthony Barboza's, in the Black Dreams / White Sheet series, imparts powerful metaphoric significations through hyperbole and irony—two components of signifying. One photograph chillingly shows a cross-marked white sheet wrapped around a corpse that is not visible, with the face of a dead Black youth on a television screen placed at the head of the covered body (opposite). The photograph is an indictment of racism in America and the failure of the American Dream for Black Americans. The other image, in its caustic exaggeration and the severe contrast between the dark body and white markings, is suggestive of the emasculation of the Blacks by White supremacists' beliefs and actions (p. 48). The title of the series further sharpens the irony.

Charles Martin's *Christian Procession, Salvador da Bahía* lends itself to interpretations from the aesthetic principle and tradition of signifying (p. 150). He has organized the visual material using off-center placement and slant angles, as well as silhouetted and blurred figures dwarfed by a huge, framed image of Christ dominating the foreground. Even the image of Christ—one eye obscured behind a white band across the face and the

other eye looking straight at the viewer—conjures up a variety of interpretations. It is a grim-faced Christ in a religious procession supposed to arouse fervent emotions. The photograph, taken in Brazil, might raise questions about the history of Christianization and the church's role in the life and politics of the people. The ambiguity and indirection invoked by the image are what make it so intriguing. The apparent significance of the message in the photograph differs from its real significance, to recall Claudia Mitchell-Kernan; the image thus constitutes a visual pun. Beuford Smith's photographs from the Hip-Hop Poster series embody another feature of signifying: repetition and reversal. Most commonly seen are poster pictures of young Blacks as dissipated hoodlums and addicts. But the baseball-capped young man, with a thick iron chain across his face and enclosed by a setting that reeks of squalor, presents a strong and determined look (p. 200). The contrast between the young man's direct and composed expression and the peeling, squalid walls in this photograph, or between the sensuous and unembittered gaze of the young woman in *Kelly-P* and the photograph's effect of being torn and damaged (p. 201), adds to the emotionally charged significations. In both photographs the viewer is transfixed by a single exposed eye in a direct and unflinching stare that seems to question and needle the audience. Smith's nuanced imagery offers a radical re-presentation that challenges the viewer and affirms a positive African American image and spirit.

Among contemporary Black photographers, Shawn W. Walker has perhaps worked most poignantly with the ironies and ambiguities of Black life in America, on both political and philosophical levels. The two images in the show are from a series that Walker entitles Self-Portraits / Shadows and Reflections (pp. 214, 215). The series, as the artist has indicated to me, draws its immediate inspiration from Ralph Ellison's *Invisible Man.* Walker's imagery is complex and layered, and signification operates thematically as well as structurally. The tableau-like images feature shadows that are centrally located, tangible presences. The photographs, as Walker designates, are self-portraits, and the shadows contour him in a very visible and palpable way, although a shadow is soulless and intangible. The layering of irony and inversion unfolds and marks the deconstruction of the very assumptions of the invisibility and the soullessness of Blacks. Parodic suggestion and marking, as devices of Black discourse, accentuate the signification. Walker and other African Americans engaged in the photographic arts have made sophisticated use of light, not only to confirm their reality, in Ellison's words, and to interpret the personal and collective experience and vision, but also to assert their distinctive aesthetic sensibility, approach, and iconography. In so doing, contemporary Black photographers have transformed and enriched American culture, history, and visual arts.

NOTES

1. See bell hooks, "In Our Glory: Photography and Black Life," in *Picturing Us: African American Identity in Photography*, ed. Deborah Willis (New York: The New Press, 1994), pp. 43–53. Antique photographs were made to be celebrated, shared, and bequeathed to future generations. As bell hooks pointedly remarks, they function as documentation of resistance and redemptive memory and enjoyed a very special place in the homes and lives of Black Americans.

2. A. D. Coleman, *Light Readings* (New York: Oxford University Press, 1979), p. 21.

3. Ralph Ellison, *Shadow and Act* (New York: Vintage, 1964), pp. 78–79.

4. James Baldwin, *Just above My Head* (New York: Dial Press, 1979), p. 428.

5. Henry Louis Gates, Jr. (ed.), *Black Literature and Literary Theory* (New York: Routledge, 1990), p. xxiii.

6. W. E. B. Du Bois, *The Souls of Black Folk* (New York: Library of America, 1986), p. 38.

7. Henry Louis Gates, Jr., *Figures in Black: Words, Signs, and the "Racial" Self* (New York: Oxford University Press, 1987), p. 236.

8. Roger D. Abrahams, *Deep Down in the Jungle: Negro Narrative Folklore from the Streets of Philadelphia* (Chicago: Aldine, 1970), pp. 51–53. Abrahams's book is an authoritative study of the Signifying Monkey. See also his *Talking Black* (Rowley, Mass.: Newbury House, 1976).

9. Claudia Mitchell-Kernan, "Signifying," in *Mother Wit from the Laughing Barrel*, ed. Alan Dundes (Englewood Cliffs, N.J.: Prentice-Hall, 1973), pp. 313, 325.

(overleaf) Mel Wright, *Boy on Beach with Mask*, 1985 (detail; see p. 228)

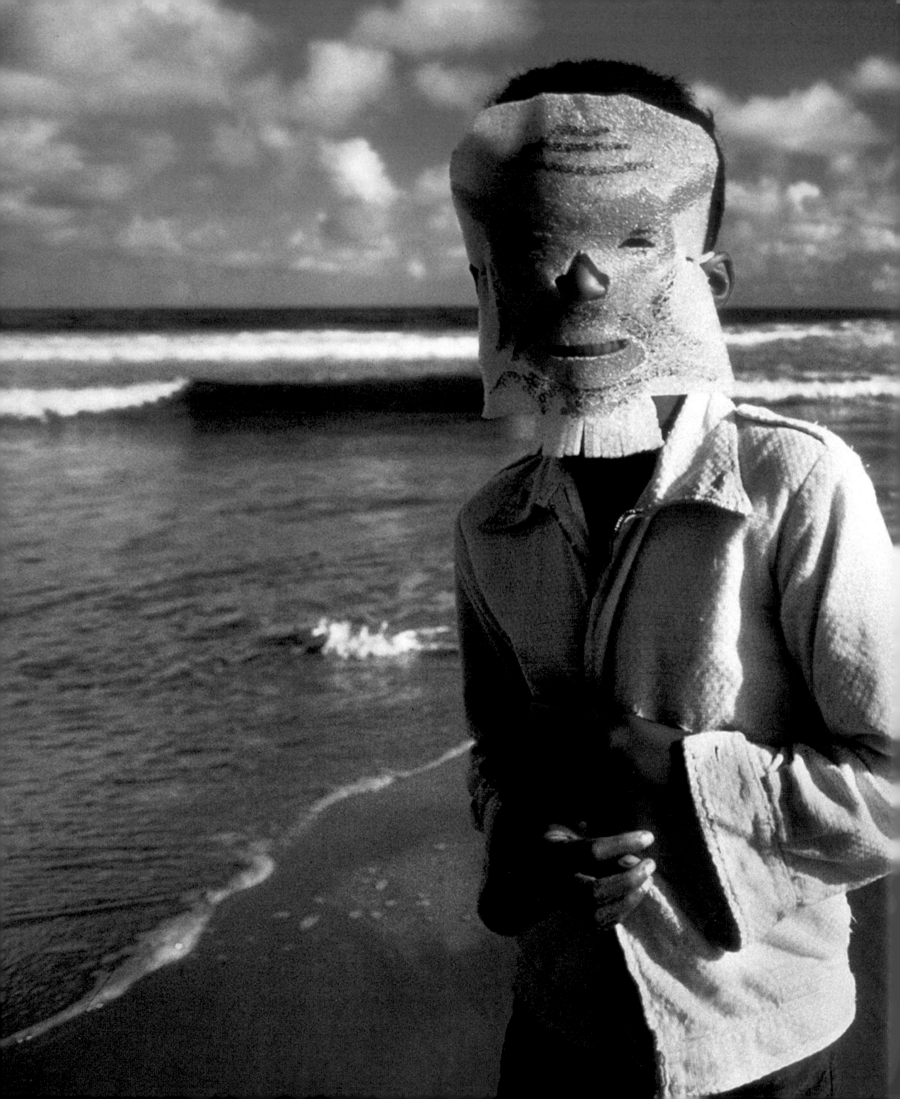

The Photographers

In the captions, the dimensions of the exhibition prints are given height before width and reflect the measurements of the entire sheet. In the dates of certain works, a slash divides the year the photograph was taken from the year of the print.

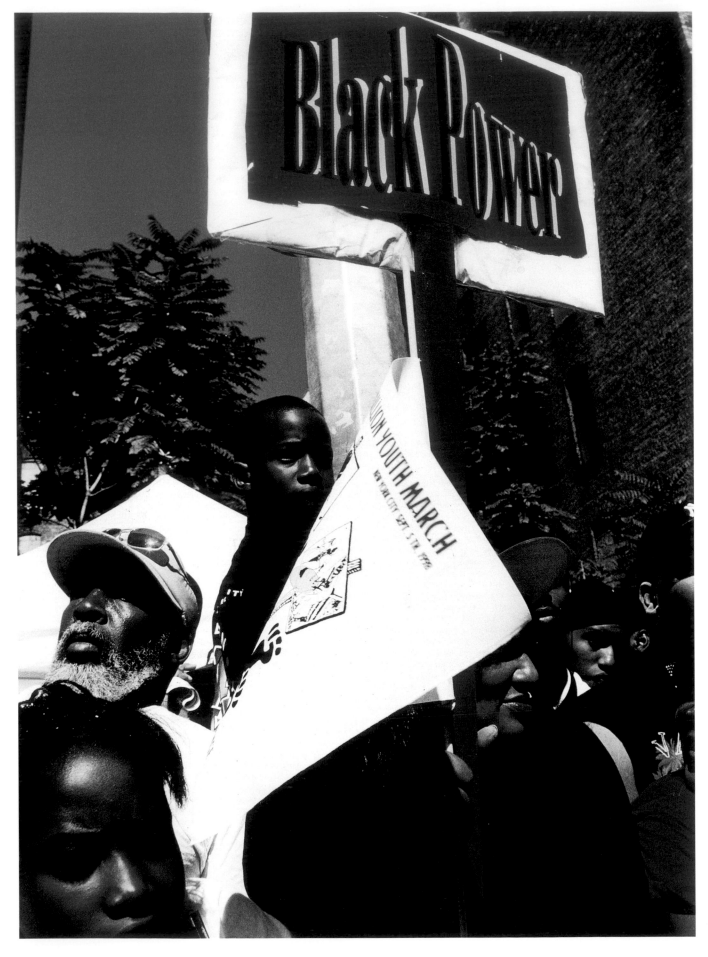

Salimah Ali (b. 1954). *Million Youth March: Power*, 1998. C-print, 20 x 16 in. (50.8 x 40.6 cm). Lent by the artist.

It takes a number of
important steps in one's life
to bring together a career
in photography. For me,
capturing the essence of
my subject is the ultimate
challenge and triumph.—S.A.

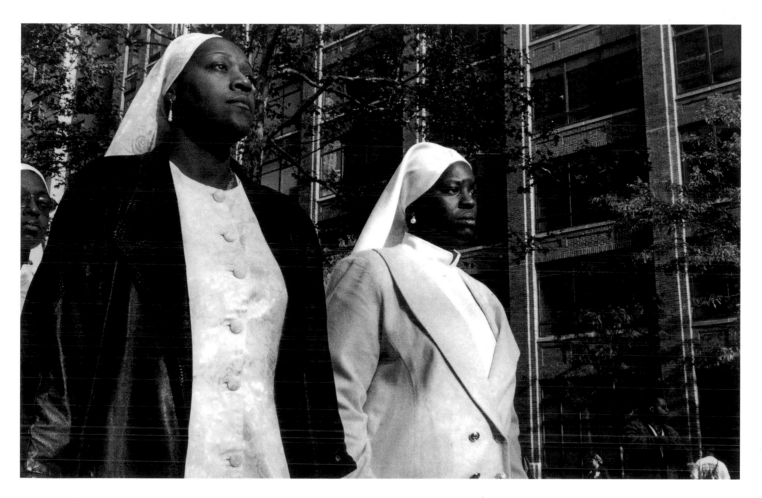

Salimah Ali (b. 1954). *Day of Atonement at the UN Plaza, Muslim Women*, 1996. Gelatin silver print, 16 x 20 in. (40.6 x 50.8 cm). Lent by the artist.

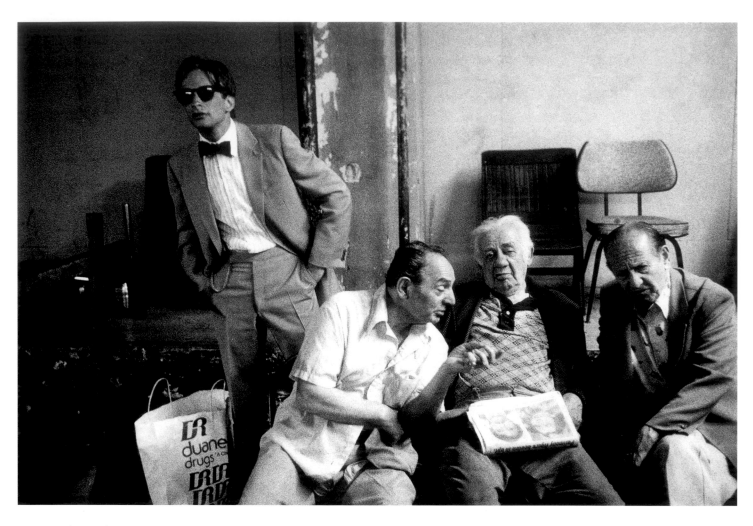

Jules Allen (b. 1947). *Gleason's Gym,* 1983, from the Trainers and Boxers series. Gelatin silver print, 16 x 19³/₄ in. (40.6 x 50.2 cm). Brooklyn Museum of Art, Gift of the artist, 1995.77.

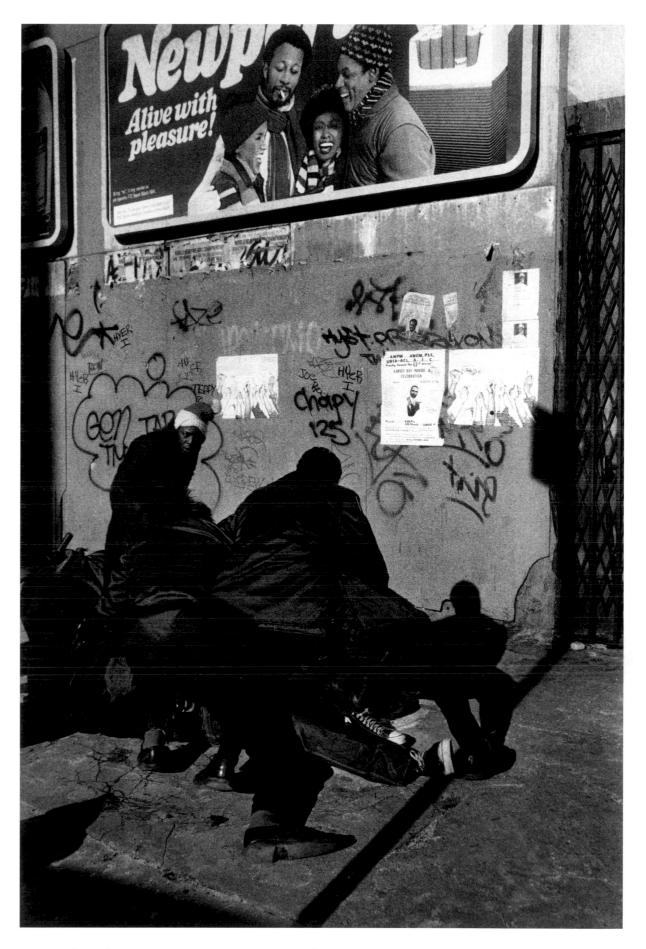

Jules Allen (b. 1947). *Untitled*, 1987. Gelatin silver print, 20 x 16 7/8 in. (50.8 x 42.9 cm). Brooklyn Museum of Art, Purchased with funds given by the Horace W. Goldsmith Foundation, Ardian Gill, the Coler Foundation, Harry Kahn, and Mrs. Carl L. Selden, 1995.73.

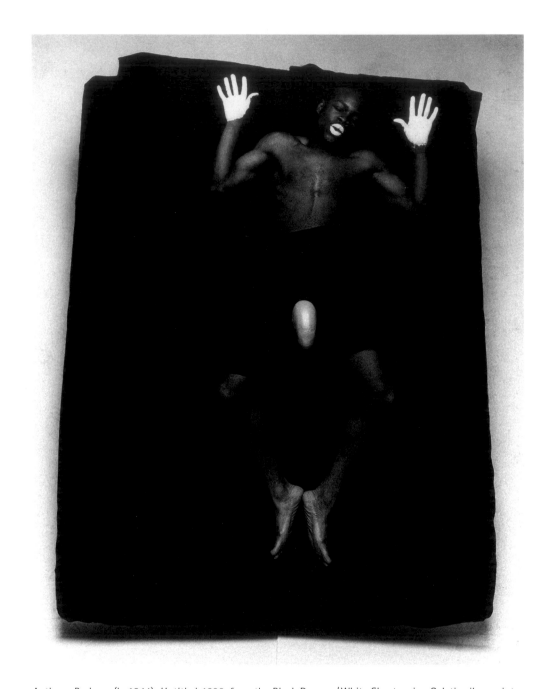

Anthony Barboza (b. 1944). *Untitled*, 1996, from the Black Dreams / White Sheet series. Gelatin silver print, 40 x 30 in. (101.6 x 76.2 cm). Lent by the artist.

My series Black Dreams / White Sheet portrays the essence of us as a people living in America. The photographs are political but also about our fantasies, fears, hopes, and dilemmas. They don't try to answer questions, but they do demand response. I don't believe in failure. That is only possible if I don't attempt to capture what I feel.—A.B.

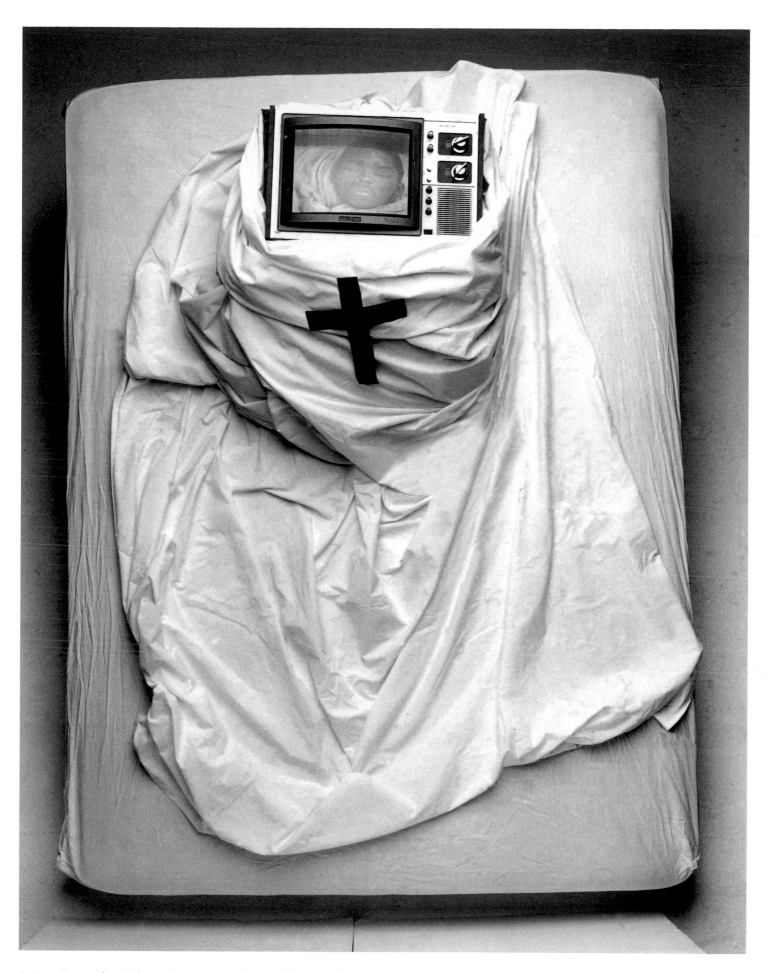

Anthony Barboza (b. 1944). *Untitled*, 1996, from the Black Dreams / White Sheet series. Gelatin silver print, 40 x 30 in. (101.6 x 76.2 cm). Lent by the artist.

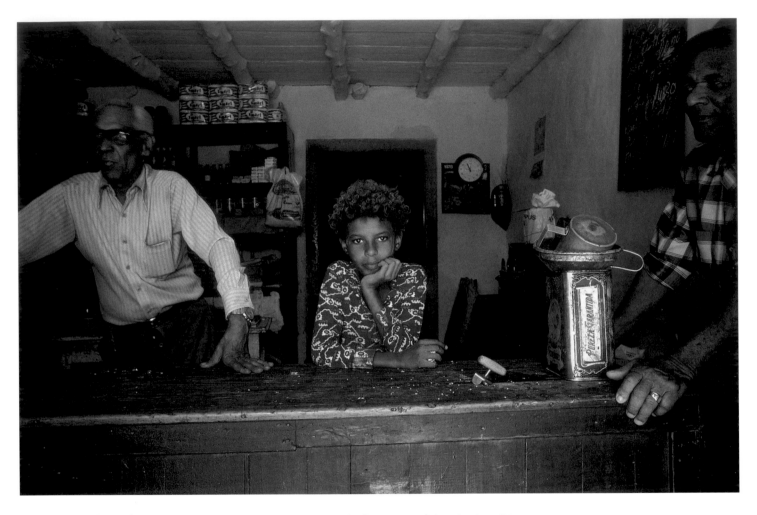

Ronald Barboza (b. 1946). *Framed for the Future*, 1979. C-print, 20 x 24 in. (50.8 x 61 cm). Lent by the artist.

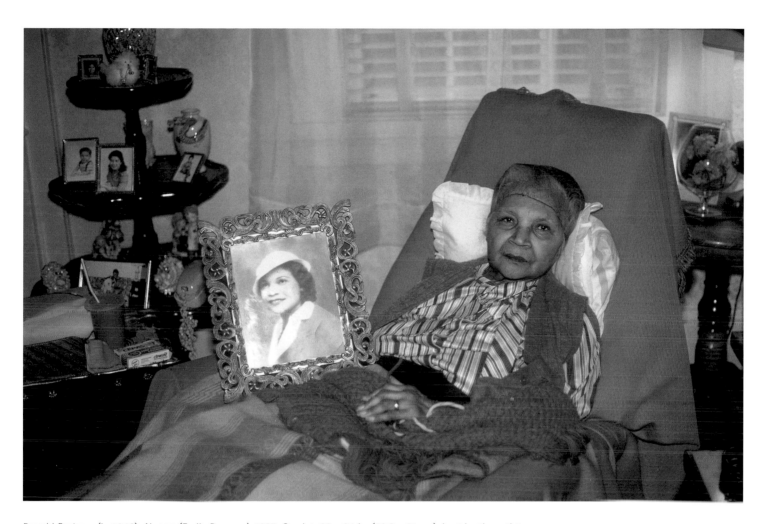

Ronald Barboza (b. 1946). *Nanna (Emily Barrows)*, 1987. C-print, 20 × 24 in. (50.8 × 61 cm). Lent by the artist.

Photography has offered me an opportunity to document my cultural heritage, which has enabled me to examine my own essence. The creative expressions of music, dance, and painting have always inspired me to understand the elements of poetry and rhythm that are woven into great photographs.—R.B.

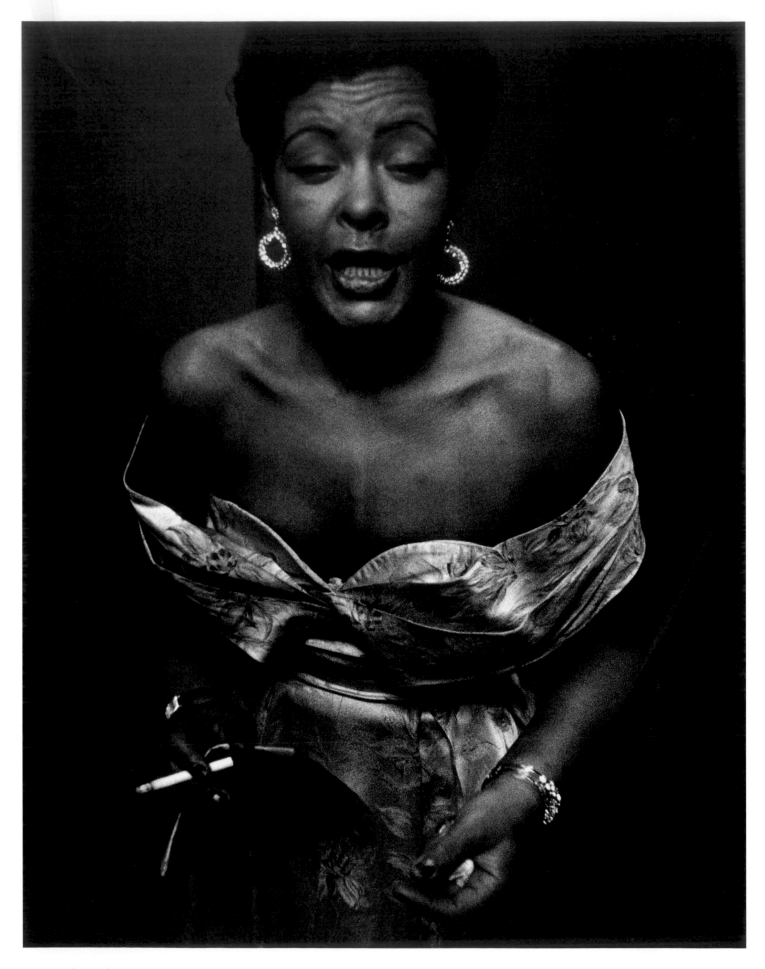

Hugh Bell (b. 1927). *Billie Holiday, Carnegie Hall Dressing Room*, 1956. Gelatin silver print, 20 x 16 in. (50.8 x 40.6 cm). Lent by the artist.

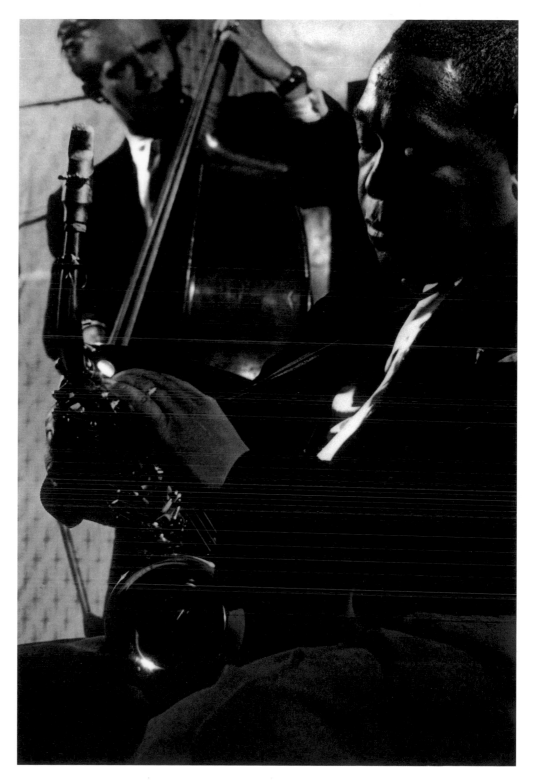

In my photography,
I try to depict emotional
states. The picture of
Billie Holiday shows her
distracted and addicted.
Charlie Parker's eyes are
closed because he has
fainted.—H.B.

Hugh Bell (b. 1927). *Charles Parker at Open Door Café*, 1953. Gelatin silver print, 20 x 16 in. (50.8 x 40.6 cm).
Lent by the artist.

The Million Man March provoked me into reexamining the
social and cultural standards of America. The related photography
project is a celebration of Black men's success, responsibility,
and coming together in peace. I hope that my work speaks to
its audience of change, commitment, and self-reliance.—D.L.B.

Donald L. Bernard (b. 1942). *Million Man March: Blurrrrred Vision*, 1996/1997. Polaroid image transfer, 35 mm transparency, watercolor, 9³/₄ x 11⁵/₈ in.
(24.8 x 29.5 cm). Lent by the artist.

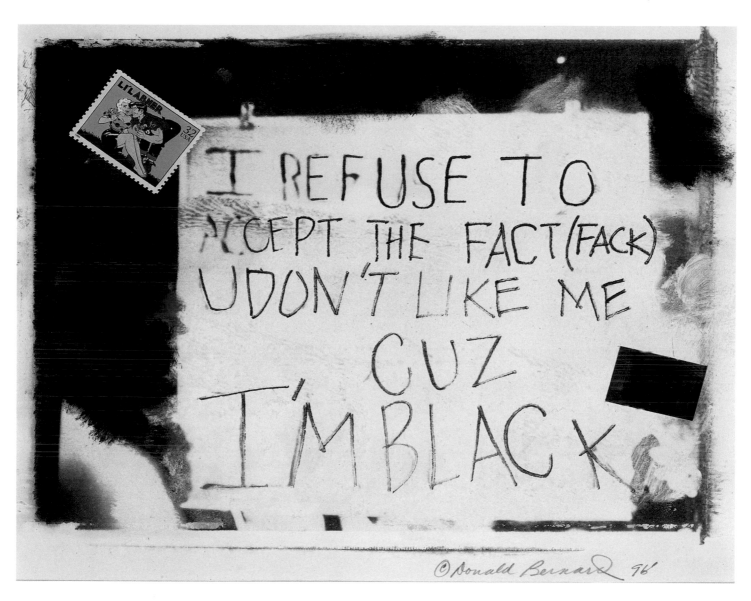

Donald L. Bernard (b. 1942). *Million Man March: "Cuz I'm Black,"* 1996/1997. Polaroid image transfer, 35 mm transparency, watercolor, oil, color pencil, Sharpie, postage stamp, 10¹/₂ x 13 in. (26.7 x 33 cm). Lent by the artist.

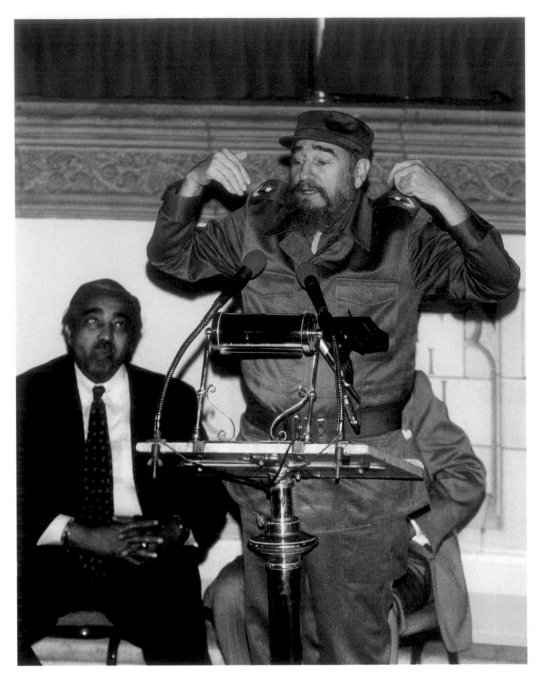

Kwame Brathwaite (b. 1938). *Fidel Castro Returns to Harlem*, 1995. C-print, 20 x 16 in. (50.8 x 40.6 cm).
Lent by the artist.

While earning a living as a fashion and entertainment photographer, my primary interest has been recording the history of the African and African American struggles for liberation and equality. My photos have been used to spread the "Black Is Beautiful" theme throughout the U.S. and the world.—K.B.

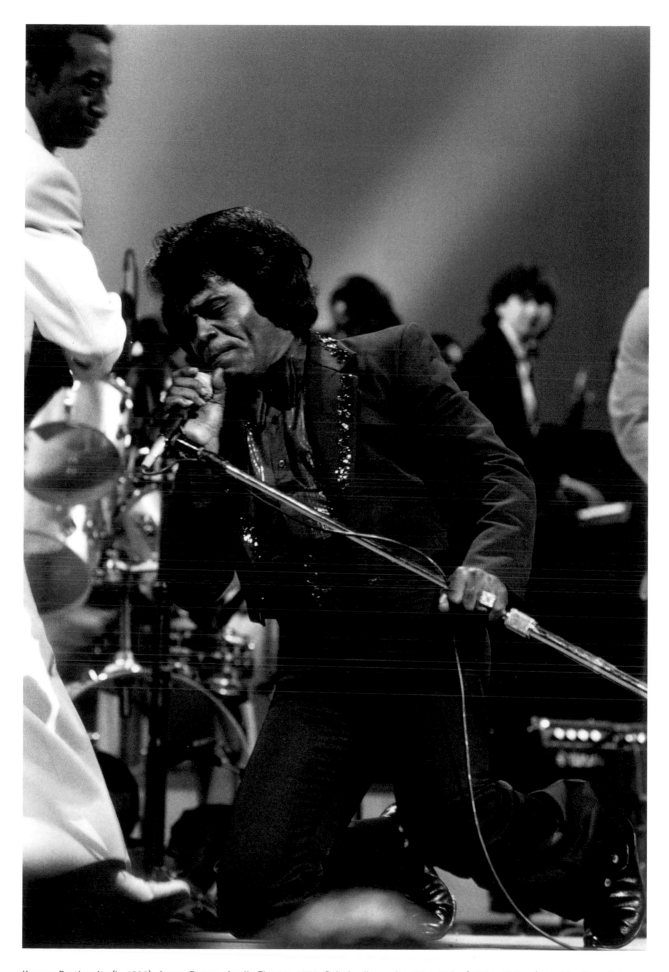

Kwame Brathwaite (b. 1938). *James Brown—Apollo Theatre*, 1988. Gelatin silver print, 20 x 16 in. (50.8 x 40.6 cm). Lent by the artist.

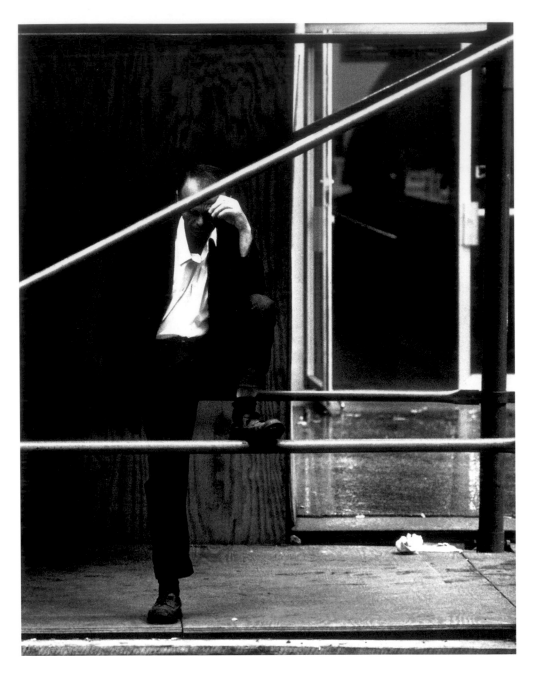

Nathaniel Burkins (b. 1953). *Monroe Street, Chicago*, 1977. Gelatin silver print, 14 x 11 in. (35.6 x 27.9 cm). Lent by the artist.

I don't go out especially to take pictures, but I always bring my camera with me. I don't look for anything in particular; I just react to what I feel is visually significant. The rest is composition, timing, and familiarity with the photographic tools and materials.—N.B.

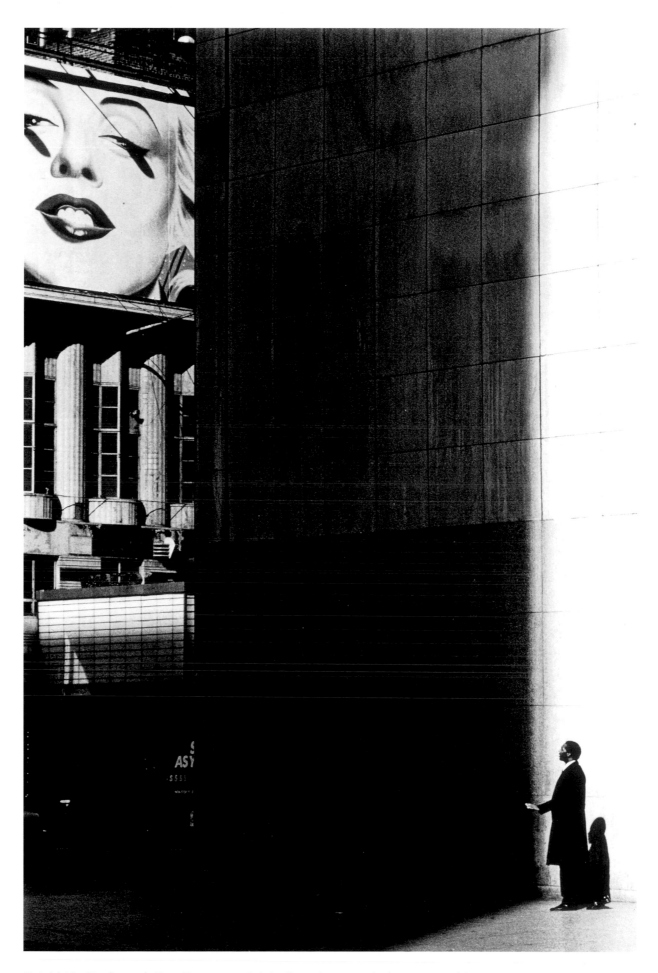

Nathaniel Burkins (b. 1953). *Times Square*, 1987. Gelatin silver print, 14 x 11 in. (35.6 x 27.9 cm). Lent by the artist.

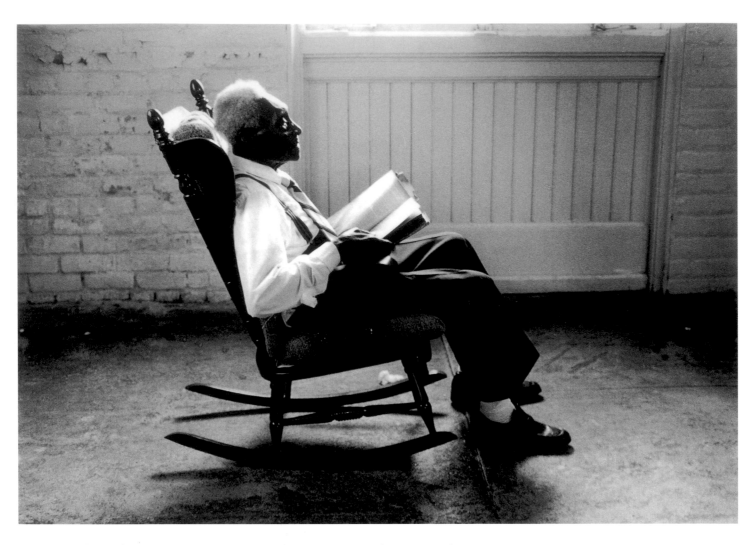

Keith Calhoun (b. 1955). *Reverend Brown*, 1980. Gelatin silver print, 16 x 20 in. (40.6 x 50.8 cm). Lent by the artist.

I have developed an eye, a point of view, and my work is a story. In these images, I want to document the world of the Black working class in Louisiana—the dying traditions and ceremonies that are being replaced by a commercial way of life.—K.C.

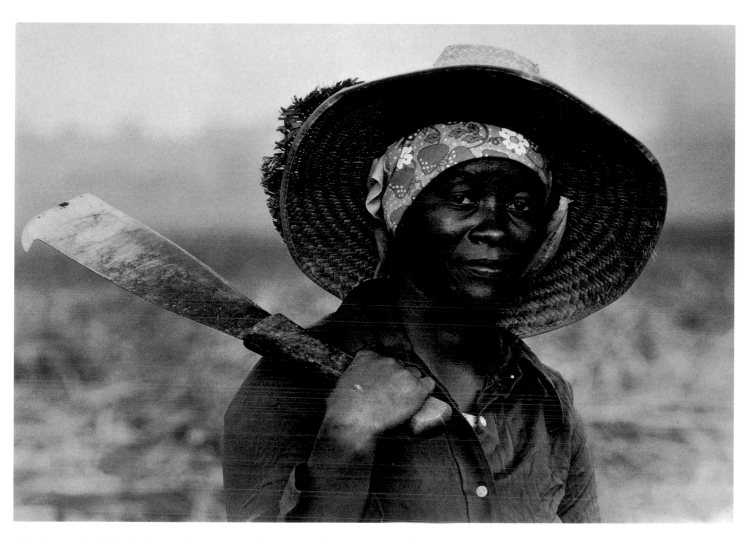

Keith Calhoun (b. 1955). *Gail Dorsey, Cane Scrapper*, 1986. Gelatin silver print, 16 x 20 in. (40.6 x 50.8 cm). Lent by the artist.

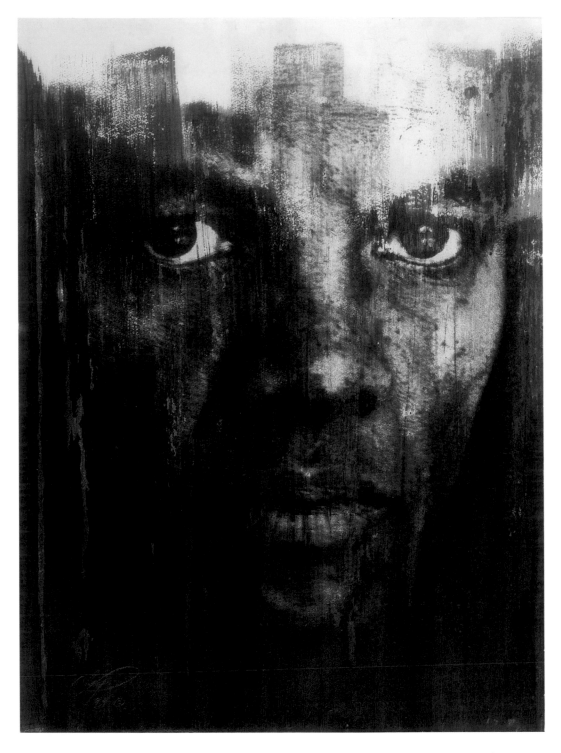

Don Camp (b. 1940). *Man Who Writes, John Edgar Wideman*, n.d. Earth pigment, casein monoprint, 29$^1/_2$ x 21 in. (74.9 x 53.3 cm). Lent by Dr. Roy N. Gay.

The absolute acceptance
of the content of
photographic images as
fact can determine what
we believe about others
and often what we believe
about ourselves. Yet such
images simply reflect the
interaction of dark and
light. It is this relationship
that I use to explore
themes of spiritual voids
and barriers.—D.C.

Don Camp (b. 1940). *Man Who Hears Music, Andre Raphel Smith*, n.d. Earth pigment, casein monoprint, 29³/₄ x 21⁵/₈ in. (75.6 x 54.9 cm). Lent by the Pennsylvania Convention Center Authority.

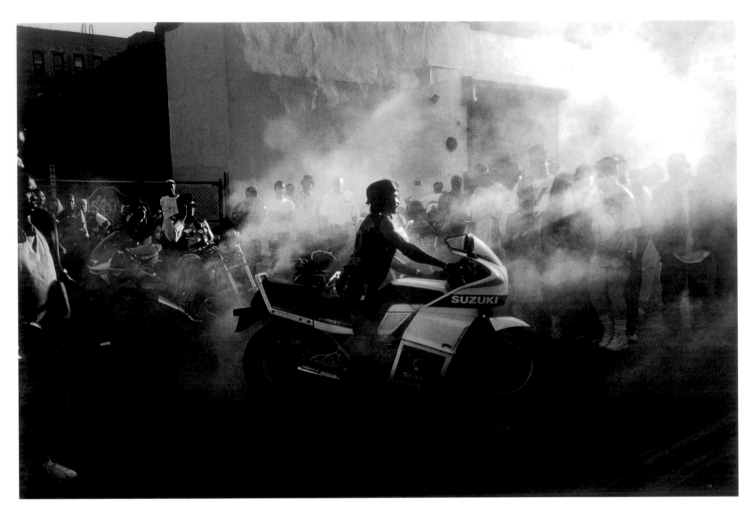

Ron Campbell (b. 1955). *Smokin'*, 1997. Gelatin silver print, 16 x 20 in. (40.6 x 50.8 cm). Lent by the artist.

Taking a picture is more than just capturing an image. This action can record a moment in time, document history, and distill the essence of human emotion and movement. This potential remains the motivating force pushing me to that next level of creative vision.—R.C.

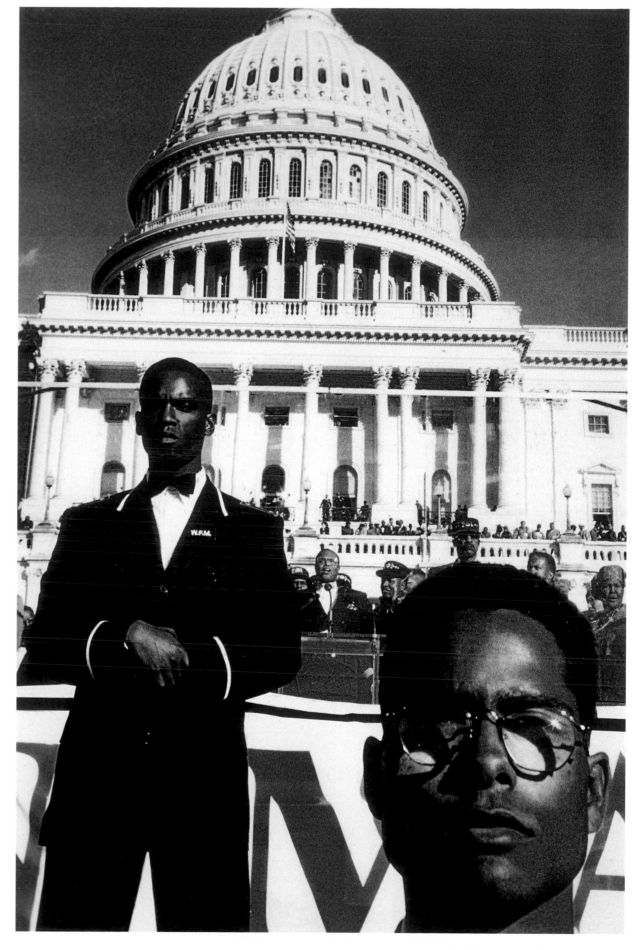

Ron Campbell (b. 1955). *A Day of Atonement*, 1985. Gelatin silver print, 20 x 16 in. (50.8 x 40.6 cm). Lent by the artist.

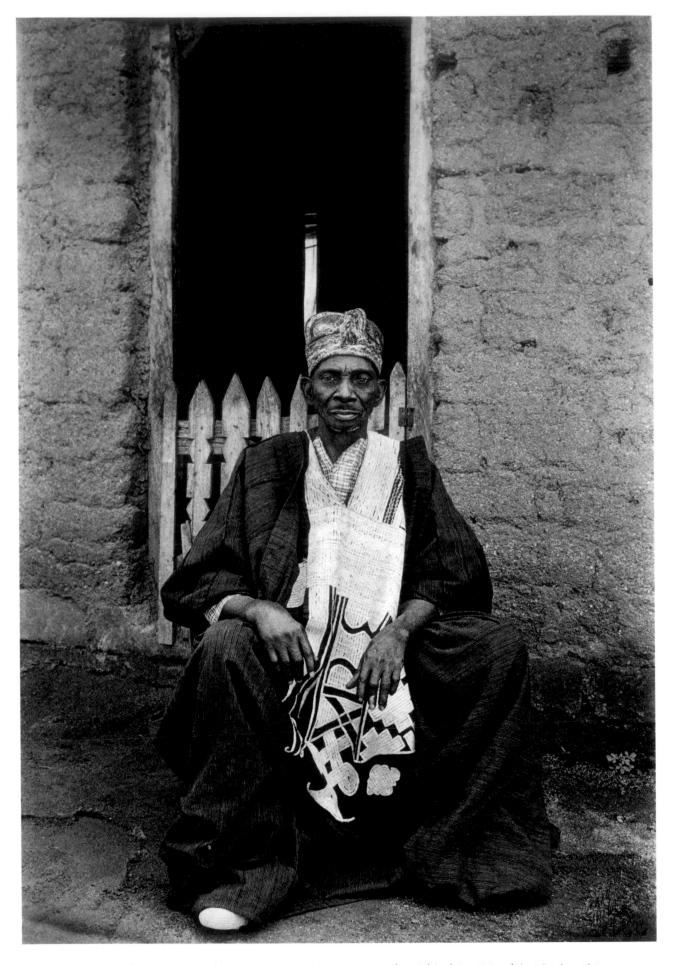

Howard T. Cash (b. 1953). *Abiodun, King of Hunters*, 1984. Gelatin silver print, 18 1/2 x 12 1/2 in. (47 x 31.8 cm). Lent by the artist.

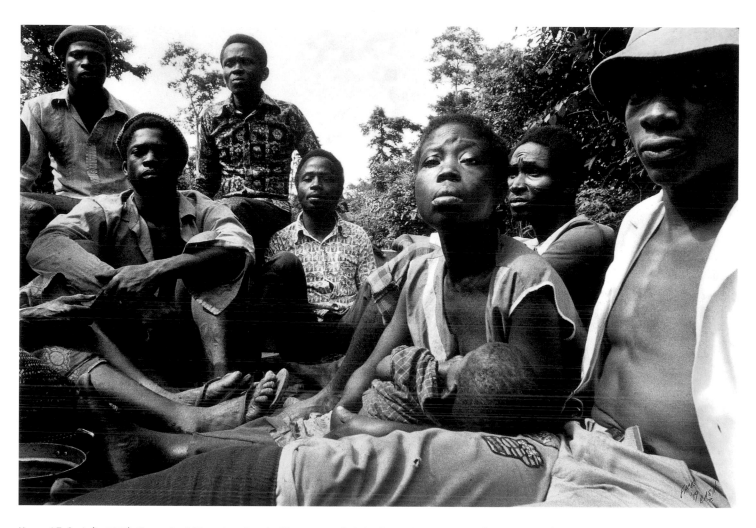

Howard T. Cash (b. 1953). *Faces: An African American in Ghana*, 1978. Gelatin silver print, 16 x 20 in. (40.6 x 50.8 cm). Lent by the artist.

My work is a reflection of the relationships people have with themselves and with one another. I try to blend in, drawing little attention to myself, as I photograph people engaged in activities that are important to them.—H.T.C.

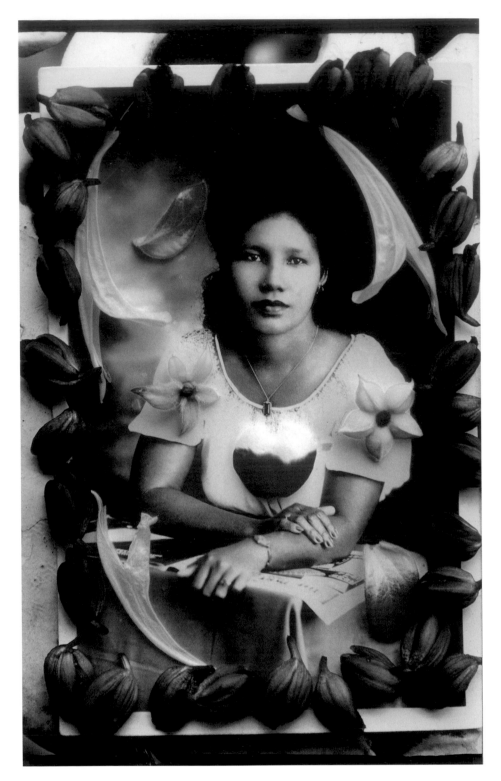

Albert Chong (b. 1958). *Aunt Winnie*, 1995. C-print, 65¼ x 40 in. (165.7 x 101.6 cm). Lent by the artist.

My art is about curiosity, an interest in the forms of the world—the structure and design of things man-made and organic, particularly organic. I am totally consumed by the activity of art making. It provides me with excitement. It is its own evolving story and runs a parallel course with my life. My life informs my art and my art informs my life.—A.C.

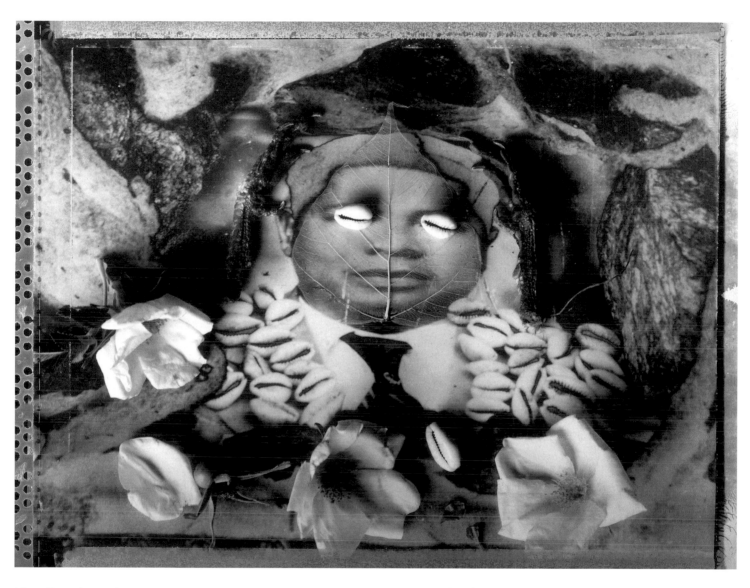

Albert Chong (b. 1958). *Justice Variant with Eyes of Cowrie*, 1998. Gelatin silver print, 45 x 62 ¹/₂ in. (114.3 x 158.8 cm). Lent by the artist.

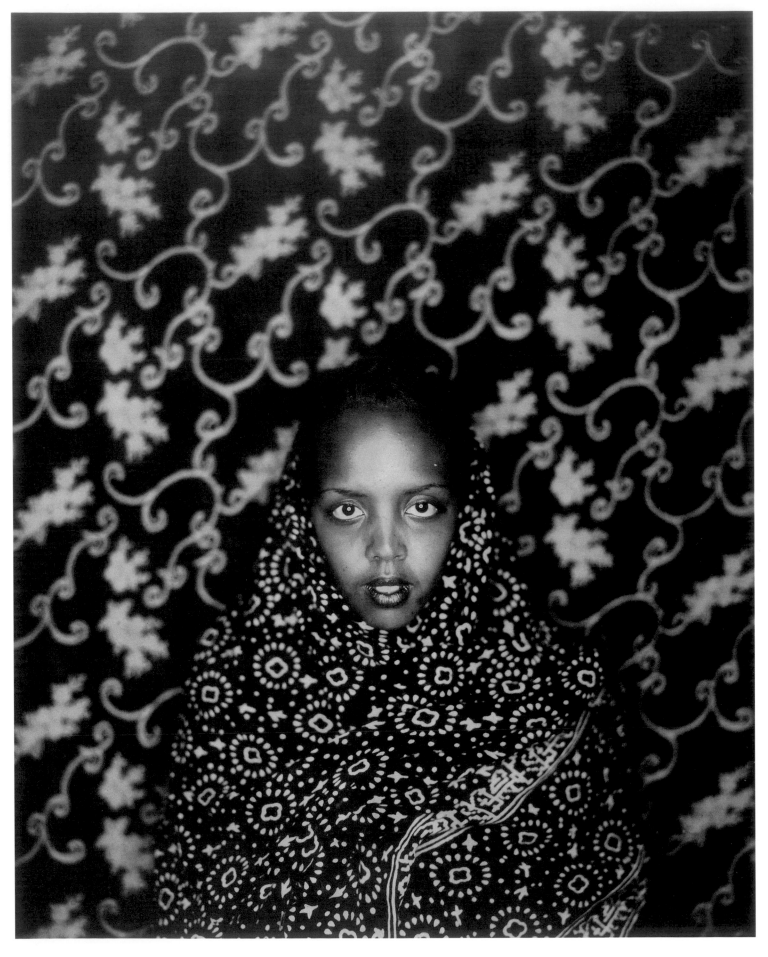

Barron Claiborne (B. C. Africanus; b. 1967). *The Ethiopian: Timaj,* 1999. C-print, 39 ¹/₈ x 35 ⁷/₈ in. (99.4 x 91.1 cm). Lent by the artist.

I cover many photographic
disciplines: portraits, nudes,
and landscapes. I strive to
capture the legendary, the
symbolic, and the religious,
and, in so doing, to give
my photographs a timeless
quality and a historic
relevance. *The Ethiopian:
Timaj* and *Orleans* illustrate
this powerful combination
of history and the future,
of myth and reality.—B.C.

Barron Claiborne (B. C. Africanus; b. 1967). *Orleans*, 1999. C-print, 39 1/8 x 35 7/8 in. (99.4 x 91.1 cm).
Lent by the artist.

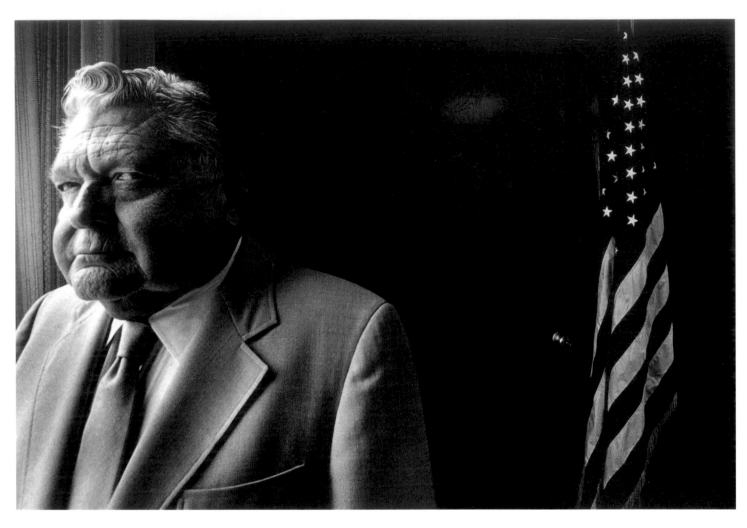

Carl Clark (b. 1933). *Government Official*, 1989. Gelatin silver print, 11 x 14 in. (27.9 x 35.6 cm). Lent by the artist.

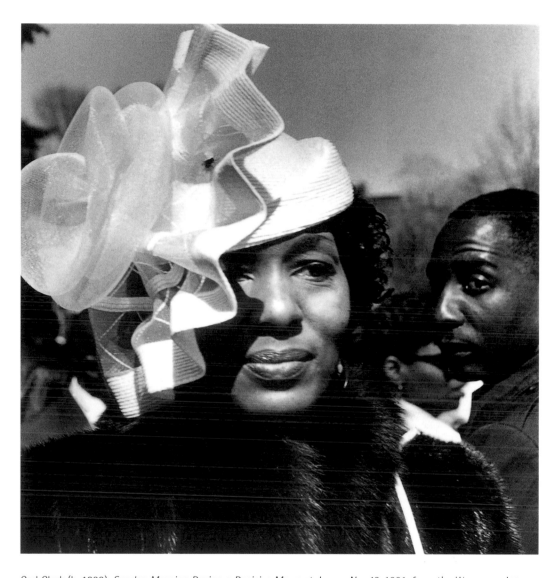

Carl Clark (b. 1933). *Sunday Morning During a Decisive Moment, Image No. 43*, 1991, from the Women series. Gelatin silver print, 11 x 14 in. (27.9 x 35.6 cm). Lent by the artist.

The passions that drove me to pursue college degrees also propel me toward social documentary. This genre, once the painter's domain, has been passed on to the photographer. I accept this responsibility with a reverence infused with spiritualism and vision born of my African American roots. I entice viewers with visual excitement and then confront them with content.—C.C.

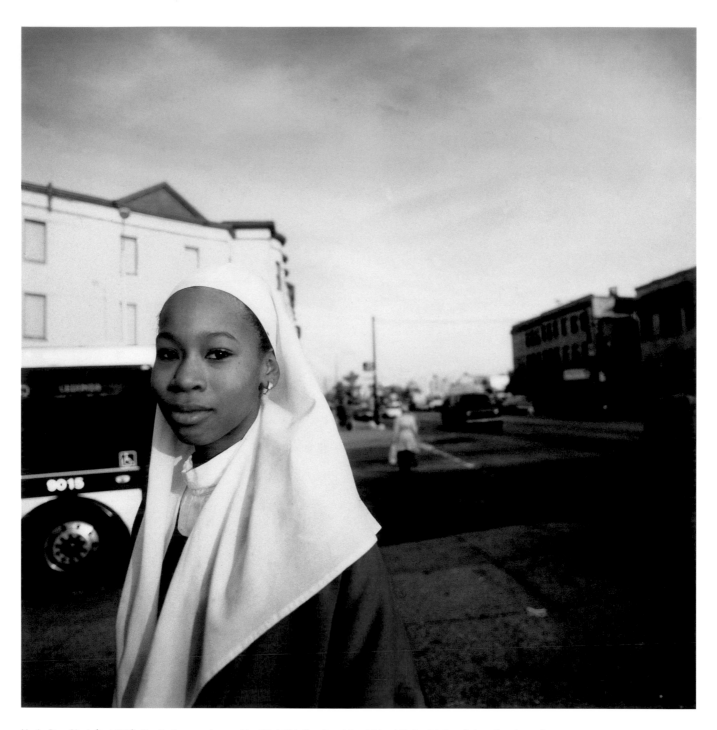

Linda Day Clark (b. 1963). *North Avenue, Image No. 85*, 1994. C-print, 16 x 20 in. (40.6 x 50.8 cm). Lent by the artist.

The uniqueness of ordinary people intrigues me. I use the camera to get closer, to talk to strangers, to sustain eye contact, to learn, to touch, and to inform. I create images that serve as witnesses to the connections made in these fleeting encounters. My portraits of the people of North Avenue, Baltimore, depict resilience, individuality, trust, dignity, and beauty.—L.D.C.

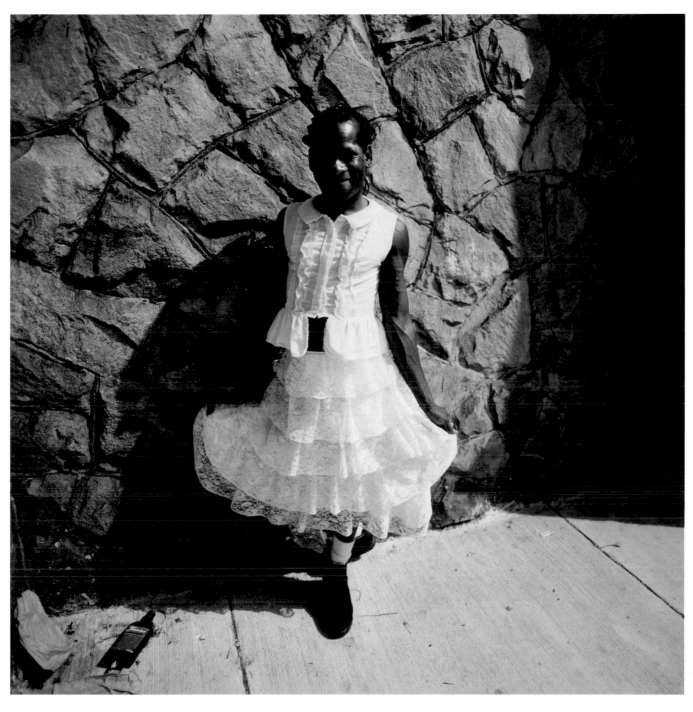

Linda Day Clark (b. 1963). *Junior, North Avenue*, 1994. C-print, 16 x 20 in. (40.6 x 50.8 cm). Lent by the artist.

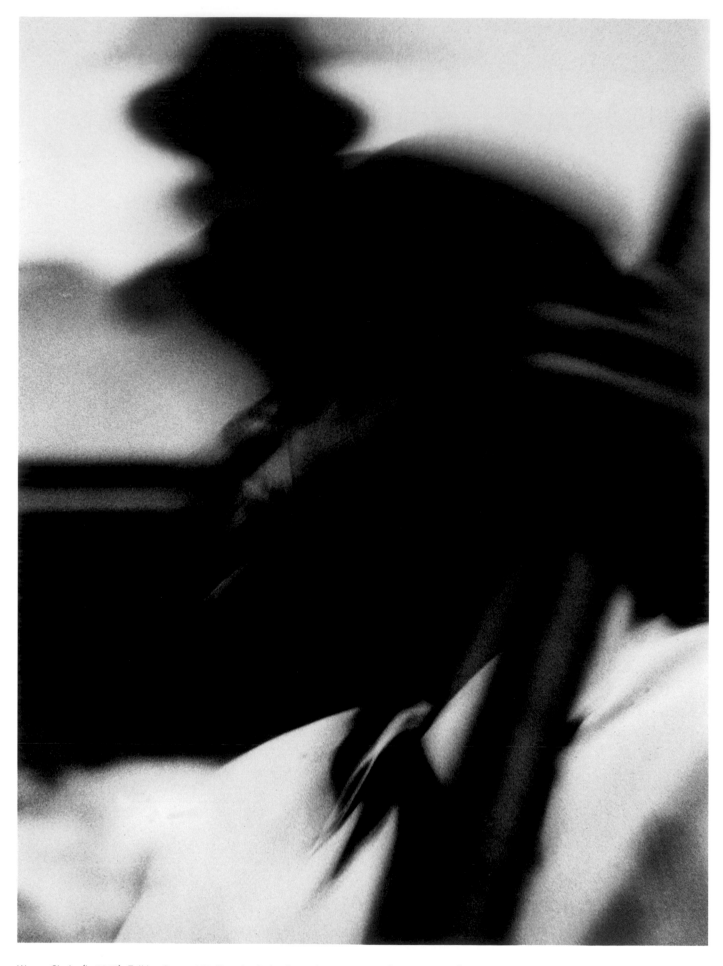

Wayne Clarke (b. 1945). *Talking Bass*, 1997. Toned gelatin silver print, 20 x 16 in. (50.8 x 40.6 cm). Lent by the artist.

I am fascinated by music and by people, artists and musicians in particular. Jazz, with its free forms of expression, inspires me to photograph my subjects the way I feel them.—W.C.

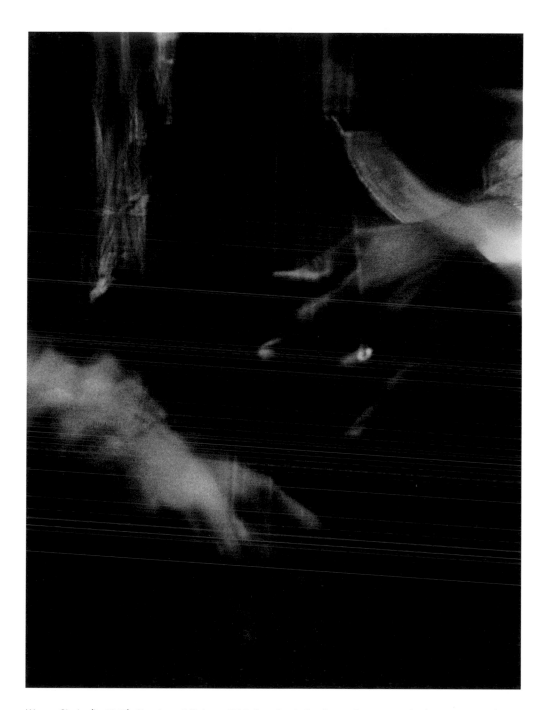

Wayne Clarke (b. 1945). *Hands and Strings*, 1995. Toned gelatin silver print, 20 x 16 in. (50.8 x 40.6 cm). Lent by the artist.

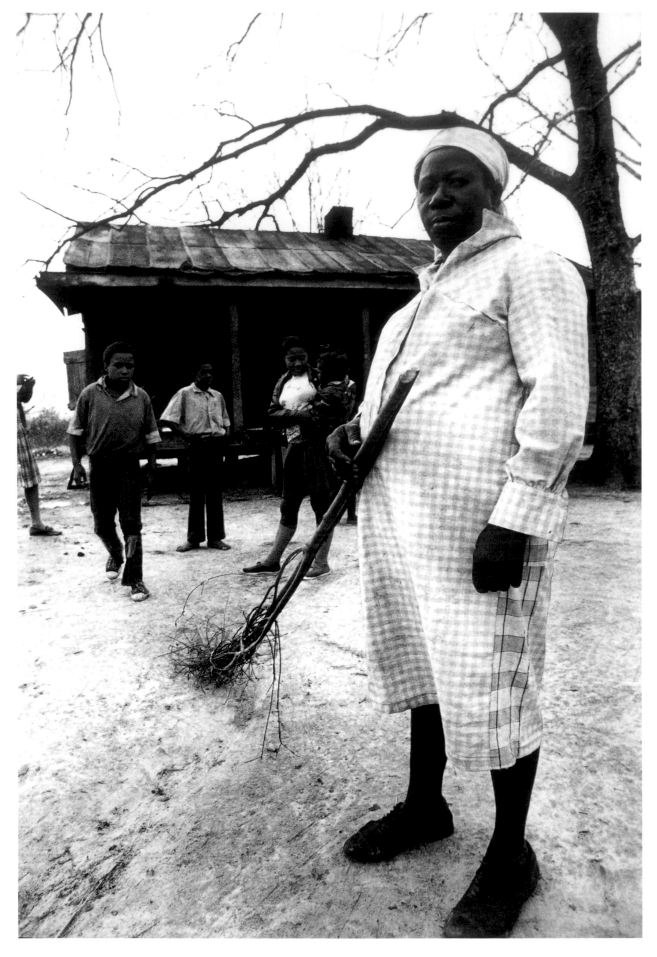

Jim Collier (b. 1942). *Mom Sweeps Yard—Southern U.S.A.*, 1971. Gelatin silver print, 20 x 16 in. (50.8 x 40.6 cm). Lent by the artist.

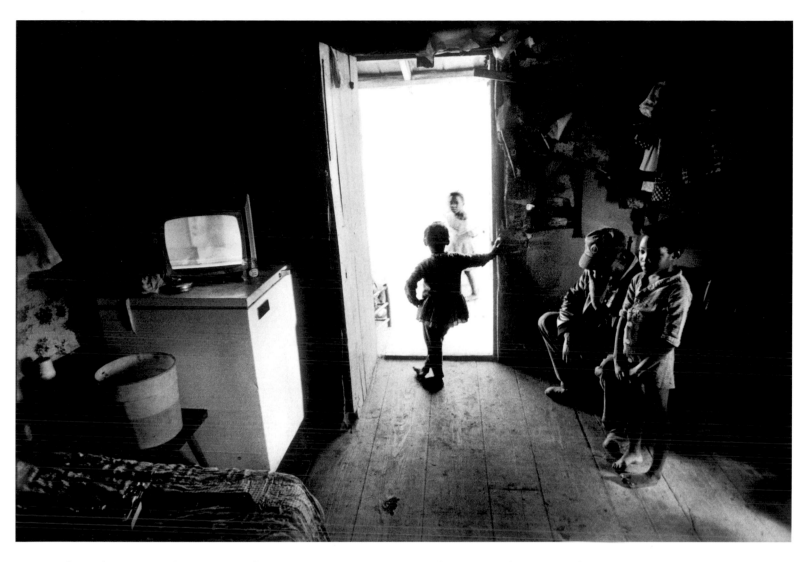

Jim Collier (b. 1942). *Living Room (One-Room Shack)—Southern U.S.A.*, 1971. Gelatin silver print, 16 x 20 in. (40.6 x 50.8 cm). Lent by the artist.

Heavily influenced by the Reverend Shelby Rooks and the church, my personal work continues to explore the changes, growth, and diversity of the family unit in the United States.—J.C.

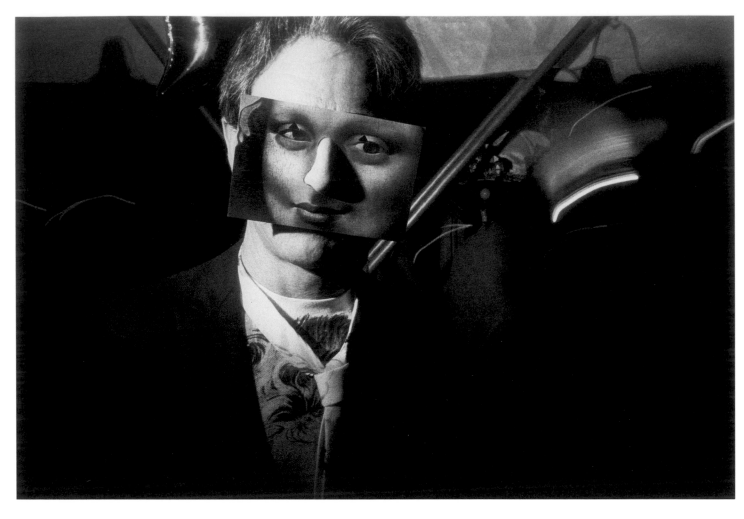

Kerry Stuart Coppin (b. 1953). *Penumbra*, 1985/98. Giclée print, 36¼ x 48 in. (92.1 x 121.9 cm). Lent by the artist.

My ambition is to produce photographic images that celebrate positive aspects of the contemporary Black experience, including the underrepresented rural Black community. I use my photographs as a tool to change the way we as Black people look at ourselves and the world.—K.S.C.

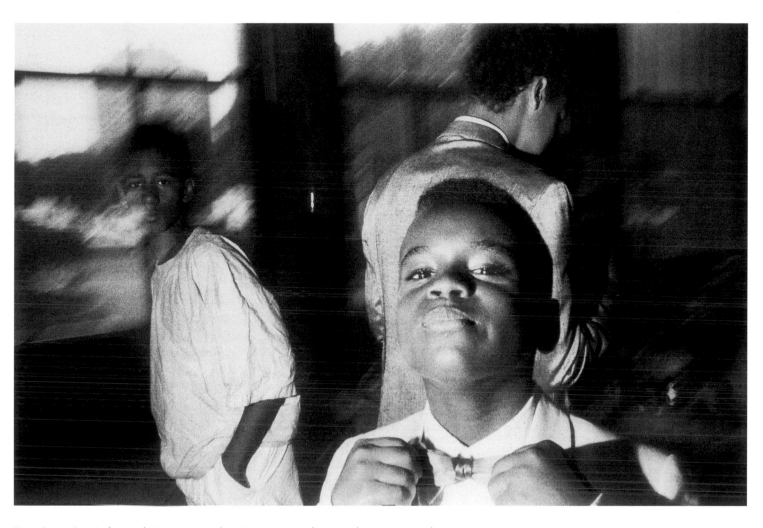

Kerry Stuart Coppin (b. 1953). *Untitled*, 1988/99. Giclée print, 36¹/₄ x 48 in. (92.1 x 121.9 cm). Lent by the artist.

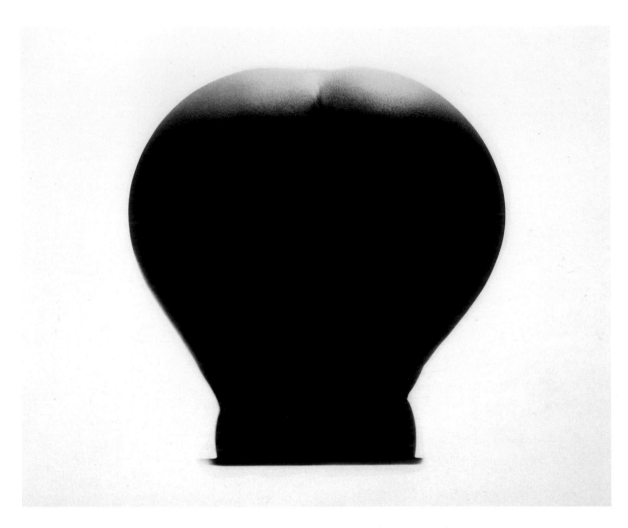

Adger W. Cowans (b. 1936). *P. B. (Nude)*, 1975. Gelatin silver print, 16 x 20 in. (40.6 x 50.8 cm). Lent by the artist.

My photography teachers emphasized the importance of having a personal point of view, stressing emotional content along with knowledge of the craft. All of my work is inspired by nature. My early influences were Edward Weston, Gene Smith, Roy DeCarava, and Gordon Parks.—A.W.C.

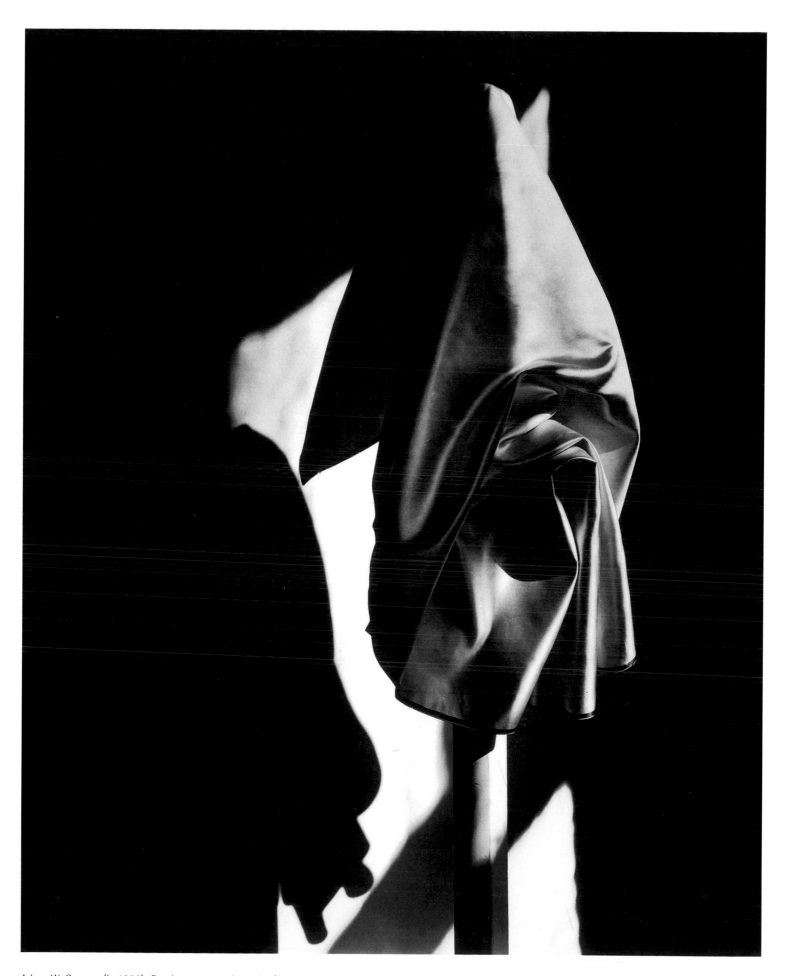

Adger W. Cowans (b. 1936). *Daydream*, 1980, from the Shadow Light series. Gelatin silver print, 20 x 16 in. (50.8 x 40.6 cm). Lent by the artist.

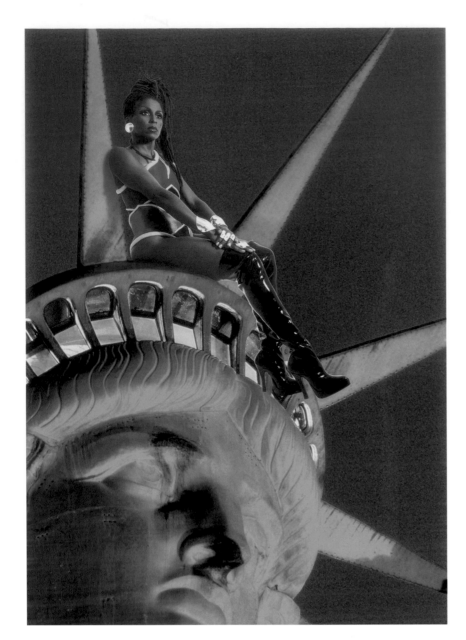

Renée Cox (b. 1960). *Chillin with Liberty*, 1998.
Ektachrome print, 60 x 48 in. (152.4 x 121.9 cm).
Lent by the artist.

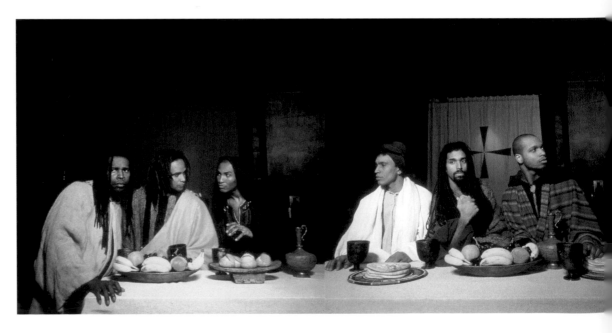

Renée Cox (b. 1960). *Yo Mama's Last Supper*, 1996. C-prints, five panels, each 31$\frac{1}{2}$ x 31$\frac{1}{2}$ in. (80 x 80 cm). Lent by the artist.

My work addresses issues of race and gender, and particularly of power and sublimation. Calling attention to the constraints of classification imposed by Western patriarchal constructs, my images demand enlightenment through an equitable realignment of our race and gender politics. Through my photography, I also strive to unleash the bisexual duality of the human psyche. –R.C.

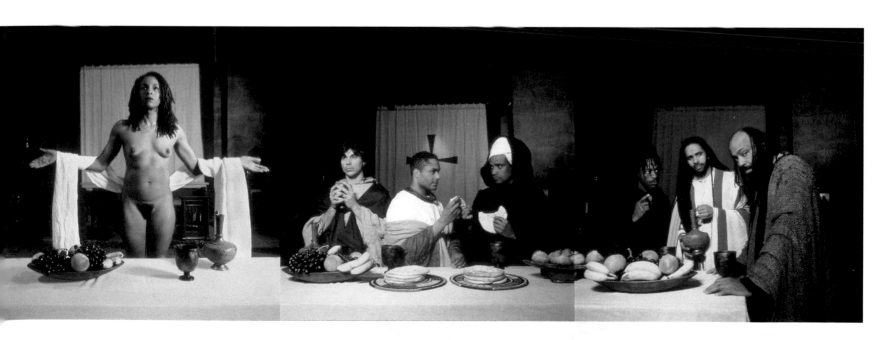

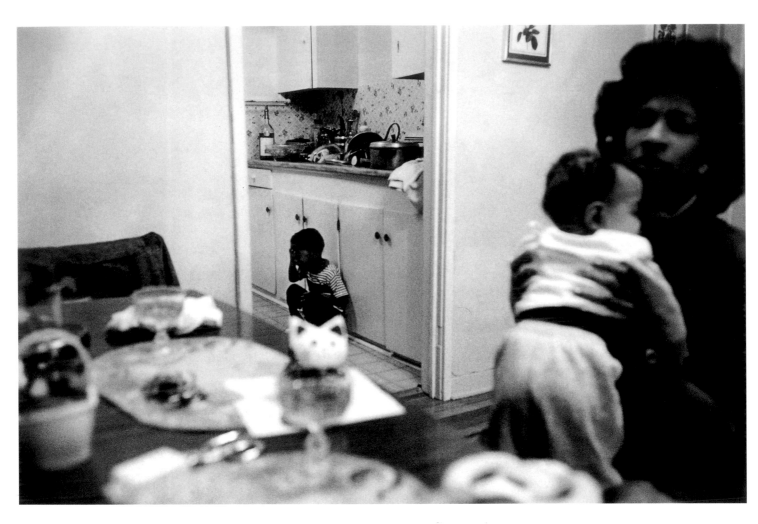

Gerald Cyrus (b. 1957). *Untitled (New Orleans)*, 1992, from the Kinship series. Gelatin silver print, 16 x 20 in. (40.6 x 50.8 cm). Lent by the artist.

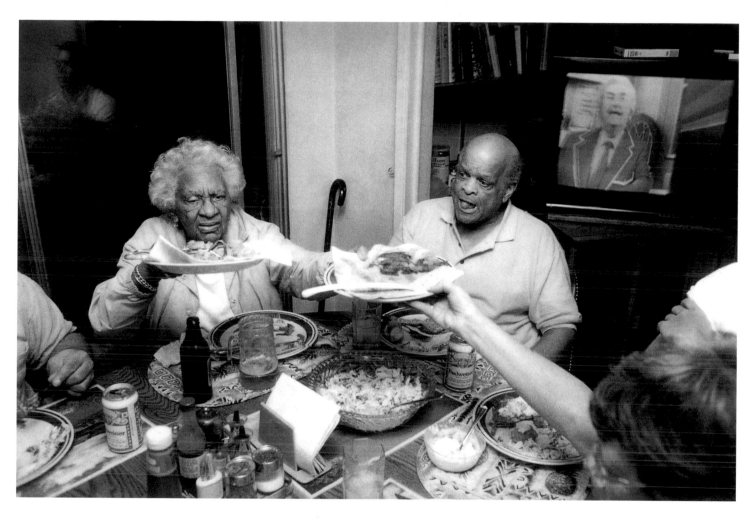

Gerald Cyrus (b. 1957). *Untitled (Los Angeles)*, 1992, from the Kinship series. Gelatin silver print, 16 x 20 in. (40.6 x 50.8 cm). Lent by the artist.

My work revolves primarily around the communities that I have been part of. The Kinship series depicts relatives and close friends. The impetus for this work has been the lack of documentary photography focusing on Black middle-class families. My goal has been to photograph these scenes with beauty, drama, and wry humor.—G.C.

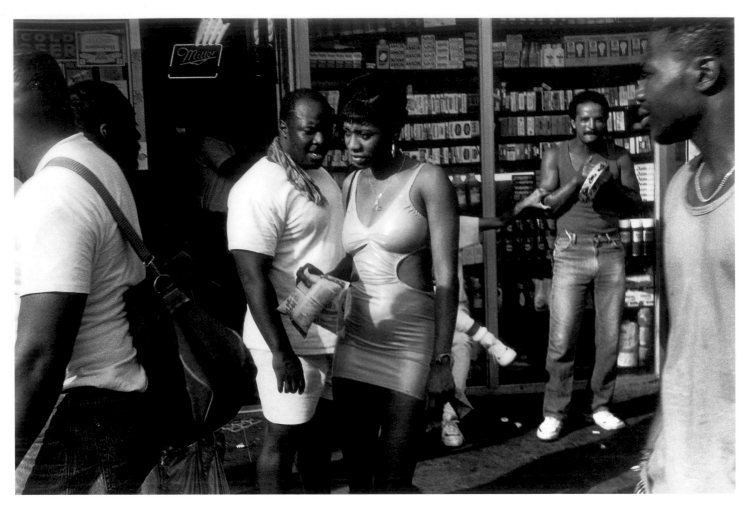

Martin Dixon (b. 1965). *Times Square Dance Queen*, 1991. Gelatin silver print, 16 x 20 in. (40.6 x 50.8 cm). Lent by the artist.

I began to move away from photojournalism in an attempt to create a body of work that more closely mirrored my personal philosophy of life and was less dependent on chance or good fortune. Staged photographs feel like film stills, with the same sense of drama and with similar lighting effects. I have started to ask, "What makes one person more American than another?" and to consider how White or Black we really are.—M.D.

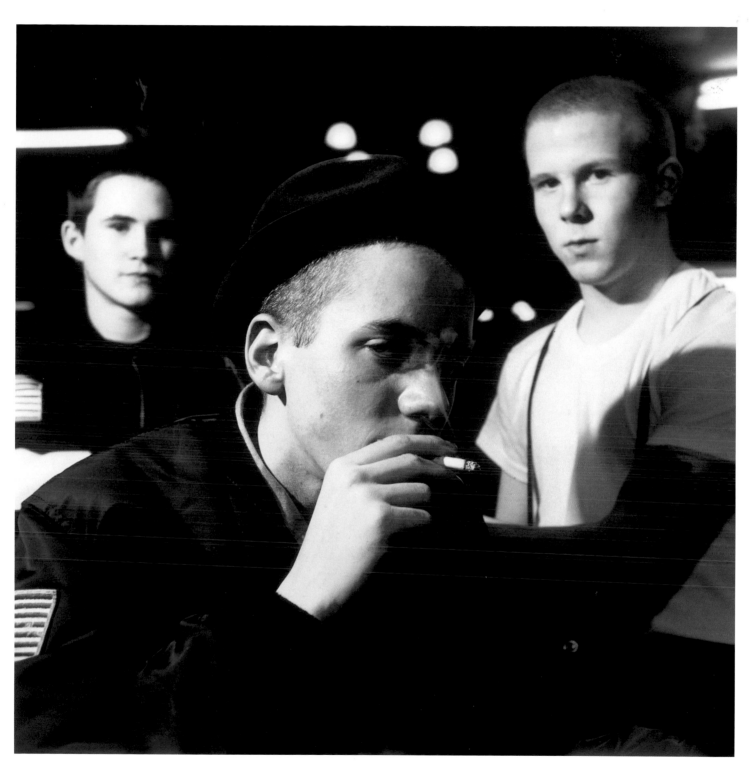

Martin Dixon (b. 1965). *Skin Deep, Ann Arbor, Michigan*, 1990, from the Nation State series. C-print, 20 x 24 in. (50.8 x 61 cm). Lent by the artist.

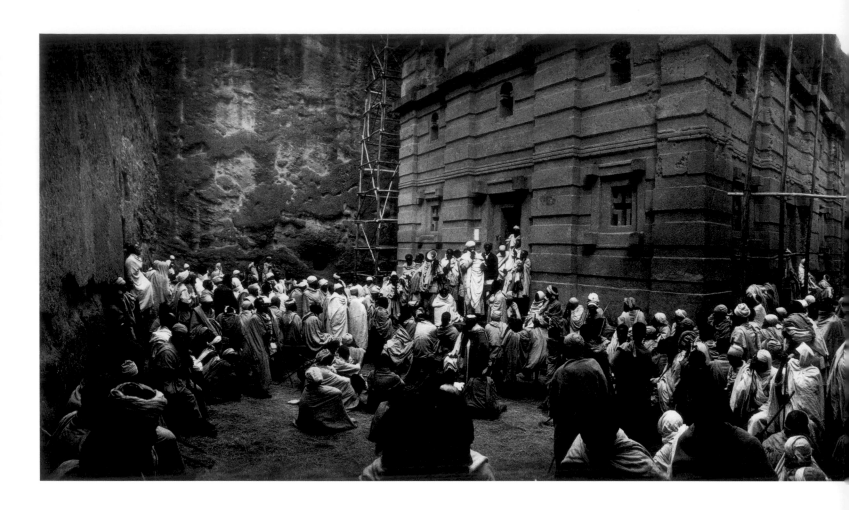

Sulaiman Ellison (b. 1951). *Ethiopian Landscape I*, 1982.
Gelatin silver print, 16 x 20 in. (40.6 x 50.8 cm). Lent by the artist.

Sulaiman Ellison (b. 1951). *Early Morning Mass at the Church of Saint Emanuel*, 1982. Gelatin silver print, 16 x 20 in. (40.6 x 50.8 cm). Lent by the artist.

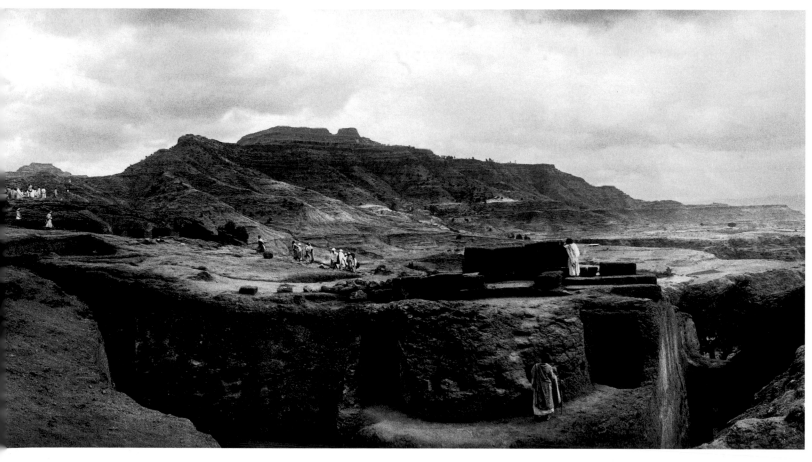

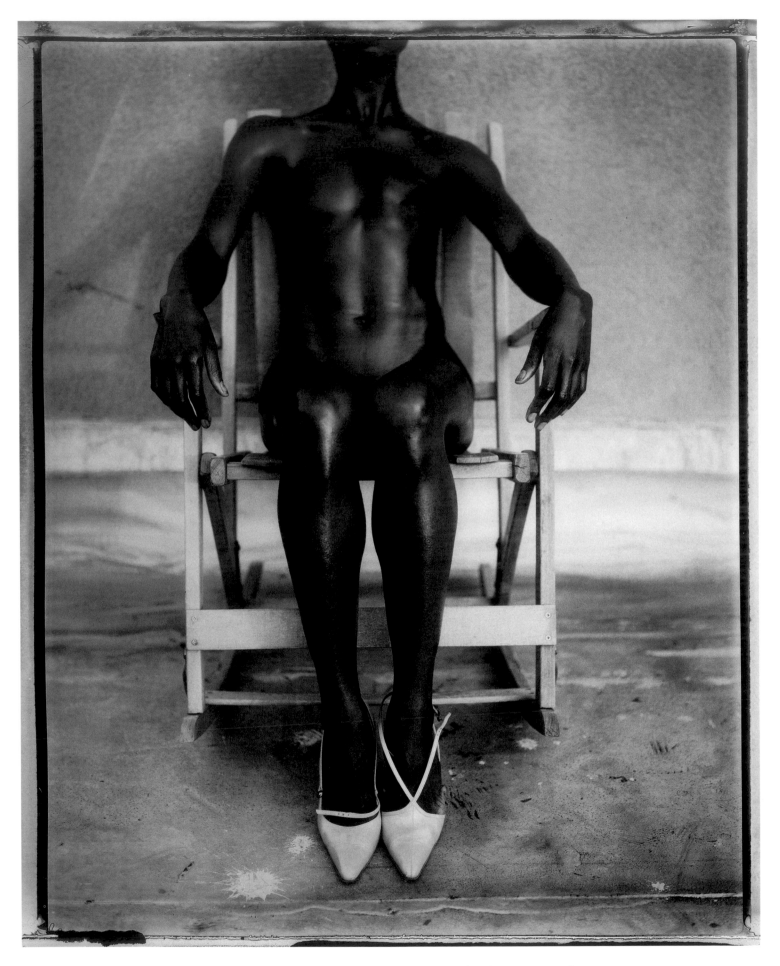

Mfon (Mmekutmfon) Essien. *The Amazon's New Clothes No. 1*, 1999. Gelatin silver print, 75 x 50½ in. (190.5 x 128.3 cm). Lent by the artist.

My work is not about what we
see, but about what we feel.
The challenging contradiction
of humanity is that although
we are individuals, together we
are all one. It is our individual
experiences that serve to
separate or unite us, not our
races, cultures, or countries.
We all need each other, for
our identities arise from
who we are in relationship
to one another.—M.E.

Mfon (Mmekutmfon) Essien. *The Amazon's New Clothes No. 2*, 1999. Gelatin silver print, 20 x 16 in.
(50.8 x 40.6 cm). Lent by the artist.

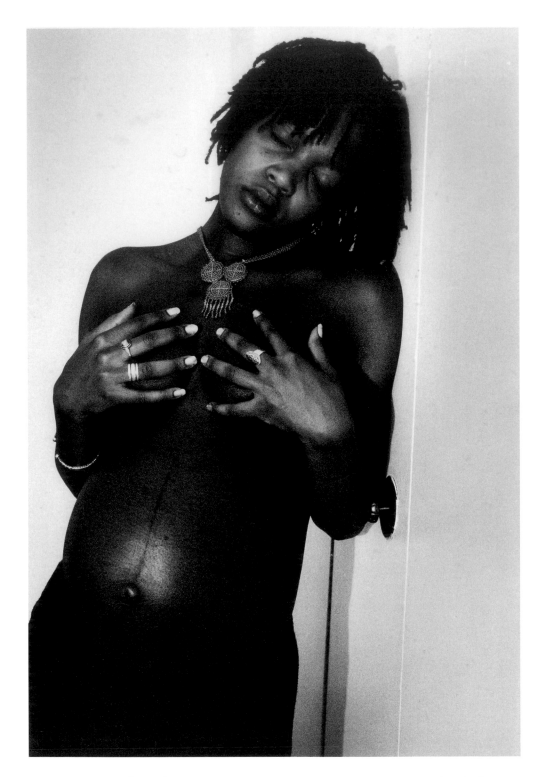

Delphine A. Fawundu (b. 1971). *I Am Seven Months Pregnant*, 1997, from the I Am series. Gelatin silver print, 14 x 11 in. (35.6 x 27.9 cm). Lent by the artist.

Photography is a medium that allows me to express myself artistically. It also gives me the wonderful opportunity to express the emotions of others through my images. As a photographer, I am inspired by people and by the stories that they silently tell.—D.A.F.

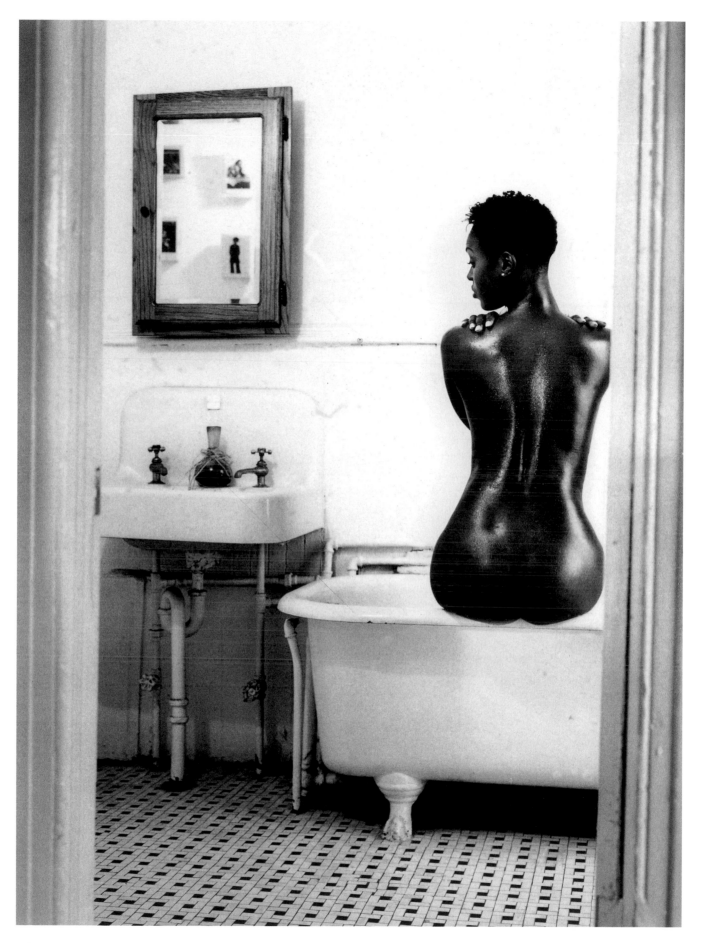

Delphine A. Fawundu (b. 1971). *Patiently Waiting*, 1995, from the Black Love series. Gelatin silver print, 14 x 11 in. (35.6 x 27.9 cm). Lent by the artist.

Albert R. Fennar (b. 1938). *Jersey Shore*, 1975. Gelatin silver print, 11 x 14 in. (27.9 x 35.6 cm). Lent by the artist.

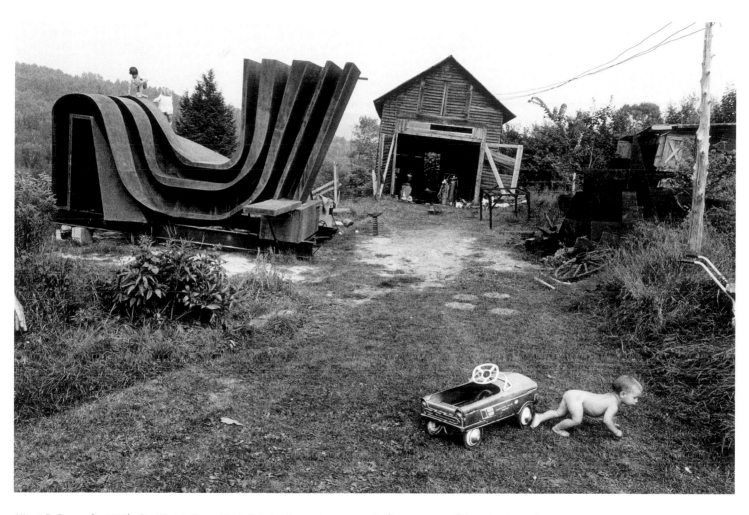

Albert R. Fennar (b. 1938). *Chet Cole's Farm*, 1969. Gelatin silver print, 11 x 14 in. (27.9 x 35.6 cm). Lent by the artist.

It's my intention to discover and share the beauty of the everyday, the mundane, the places often looked at but seldom seen.—A.R.F.

I'm influenced by my father Alex,
a portrait artist, and my mom Cynthia,
a fashion designer. My professional
influence was Gordon Parks, whom I
photographed with David Dinkins in
1999. For *James VanDerZee, NYC, 1979*,
I mixed cold and warm developers to
bring out the best tones possible,
producing a labor of love.—C.F.

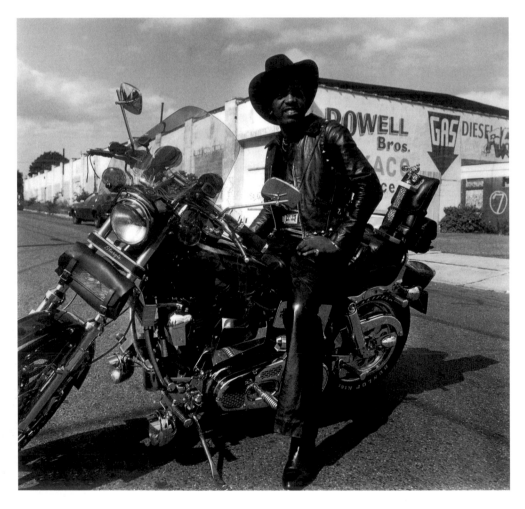

Collette Fournier (b. 1952). *Man on Harley Motorcycle, Buffalo*, 1985. Gelatin silver print, 13 1/4 x 15 1/4 in.
(33.7 x 38.7 cm). Lent by the artist.

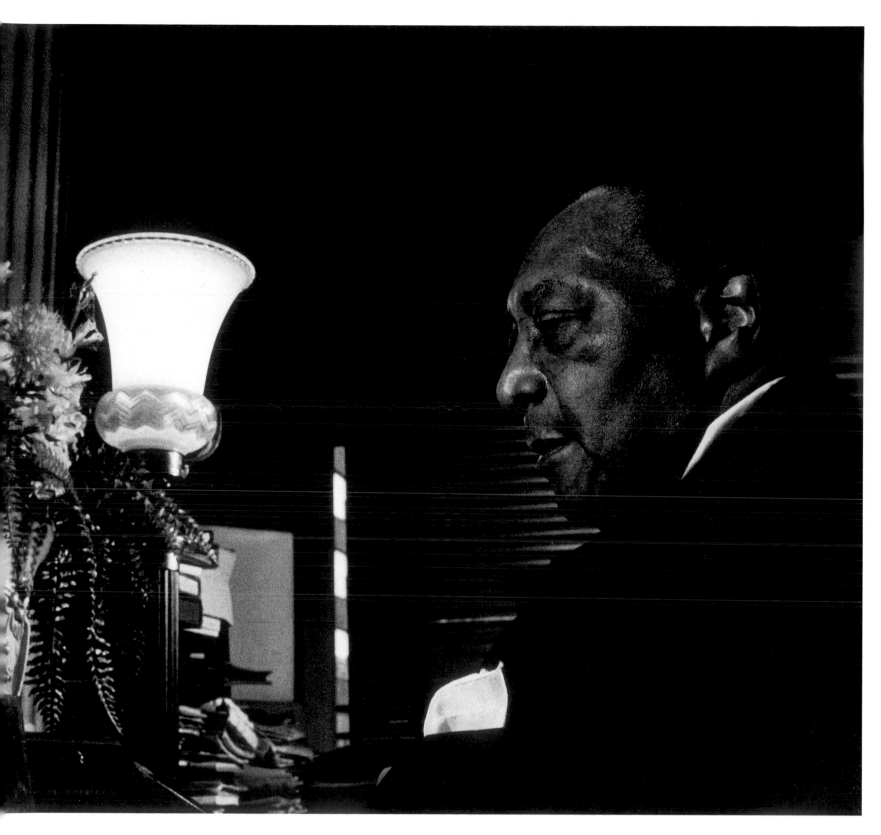

Collette Fournier (b. 1952). *James VanDerZee, NYC, 1979*, 1979. Gelatin silver print, 11 x 14 in. (27.9 x 35.6 cm). Lent by the artist.

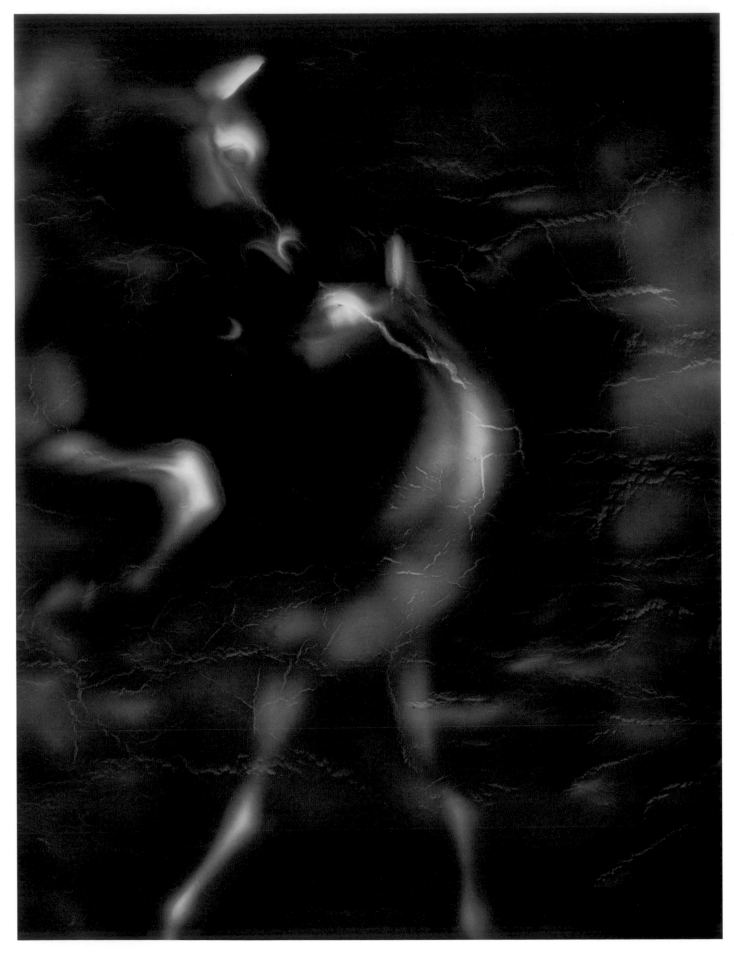

Omar Francis (b. 1972). *Untitled (Orange)*, 1999. Digital C-print, 24 x 20 in. (61 x 50.8 cm). Lent by the artist.

We play with toys for a feeling of control and as a means of expression. In the playroom or the photography studio, a world is created where the "good guys" always win. We are not playing out movie scenes, but stories in our hearts. We put ourselves into the game and use it to find answers and peace.—O.F.

Omar Francis (b. 1972). *Untitled (Red)*, 1999. Digital C-print, 24 x 20 in. (61 x 50.8 cm). Lent by the artist.

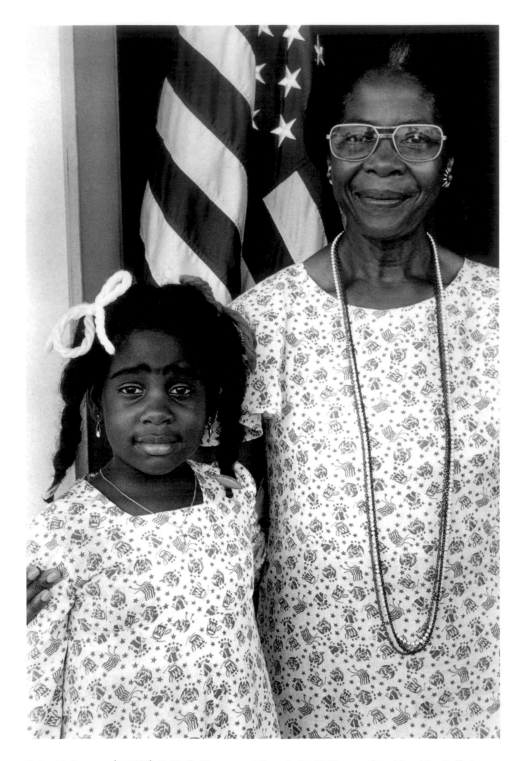

Roland L. Freeman (b. 1936). *Nellie G. Morgan and Tammie Pruitt Morgan, Granddaughter, in Their Bicentennial Outfits Made by Mrs. Morgan, Kemper County, Mississippi*, 1976. Toned gelatin silver print, 14 x 11 in. (35.6 x 27.9 cm). Lent by the artist.

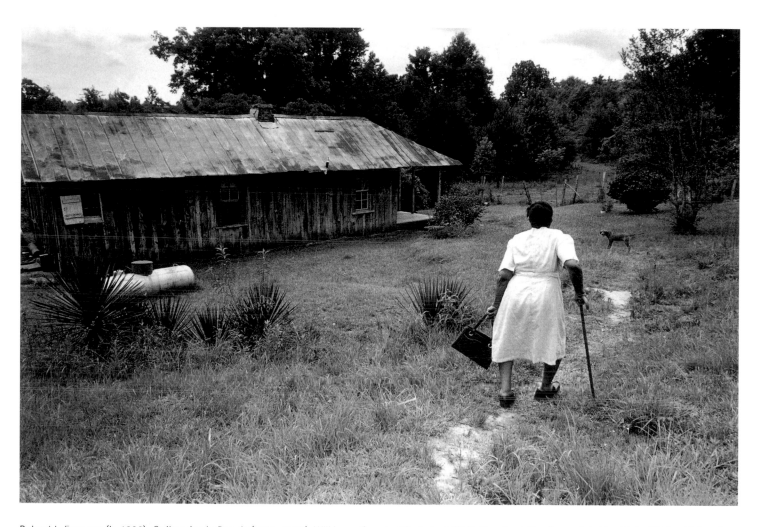

Roland L. Freeman (b. 1936). *Quilter Annie Dennis (1904–1997), Wilkinson County, Mississippi*, 1976. Toned gelatin silver print, 11 x 14 in. (27.9 x 35.6 cm). Lent by the artist.

A major emphasis of my work is the study of Black culture throughout the African Diaspora. I use the camera as a tool to research, document, and interpret the continuity of traditional African American folk practices. My work is usually done in collaboration with folklorists, historians, sociologists, and community activists.—R.L.F.

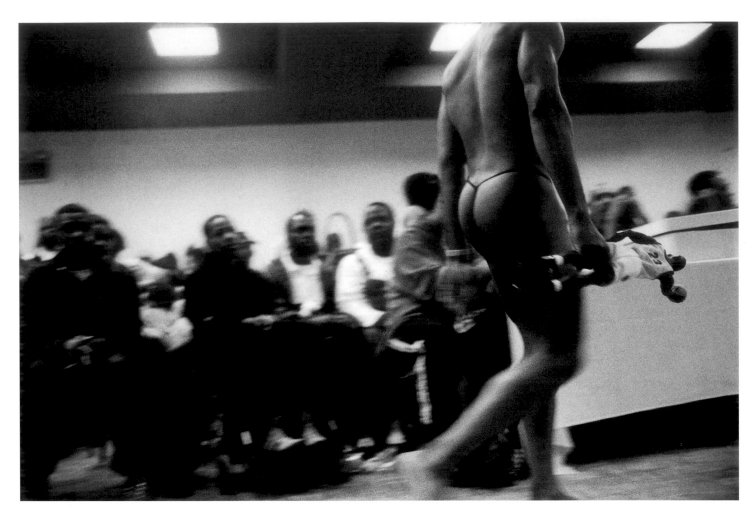

Gerard H. Gaskin (b. 1966). *Untitled*, 1997, from the A Walk in the Park series. Gelatin silver print, 16 x 20 in. (40.6 x 50.8 cm). Lent by the artist.

These images focus on participants in the Black and Latino Gay Ball in New York City, a regularly scheduled event. In this extravagant fashion masquerade, gender identity is (re)defined and critiqued. Woman and man become fluid. I am concerned with the nature of identity as it is constructed and performed.—G.H.G.

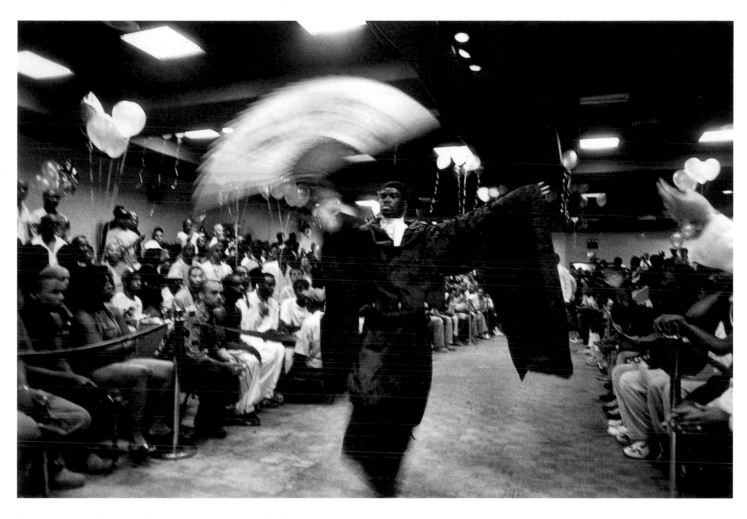

Gerard H. Gaskin (b. 1966). *Untitled*, 1997, from the A Walk in the Park series. Gelatin silver print, 16 x 20 in. (40.6 x 50.8 cm). Lent by the artist.

African Americans are often misrepresented in photographs, providing the viewer with a false perception of Black people. I try to understand and reveal the rituals, gestures, complexity, and diversity of people who are grouped as African American, and to do so in an engaging, informed manner.—B.G.

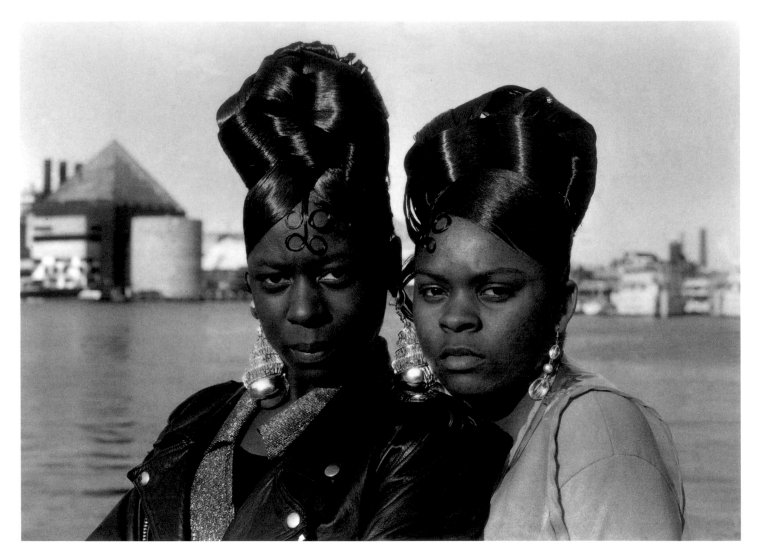

Bill Gaskins (b. 1953). *Tamara and Tireka, Easter Sunday, Baltimore, Maryland*, 1994, from the Good and Bad Hair series. Gelatin silver print, 11 x 14 in. (27.9 x 35.6 cm). Lent by the artist.

Bill Gaskins (b. 1953). *Kenny, Proud Lady Beauty Show, Chicago, Illinois*, 1994, from the Good and Bad Hair series. Gelatin silver print, 11 x 14 in. (27.9 x 35.6 cm). Lent by the artist.

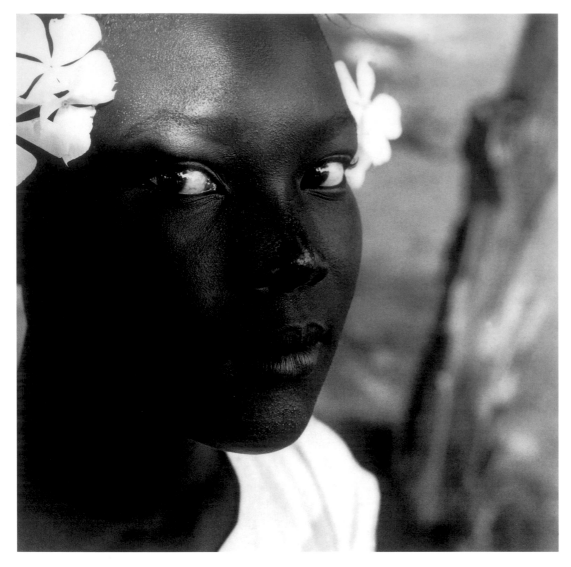

My photographic journey is an effort to define my own life, with its heritage encompassing Africa and Europe. In my search for identity, I endeavor to throw open the discourse on *mestizaje*, the racial mixing of Asian, African, and European peoples with indigenous Americans.—T.G.

Tony Gleaton (b. 1948). *Black Girl, White Flowers, Belize, Central America*, 1992. Gelatin silver print, 15³/₄ x 14³/₄ in. (40 x 37.5 cm). Brooklyn Museum of Art, Gift of Helen Griffith in memory of Seymour Griffith, 1997.134.

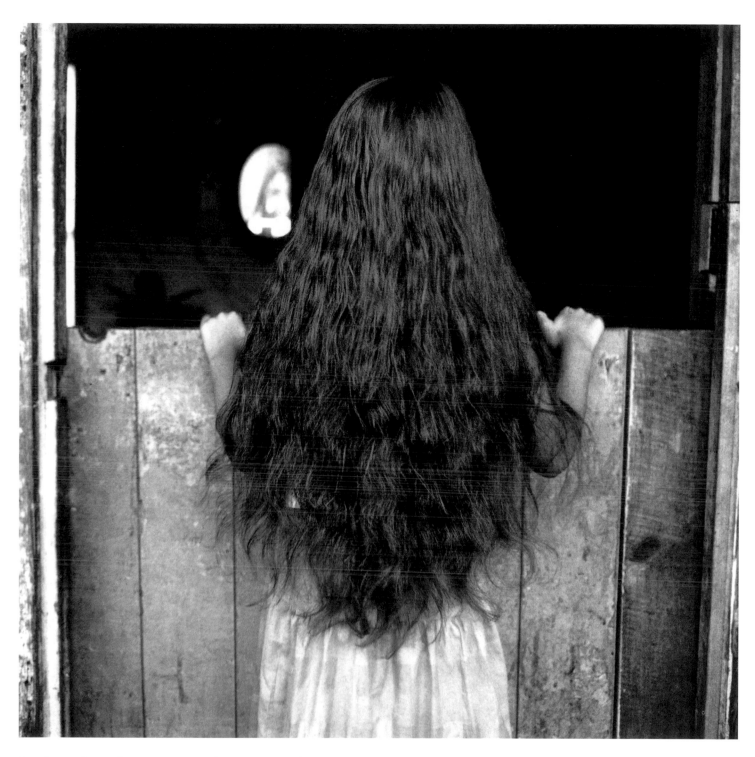

Tony Gleaton (b. 1948). *Una Hija de Jesus (Daughter of Jesus), Guatemala, Latin America*, 1992. Gelatin silver print, 19³/₄ x 15³/₄ in. (50.2 x 40 cm). Brooklyn Museum of Art, Purchased with funds given by Karen B. Cohen and Jan Staller, 1997.50.

Faith Goodin (b. 1970). *Pretty Lady in a Black Dress*, 1991. Gelatin silver print, 11 x 14 in. (27.9 x 35.6 cm). Lent by the artist.

The portraits I consider to be my most successful to date are of those I cherish and love: my family and friends. Oftentimes, it was just a feeling in the air that propelled me to pick up the camera and shoot away. Most of those instances brought satisfying results.—F.G.

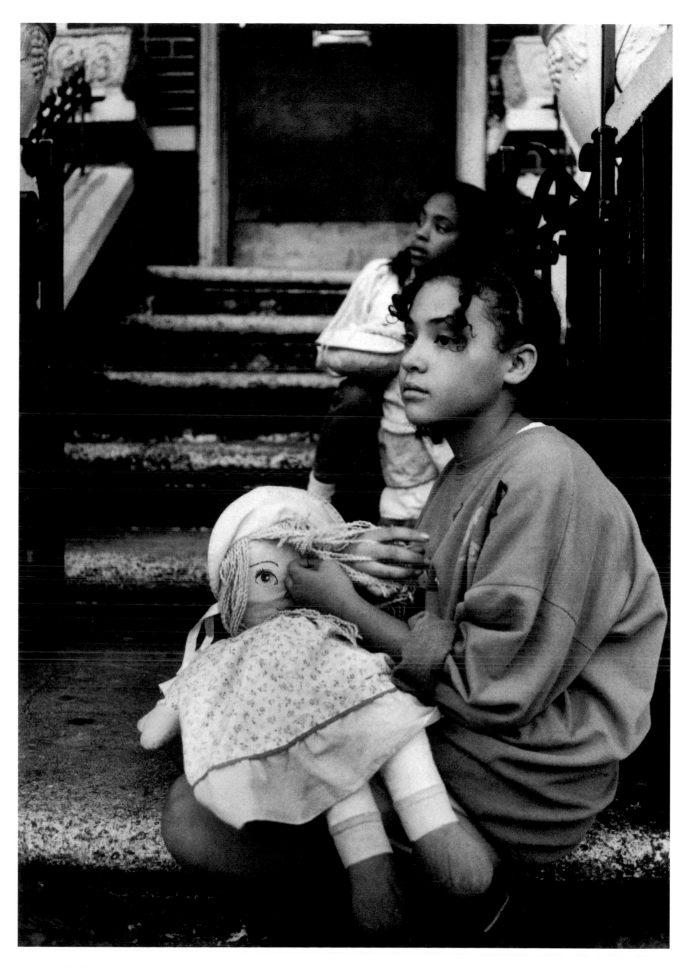

Faith Goodin (b. 1970). *Two Girls with Dolls*, 1990. Gelatin silver print, 14 x 11 in. (35.6 x 27.9 cm). Lent by the artist.

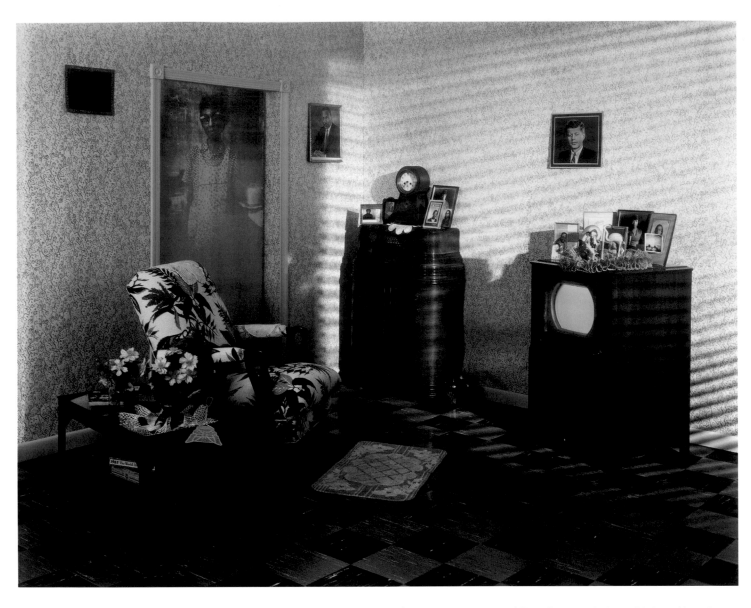

Lonnie Graham (b. 1954). *Living in a Spirit House: Aunt Dora's Room*, 1992. C-print (installation of screened silk, wallpaper, upholstery fabric, artifacts from artist's early home; part of a larger project (1992–96) that resulted in the establishment of community gardens in East Africa and the U.S.), 74 $^1/_8$ x 50 in. (188.3 x 127 cm). Lent by the artist.

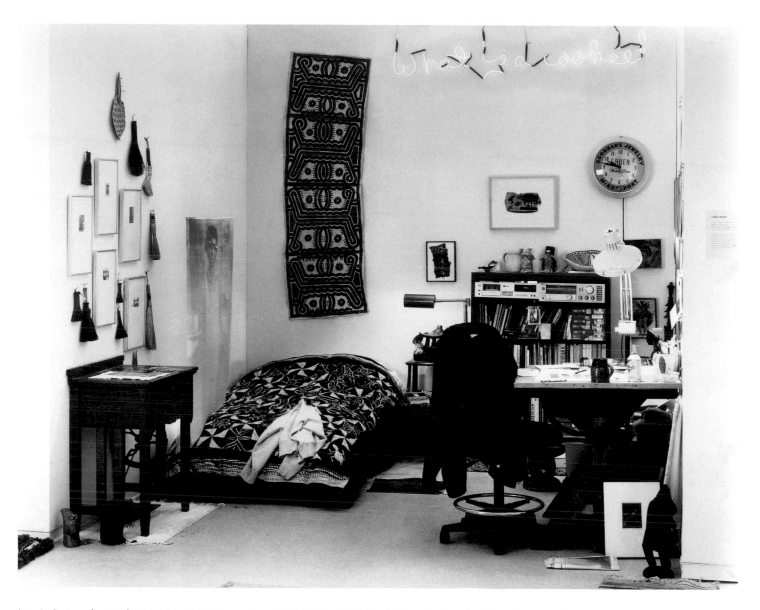

Lonnie Graham (b. 1954). *Living in a Spirit House: The Artist's Studio*, 1998. C-print (installation of artifacts from artist's home; part of a larger project (1998 to the present) in which the artist honorarium is used for food and clothes distributed to the homeless), 71¹/₈ x 50 in. (180.7 x 127 cm). Lent by the artist.

My work exists within the context of social activism. I have become interested in reestablishing the role of the artist as a vital societal component. That means rebuilding traditional links between artists and their communities by activating those communities using art as a tool for understanding and communication, and especially for confronting stereotypes.—L.G.

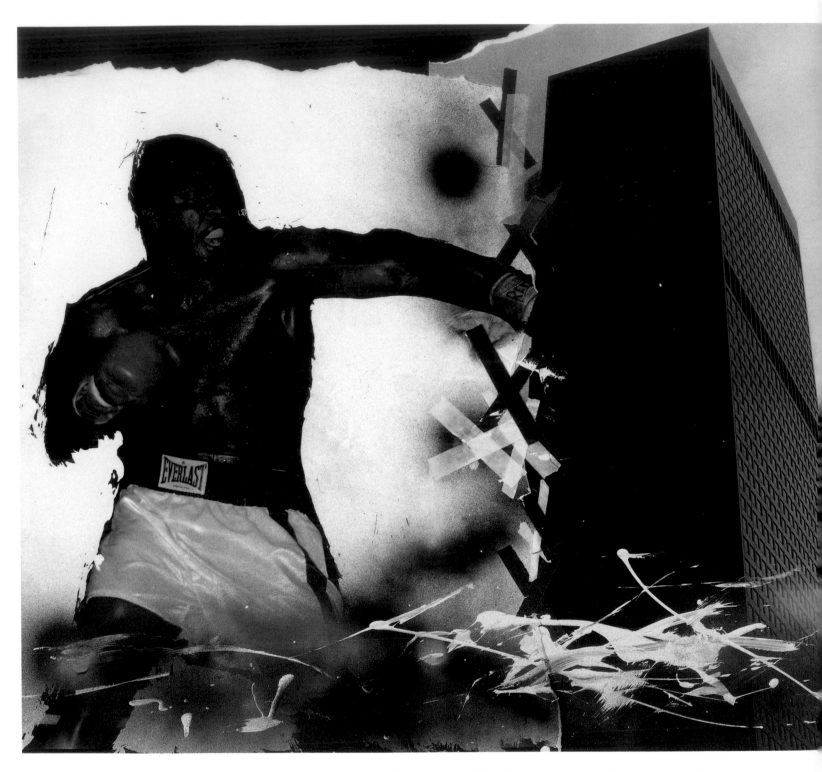

Todd Gray (b. 1954). *Untitled*, 1982. Gelatin silver print, mixed media, 70 x 82 in. (177.8 x 208.3 cm). Lent by the artist, courtesy of Soshana Wayne Gallery, Santa Monica.

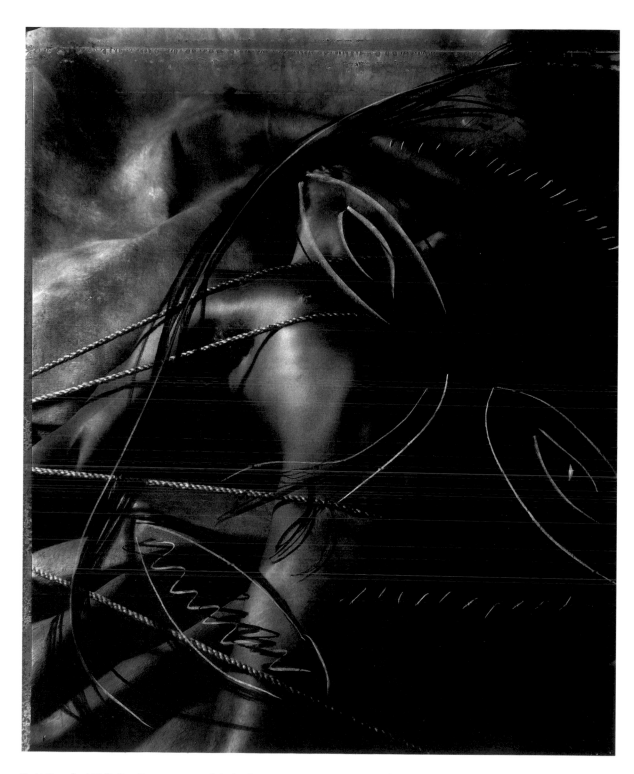

Todd Gray (b. 1954). *Free Passage*, 1983. Gelatin silver print, charcoal, Conté, 23 7/8 x 20 in. (60.6 x 50.8 cm). Lent by the artist, courtesy of Soshana Wayne Gallery, Santa Monica.

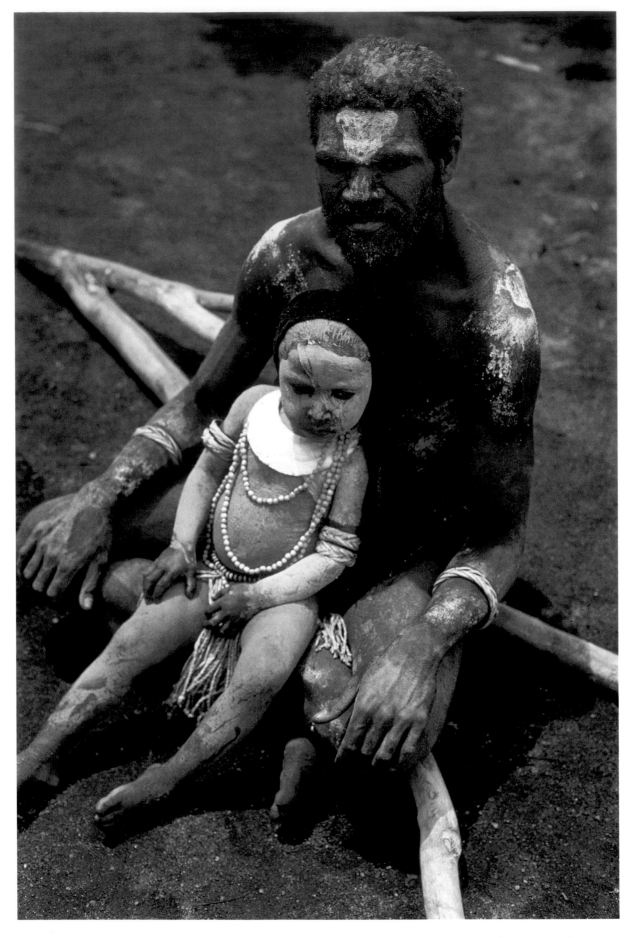

Bob Greene (b. 1935). *Untitled (Papua New Guinea)*, 1994. R-print from Kodachrome original, 20 x 16 in. (50.8 x 40.6 cm).
Lent by the artist.

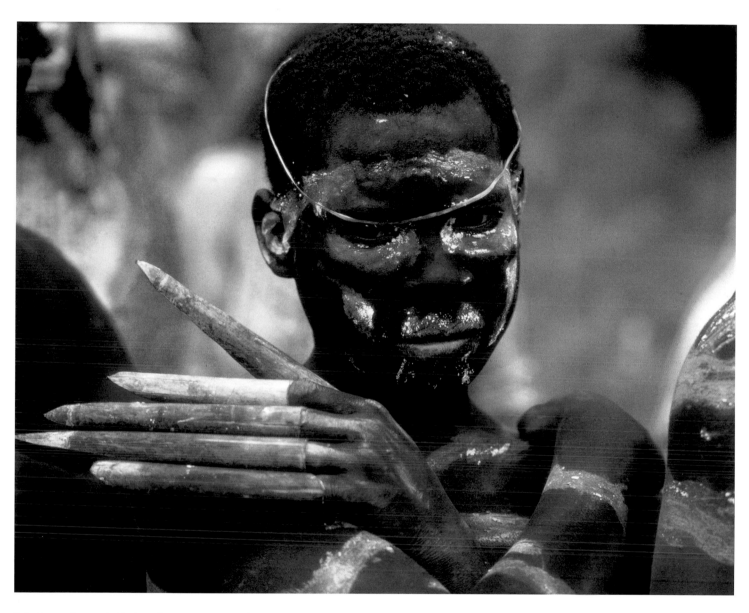

Bob Greene (b. 1935). *Untitled (Papua New Guinea)*, 1994. R-print from Kodachrome original, 16 x 20 in. (40.6 x 50.8 cm). Lent by the artist.

I am still trying to get it right!—B.G.

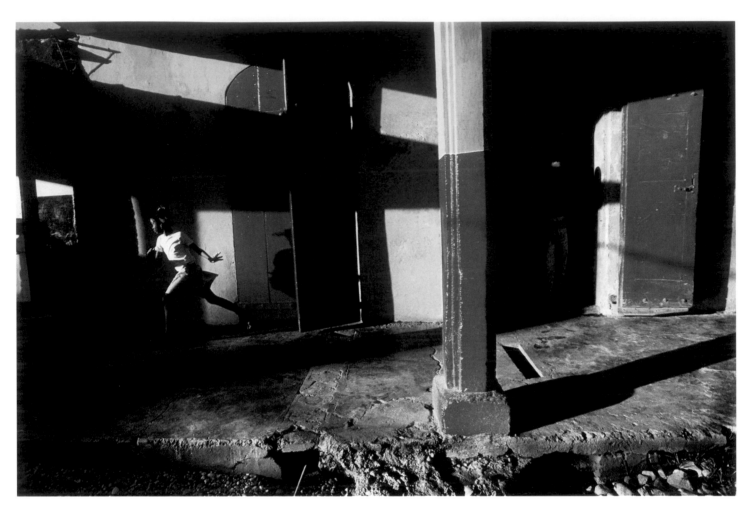

C. W. Griffin (b. 1953). *Mealtime*, 1994. Color digital print, 28 x 40 $\frac{1}{4}$ in. (71.1 x 102.2 cm). Lent by the artist.

My creativity and intense desire to do a good job have landed me challenging assignments such as an earthquake in Mexico City. I prefer working the streets and capturing found situations. This makes photography like a sport.—C.W.G.

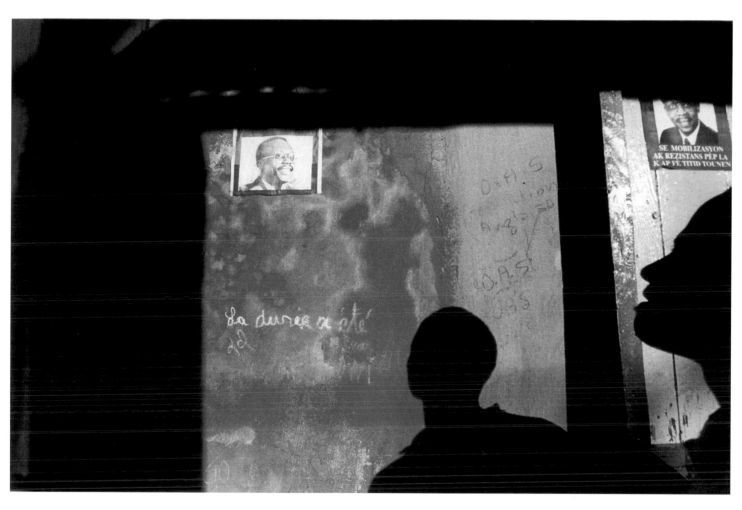

C. W. Griffin (b. 1953). *Admiration*, 1994. Color digital print, 28 x 40 in. (27.9 x 101.6 cm). Lent by the artist.

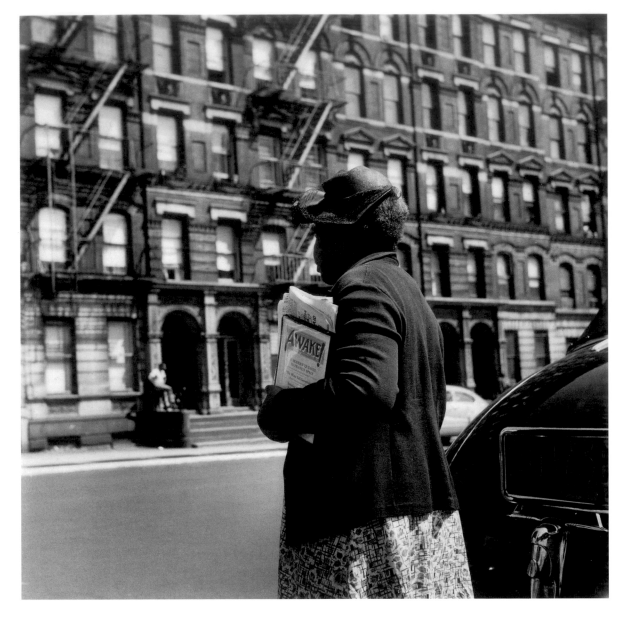

Inge Hardison (b. 1914). *Awake*, 1951. Gelatin silver print, 11 x 14 in. (27.9 x 35.6 cm). Lent by the artist.

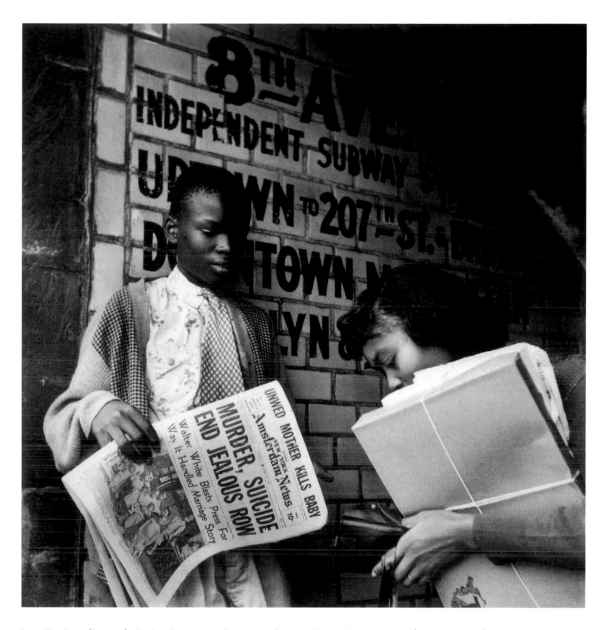

Inge Hardison (b. 1914). *Harlem Newspaper Boy*, 1949. Gelatin silver print, 11 x 14 in. (27.9 x 35.6 cm). Lent by the artist.

Portraits of figures who have made history are the main emphasis of my work. I feel that there has always been a need for role models, but they are especially needed in today's troubled world.—I.H.

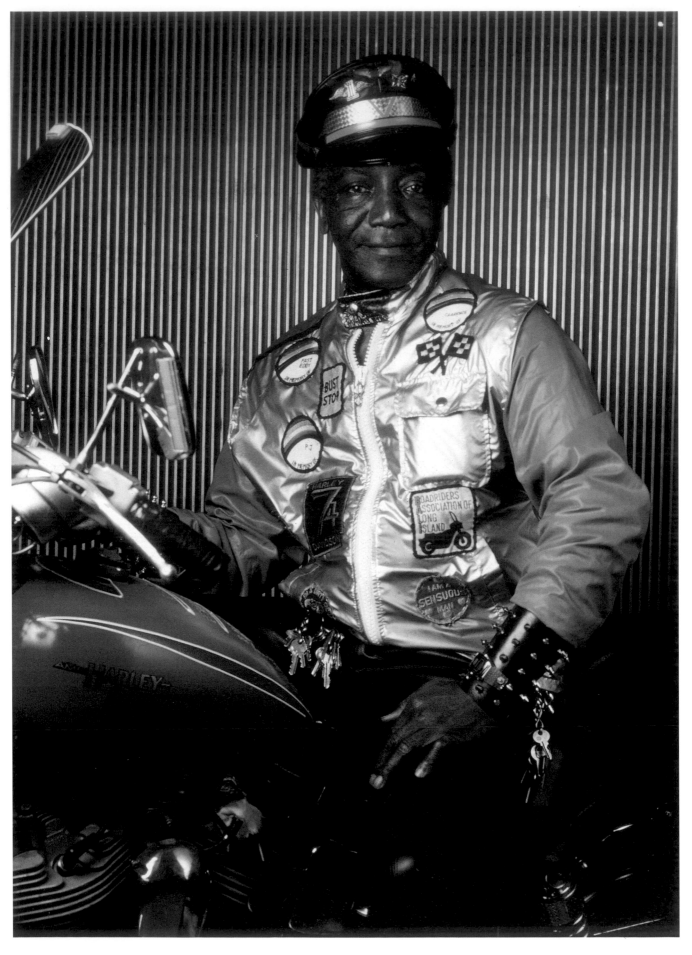

Joe Harris (b. 1940). *Biker*, 1990. Ektachrome, 20 x 16 in. (50.8 x 40.6 cm). Lent by the artist.

Joe Harris (b. 1940). *Baptism*, 1995. C-print, 20 x 16 in. (50.8 x 40.6 cm).
Lent by the artist.

I interpret the lives of Black people to show their spirituality and faith. This used to involve portraying the positive side of people living in poor and inner-city communities, for I believed their spirit would turn the tide against negative forces. Sadly, not much has changed in my time. Now I direct my work toward creating images that question the status quo.—J.H.

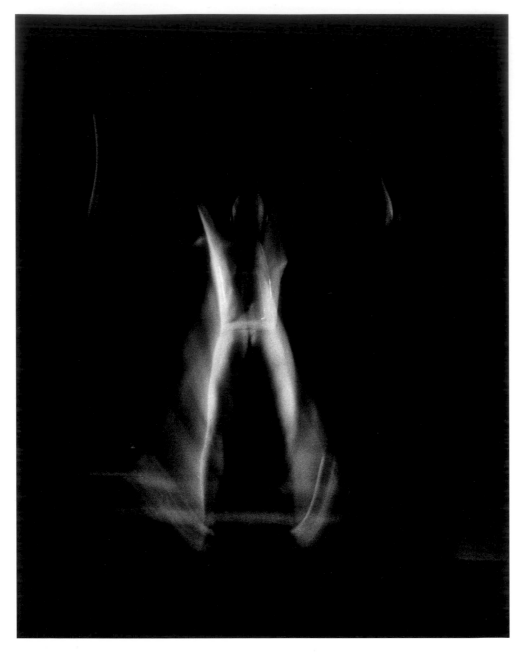

Art Harrison (Heru; b. 1937). *Jubilation*, 1993. Gelatin silver print, 20 x 16 in. (50.8 x 40.6 cm). Lent by the artist.

My work is all about capturing the physical expressions of dancers and other performing artists. I have been influenced by Jack Mitchell, who stops action in his dance photography, and Tony Barboza, who uses slow action in his jazz photos. These artists contributed to my using deliberate blurs for the emotional effects I seek.—A.H.

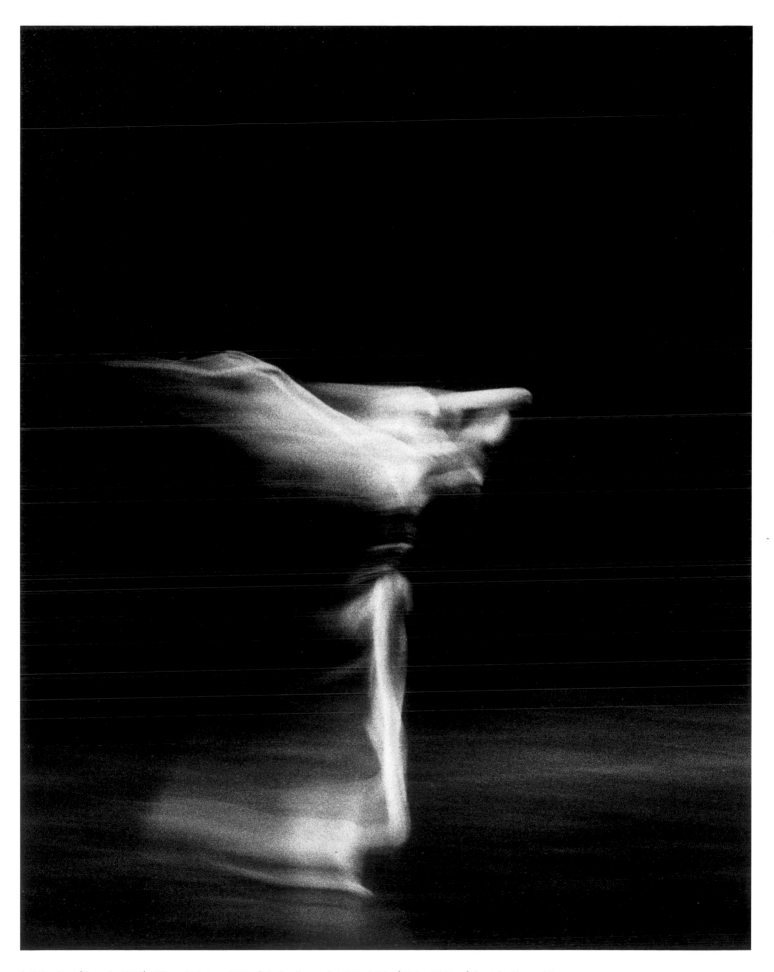

Art Harrison (Heru; b. 1937). *Winged Victory*, 1998. Gelatin silver print, 20 x 16 in. (50.8 x 40.6 cm). Lent by the artist.

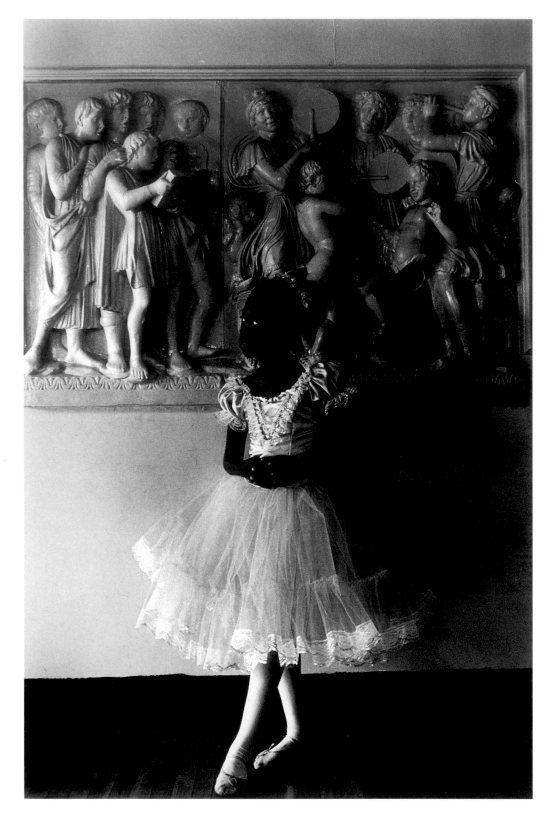

LeRoy W. Henderson, Jr. (b. 1936). *Untitled*, 1993. Gelatin silver print, 20 x 16 in. (50.8 x 40.6 cm).
Lent by the artist.

Although I use photography primarily to document events, people, and places that are culturally, politically, and socially significant to Black Americans, I have also used photography as a medium for creative expression, producing images purely for their aesthetic appeal. I am always interested in good composition, design, and, where appropriate, color.—L.W.H., Jr.

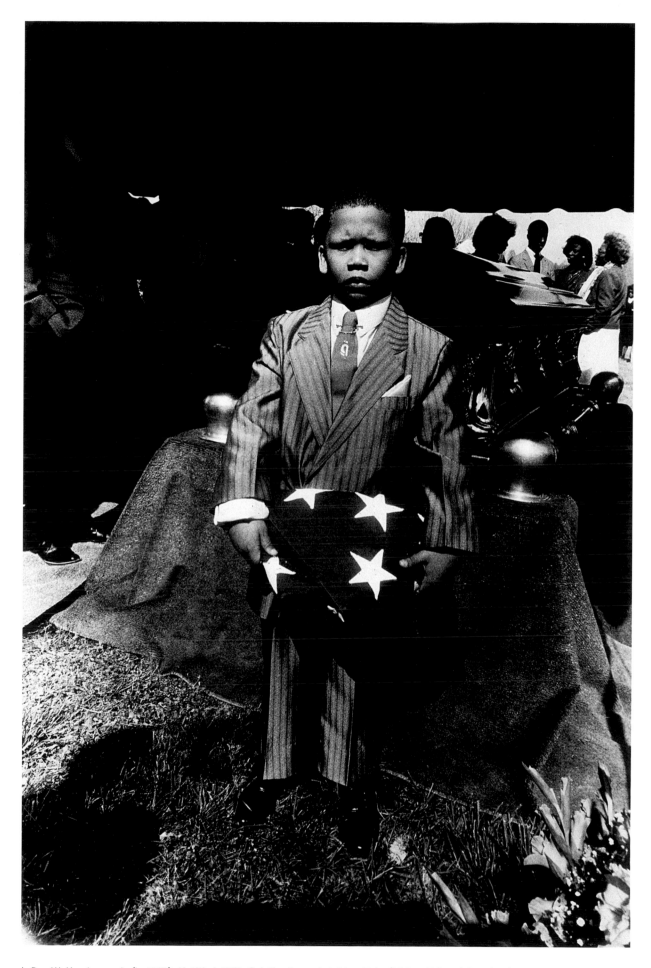

LeRoy W. Henderson, Jr. (b. 1936). *Untitled*, 1989. Gelatin silver print, 20 x 16 in. (50.8 x 40.6 cm). Lent by the artist.

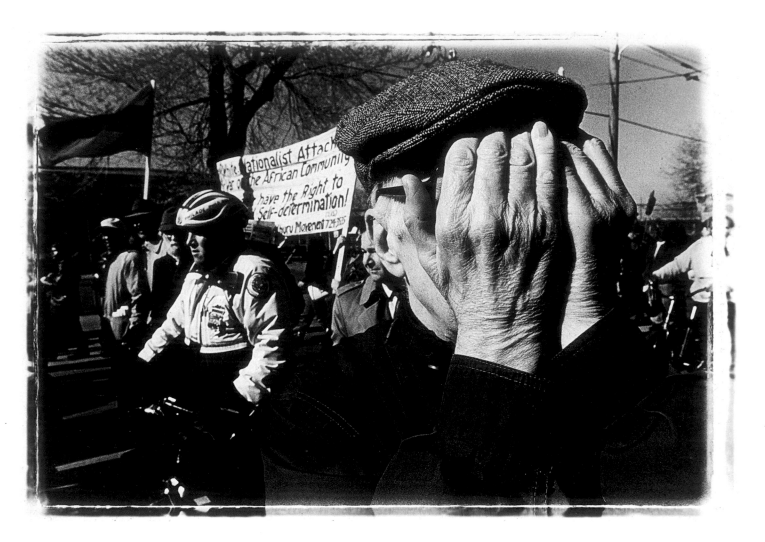

Raymond W. Holman, Jr. (b. 1948). *Ignorance*, 1997. Gelatin silver print, 11 x 13 $^{3}/_{4}$ in. (27.9 x 34.9 cm). Lent by the artist.

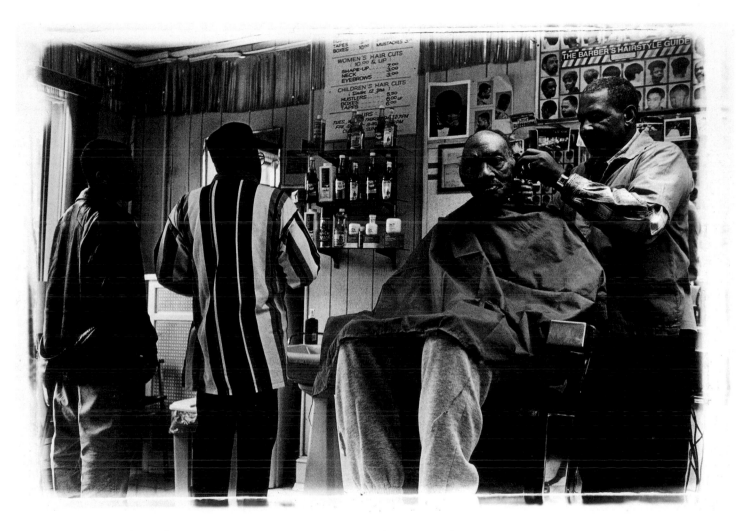

Raymond W. Holman, Jr. (b. 1948). *Big Ray*, 1998. Gelatin silver print, 11 x 14 in. (27.9 x 35.6 cm). Lent by the artist.

My work is done with black-and-white film. Form captures my attention before color. Much can be found within the world of white, gray, and black, especially in the shadow areas. I believe the secrets of the universe dwell in the shadows. My desire is to capture fleeting moments that caress and probe the human heart. —R.W.H., Jr.

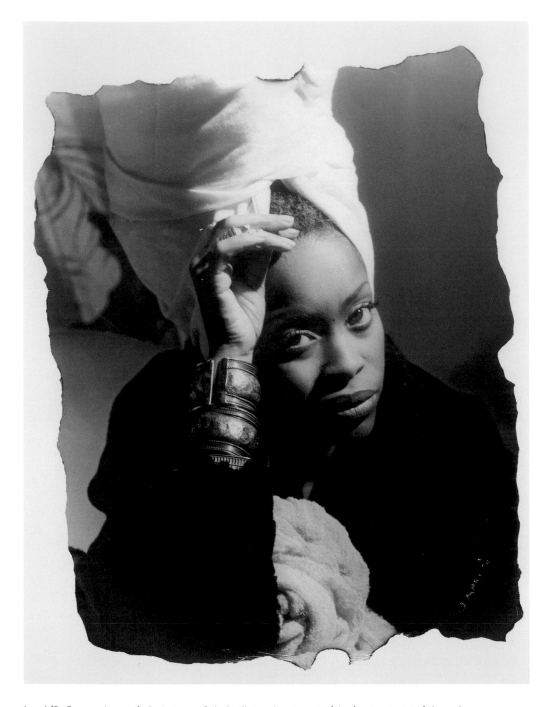

I

am

a

"Black woman"

photographer,

look.

—I.D.

Imari (DuSauzay; b. 1927). *Badu*, 1998. Gelatin silver print, 19 x 14 ½ in. (48.3 x 36.8 cm), irregular.
Lent by the artist.

Woman as cool and mysterious and beautiful as a star jeweled night . . . I exclaim only in wonderment at your sight.

—Excerpt from the poem "Black Spectacle" by the Jamaican poet Oku Onuora, published in *Echo* (Jamaica: Sangsters Publishers, 1977)

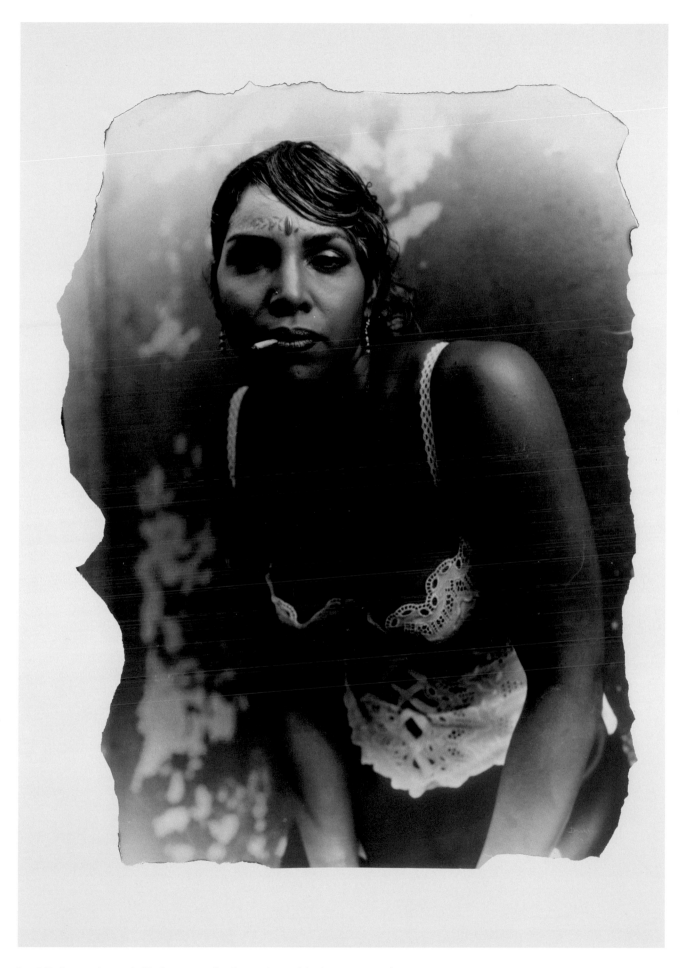

Imari (DuSauzay; b. 1927). *Marlene*, 1999. C-print, 19¹/₄ x 14³/₈ in. (48.9 x 36.5 cm), irregular. Lent by the artist.

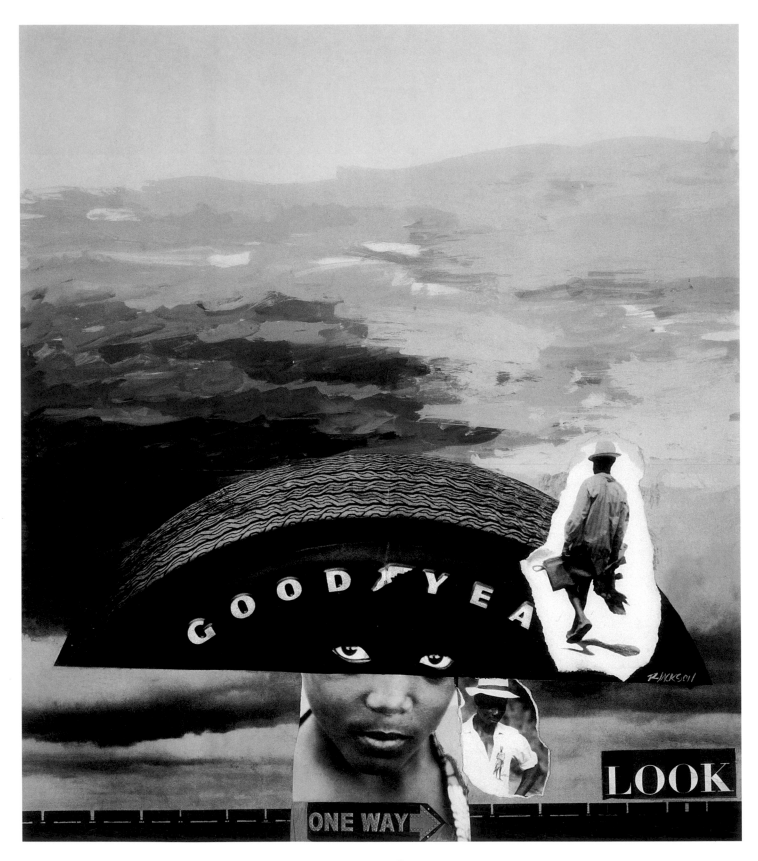

Reginald L. Jackson, Ph.D. (b. 1945). *Last Frontier, West Africa*, 1972. Photo collage, giclée print, 41¹⁄₂ x 35 in. (105.4 x 88.9 cm). Lent by the artist.

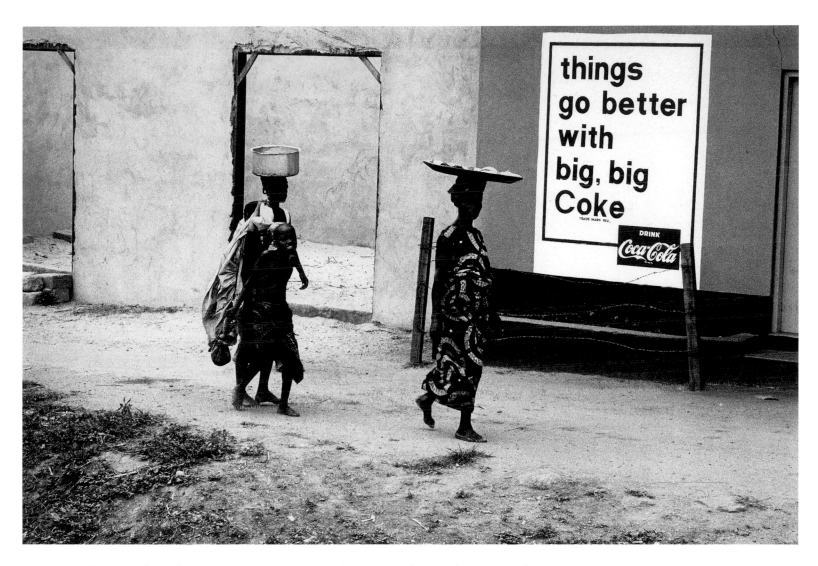

Reginald L. Jackson, Ph.D. (b. 1945). *Ghana: Things Go Better?*, 1970. Giclée print, 23¹/₂ x 31 in. (59.7 x 78.7 cm). Lent by the artist.

My work is an exploration of the cross-cultural influences between African peoples, particularly in West Africa. In my multidisciplinary approach, I combine graphic-arts techniques with experimental photography and film.—R.L.J.

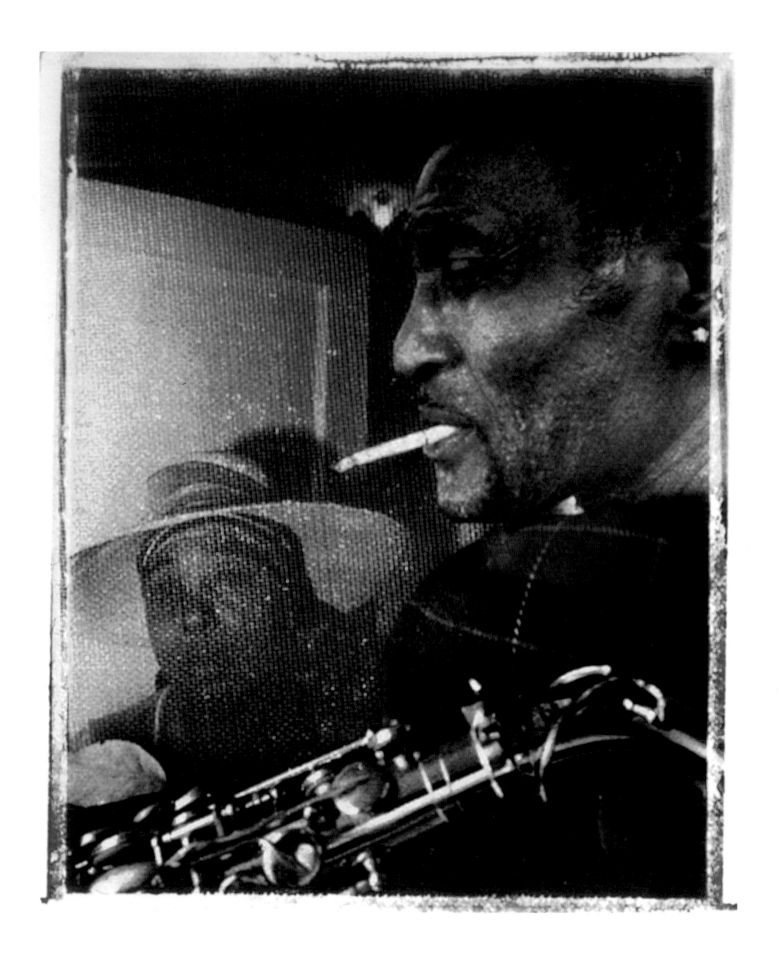

Leslie Jean-Bart (b. 1954). *Untitled*, 1996. Mixed-media collage, Polaroid transfer, 41 ³/₄ x 30 in. (106 x 76.2 cm). Lent by the artist.

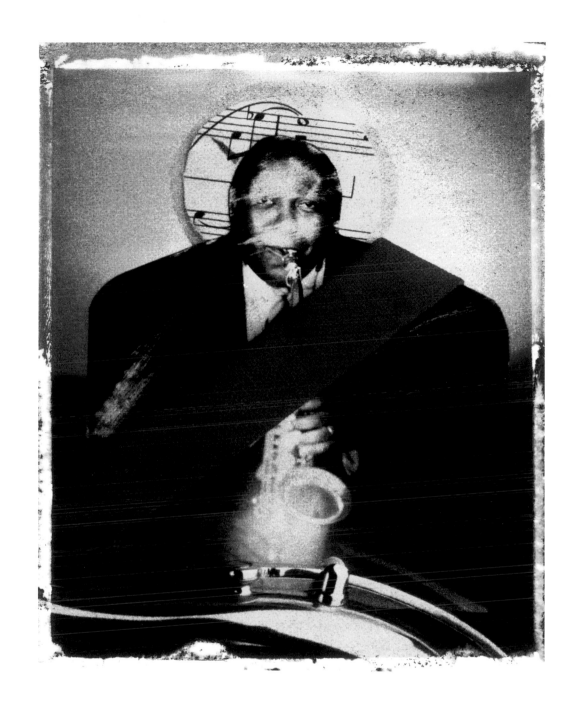

Leslie Jean-Bart (b. 1954). *Untitled*, 1992. Mixed-media collage, Polaroid transfer, 42 x 30 in. (106.7 x 76.2 cm). Lent by the artist.

I give visual shape to verbal ideas. I attempt to convey through image as much information and feeling as the spoken word, while still leaving the work open to individual interpretation.– L.J.-B.

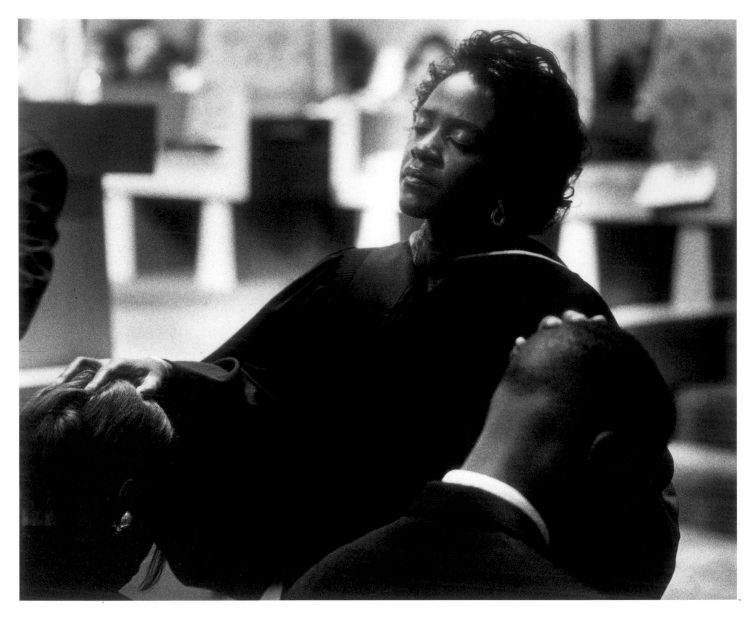

Jason Miccolo Johnson (b. 1956). *Laying of Hands: Rev. Valeria Lassiter Offers Prayers During Deacon's Ordination Service at Metropolitan Baptist Church in Washington, D.C.*, 1996. Gelatin silver print, 16 x 20 in. (40.6 x 50.8 cm). Lent by the artist.

My specialty is capturing the energy of the moment as a permanent memory. It is my desire to stretch the photographic possibilities of the art of seeing to bring out the inner beauty of the human spirit and to stimulate new understanding of and new conversation about old subjects.—J.M.J.

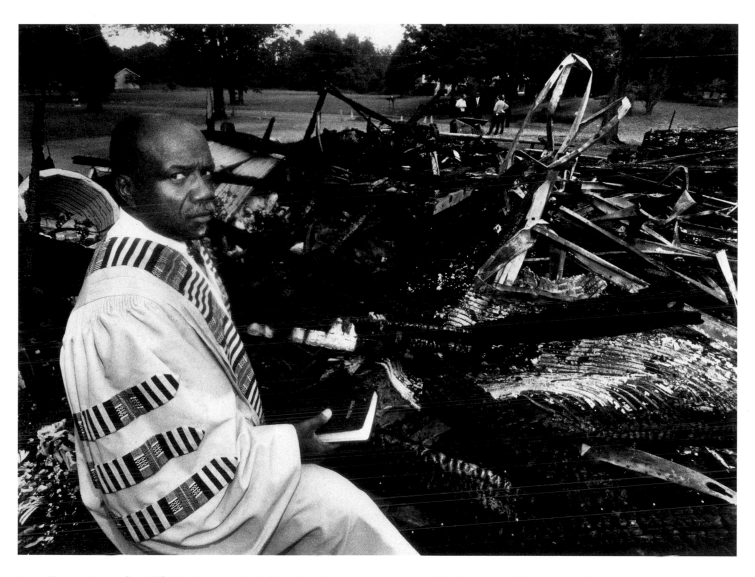

Jason Miccolo Johnson (b. 1956). *You Can Burn the Building, But Not the Spirit: Rev. Larry Hill, Pastor of the Matthews Murkland Presbyterian Church in Charlotte, North Carolina*, 1996. Gelatin silver print, 16 x 20 in. (40.6 x 50.8 cm). Lent by the artist.

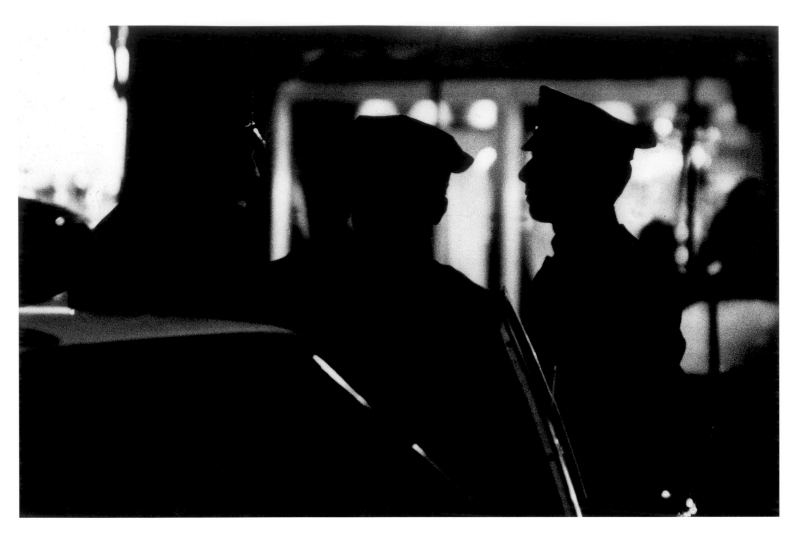

Omar Kharem (b. 1927). *On the Beat*, 1966. Gelatin silver print, 11 x 14 in. (27.9 x 35.6 cm). Lent by the artist.

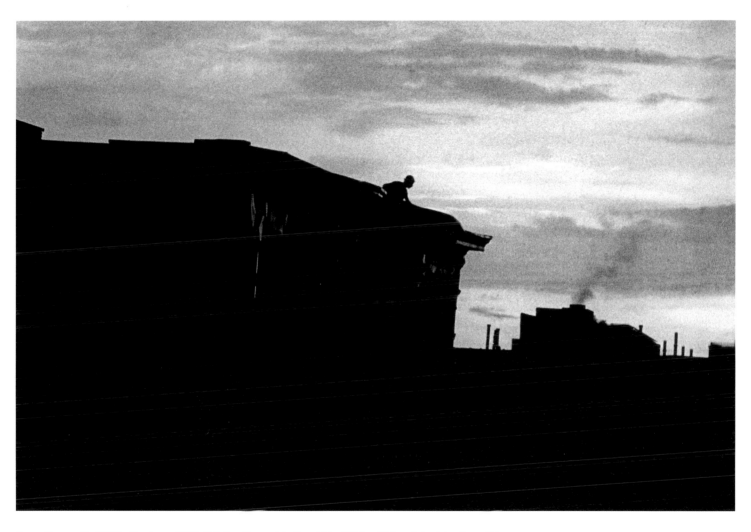

Omar Kharem (b. 1927). *Shadows*, 1968. Gelatin silver print, 11 x 14 in. (27.9 x 35.6 cm). Lent by the artist.

I am a photographer and a musician. All of my art is at one and is a reflection of my life. I reveal myself through my work, giving freely from the heart in an attempt to give the viewer or listener some understanding, peace, and joy.—O.K.

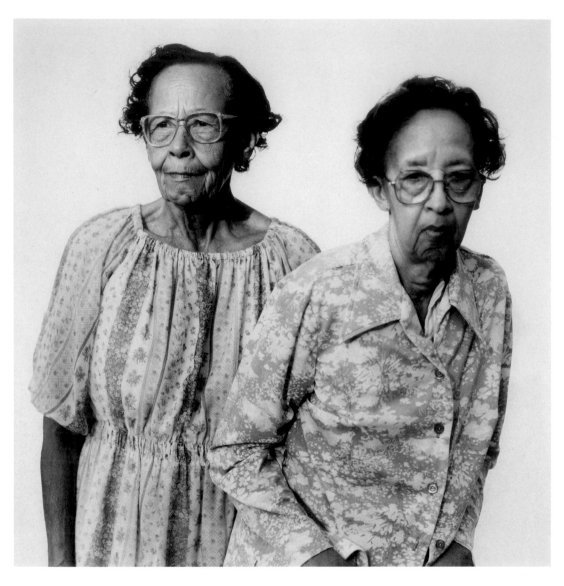

Gary Jackson Kirksey (b. 1955). *Kirksey Sisters, Claudia May, 86, and Caressa, 80,* 1997. Gelatin silver print, 20 x 24 in. (50.8 x 61 cm). Lent by the artist.

My most recent photography projects document the accomplishments of the people of the African Diaspora, and their pride in achieving success, despite the odds.—G.J.K.

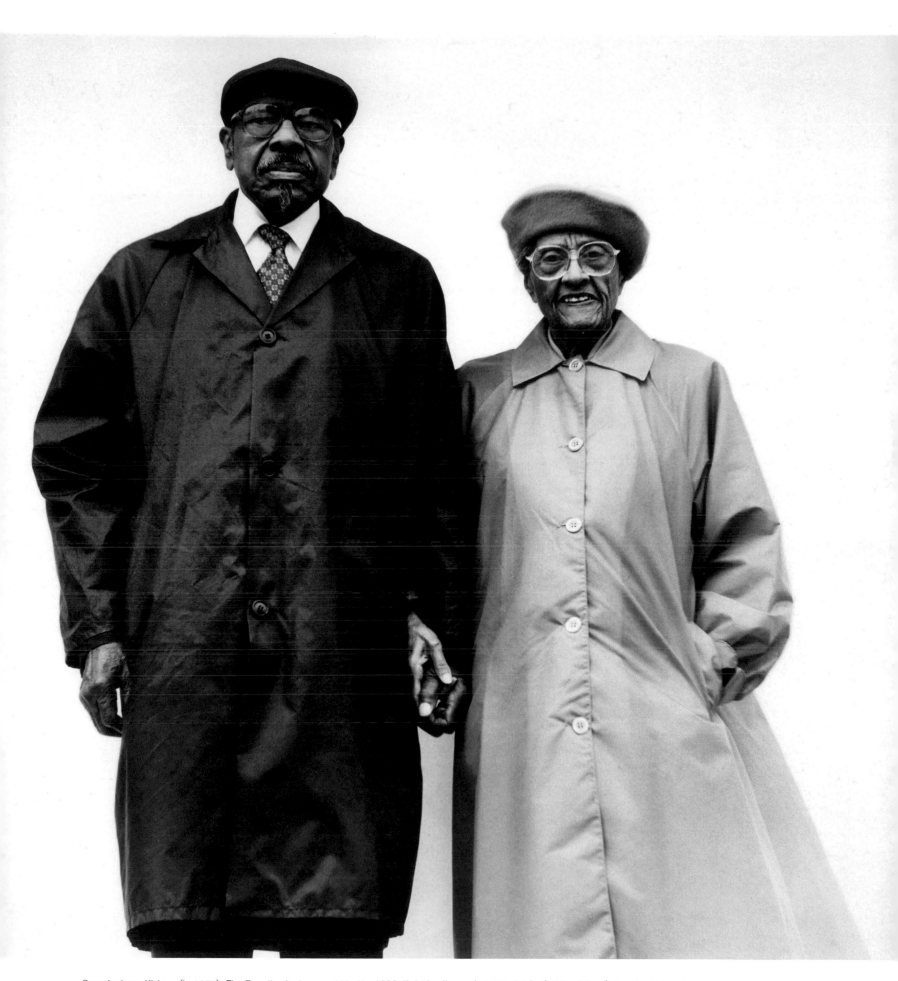

Gary Jackson Kirksey (b. 1955). *The Terrells, Andrew and Veetta*, 1996. Gelatin silver print, 20 x 24 in. (50.8 x 61 cm). Lent by the artist.

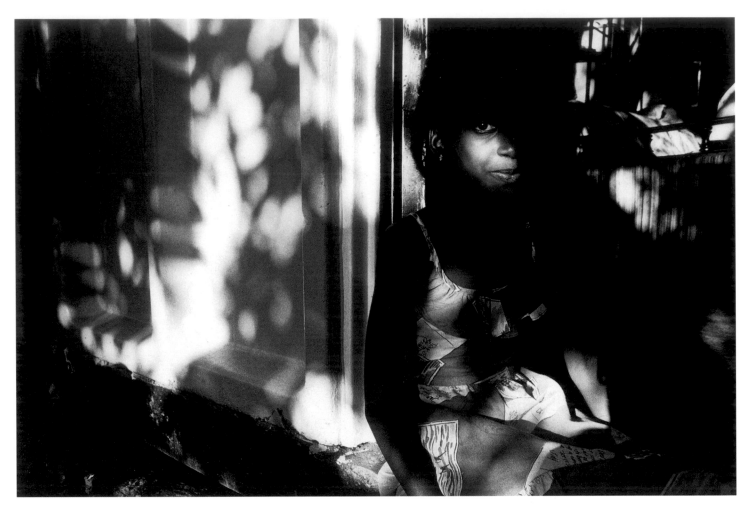

Andrea Davis Kronlund (b. 1965). *Eye No See, Kingston, Jamaica*, 1989. Gelatin silver print, 11 x 14 in. (27.9 x 35.6 cm). Lent by the artist.

My work is informed by the notion of boundaries: physical boundaries, such as the juncture between light and shadow, and conceptual boundaries, such as the meeting of the personal, cultural, and political. Hairstyles chosen by Black women express statements we wish to make about our personal and political place within a culture.—A.D.K.

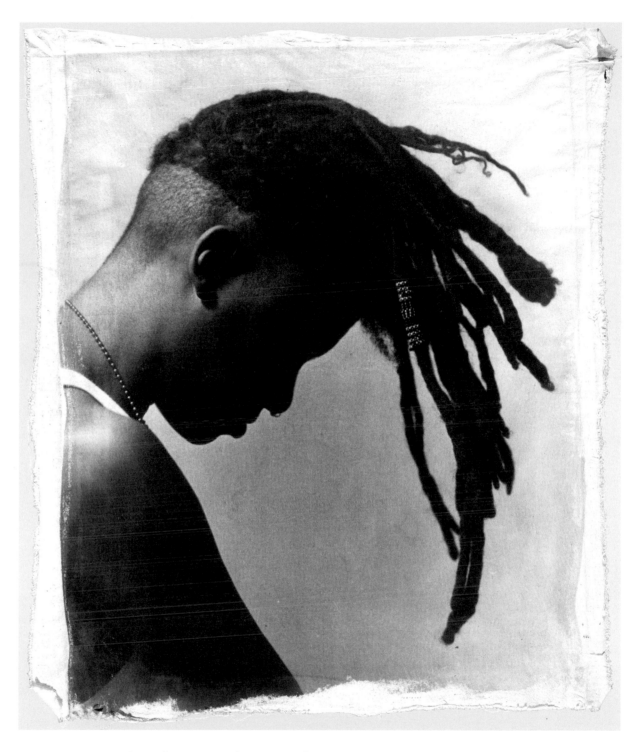

Andrea Davis Kronlund (b. 1965). *Hairpiece #5 (Jamika-Dreads)*, 1994. Photoemulsion on canvas, 34 x 29 in. (86.4 x 73.7 cm), irregular. Lent by the artist.

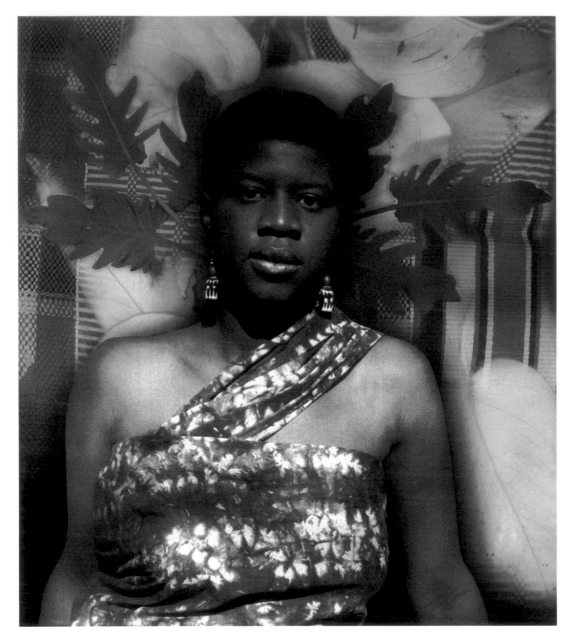

Fern Logan (b. 1945). *Earth Goddess*, 1997. Iris print, 35 x 32 in. (88.9 x 81.3 cm). Lent by the artist.

These goddesses set a standard—of dignity, pride, and self-assurance—for all women. As an African American artist, I endeavor to reveal the beauty in the faces of my people. This beauty reflects the "magic" and mystique of the African American woman.—F.L.

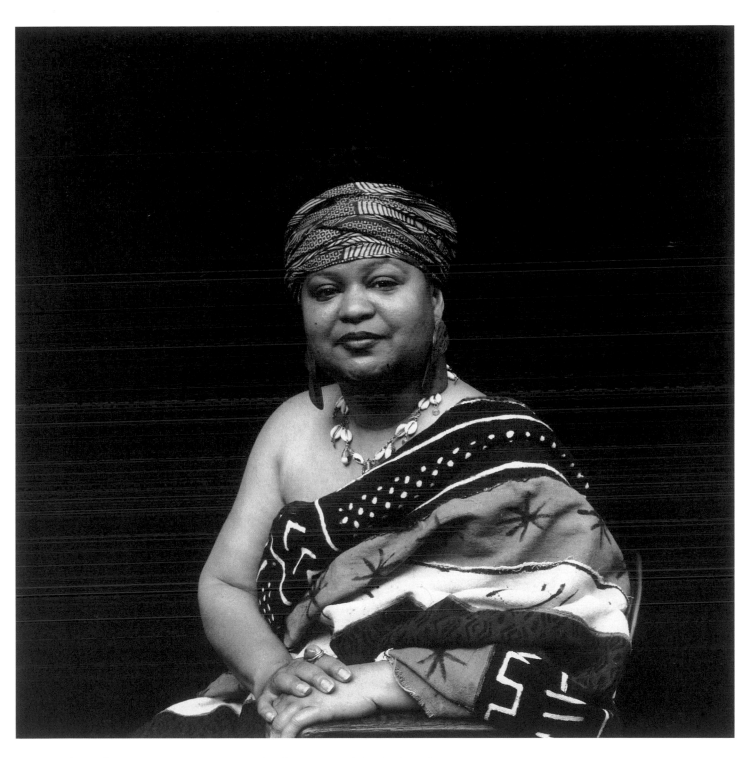

Fern Logan (b. 1945). *Eunice*, 1998. Iris print, 34 x 35⅞ in. (86.4 x 91.1 cm). Lent by the artist.

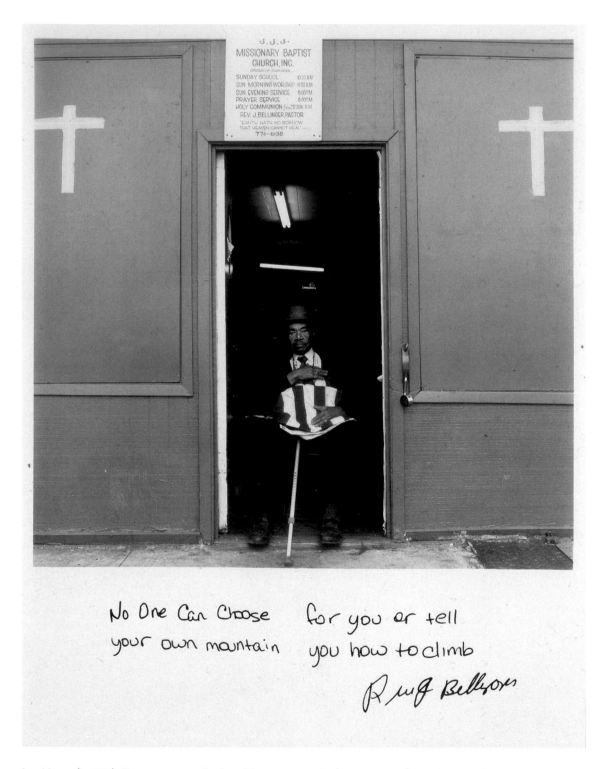

No One Can Choose for you or tell
your own mountain you how to climb

R.W.J. Bellinger

Lauri Lyons (b. 1971). *Testament*, 1995. C-print with text, 20 x 16 in. (50.8 x 40.6 cm). Lent by the artist.

My work is driven by a need to interact with people on a personal level. The pleasure of photography is learning people's stories. The challenge is translating them onto film. For me the whole point of going to unfamiliar places and interacting with people is not to "take pictures" but to learn about the variety of life.—L.L.

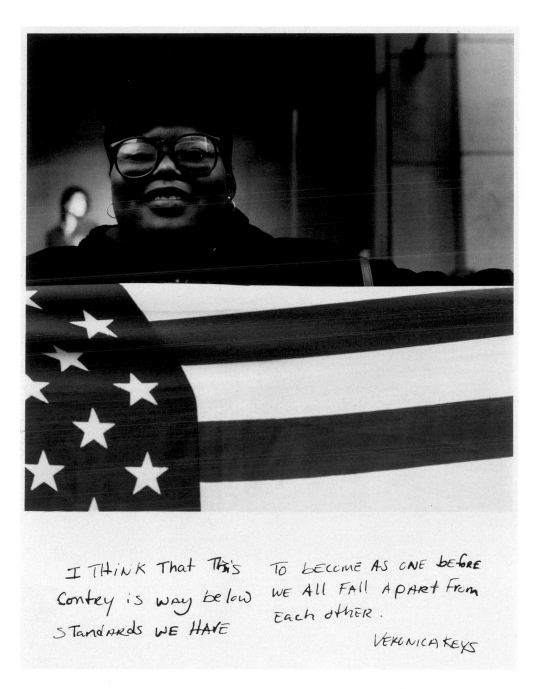

Lauri Lyons (b. 1971). *Testament*, 1995. C-print with text, 20 x 16 in. (50.8 x 40.6 cm). Lent by the artist.

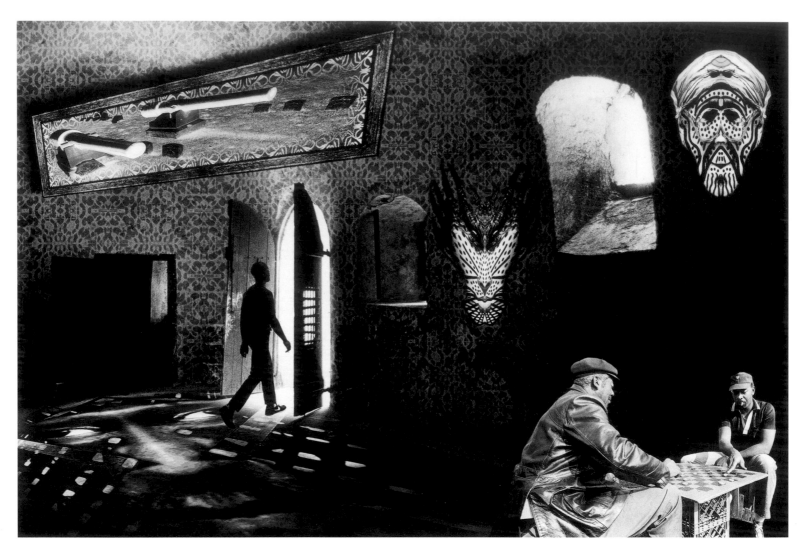

Stephen Marc (b. 1954). *Untitled*, 1996, from the Soul Searching series. RC silver print, 25 ¹/₄ x 37 ¹/₄ in. (64.1 x 94.6 cm). Lent by the artist.

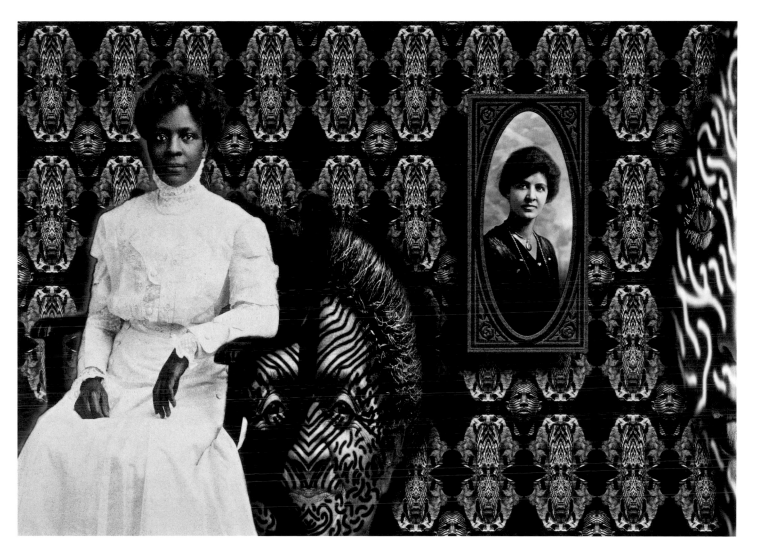

Stephen Marc (b. 1954). *Untitled*, 1999, from the Soul Searching series. Ilfochrome, 26¹/₄ x 36¹/₄ in. (66.7 x 92.1 cm). Lent by the artist.

Working digitally allows me to express creatively my autobiographical exploration of the African Diaspora. In a romantic search for my ancestral roots, I incorporate self-portraits into images of mythic narrative and ritual.—S.M.

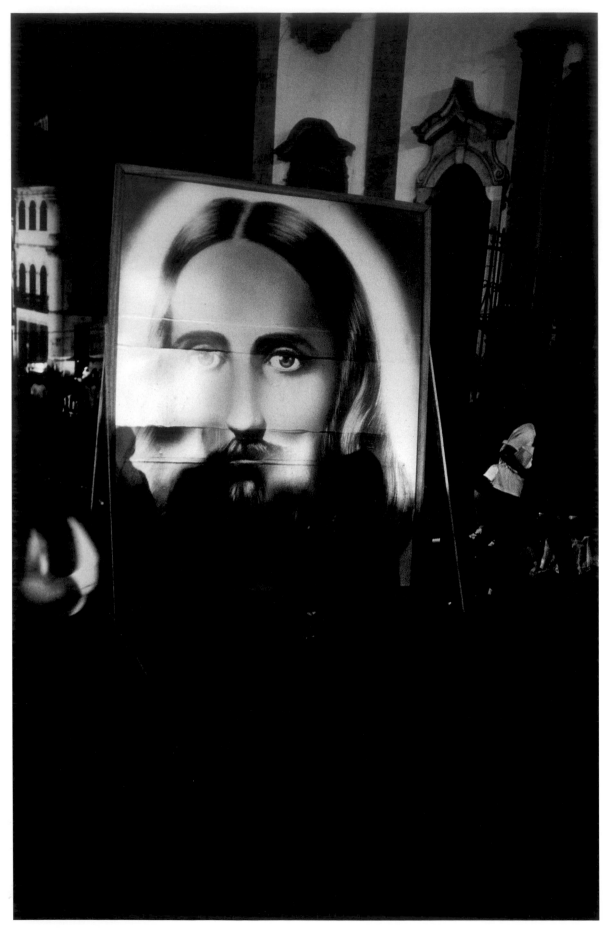

Charles Martin (b. 1952). *Christian Procession, Salvador da Bahia*, 1994. Gelatin silver print, 24 x 20 in. (61 x 50.8 cm).
Lent by the artist.

I work both as a producer of photographic art and as an illustrator of my academic writing. My photography exhibitions are purely about exploring the visual world. In my work as a professor of comparative literature, on the other hand, my photography serves to support my writings on cross-cultural relationships.—C.M.

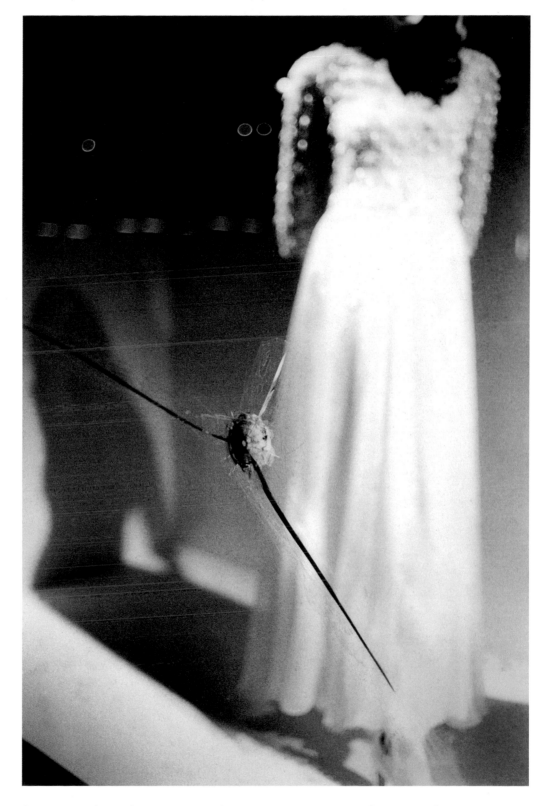

Charles Martin (b. 1952). *Hatching*, 1996. Gelatin silver print, 24 x 20 in. (61 x 50.8 cm). Lent by the artist.

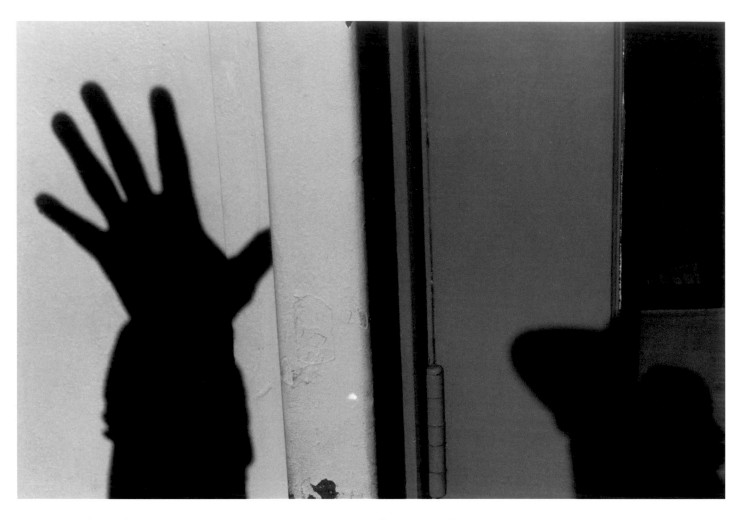

Steve J. Martin (b. 1945). *Shadow Self-Portrait No. 1*, 1995. C-print, 16 x 20 in. (40.6 x 50.8 cm). Lent by the artist.

I want my images to engage fully the viewer's intellect and emotions. The self-portraits are an affirmation of my existence. They are attempts to overcome my feelings of alienation by immersing myself in an environment and capturing it on film, making myself a permanent part of my surroundings.—S.J.M.

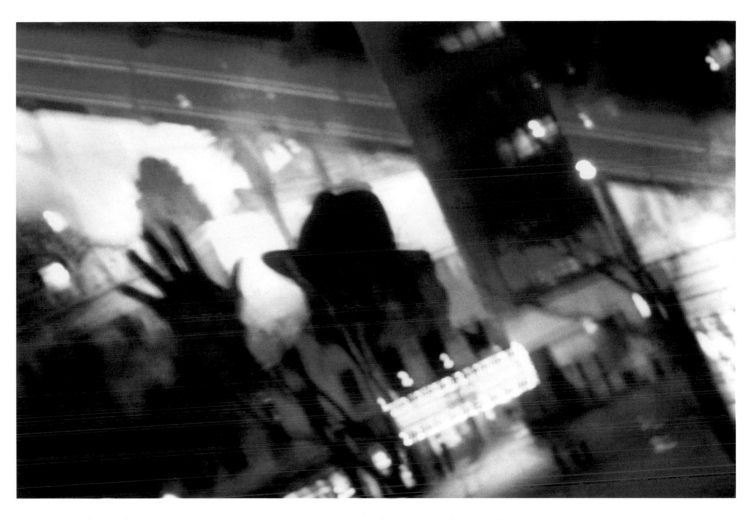

Steve J. Martin (b. 1945). *Shadow Self-Portrait No. 2*, 1995. C-print, 16 x 20 in. (40.6 x 50.8 cm). Lent by the artist.

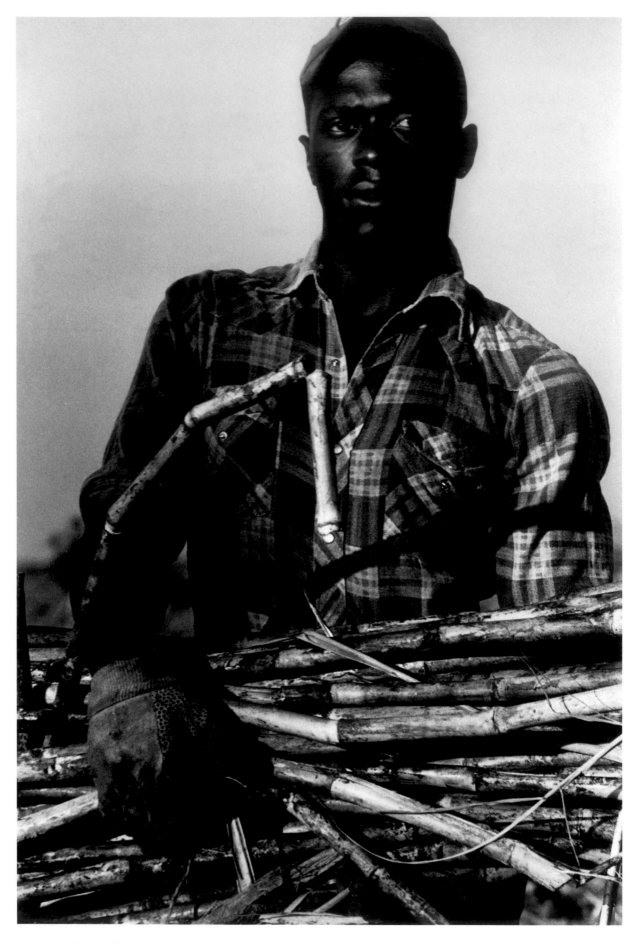

Chandra McCormick (b. 1957). *Mark Gale*, 1986, from the Glendel Plantation Sugar Cane series. Gelatin silver print, 20 x 16 in. (50.8 x 40.6 cm). Lent by the artist.

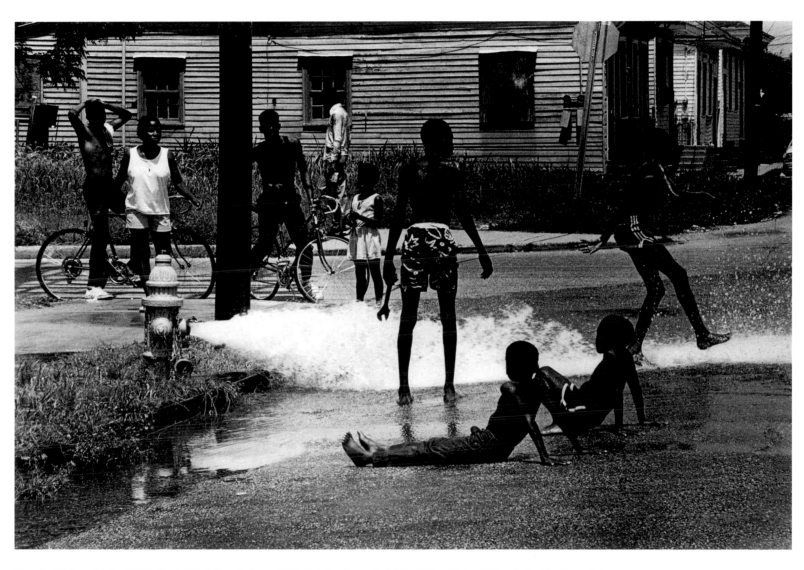

Chandra McCormick (b. 1957). *Coolin' Out, New Orleans*, 1984. Gelatin silver print, 16 x 20 in. (40.6 x 50.8 cm). Lent by the artist.

I photograph a vanishing way of life for Black Americans, that of the traditional South. I try to capture the subject in its best light, to depict the pride, dignity, and strength of the people I photograph. My commitment is to share with the world the profound culture of my people.—C.M.

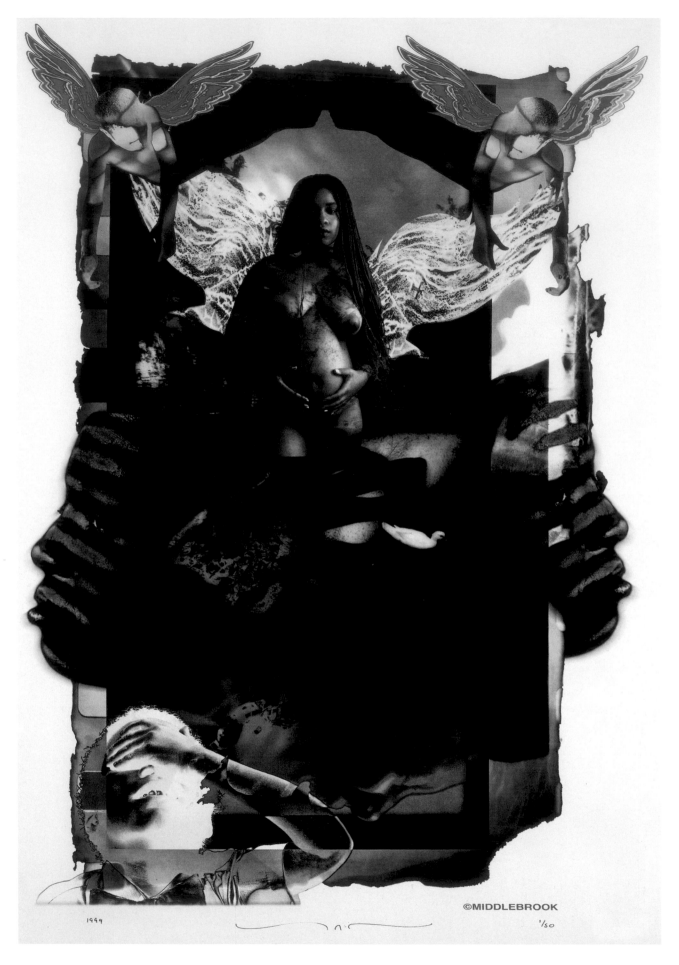

Willie Middlebrook (b. 1957). *Black Angel No. 20*, n.d. Digital image, 24 x 17 in. (61 x 43.2 cm). Lent by the artist.

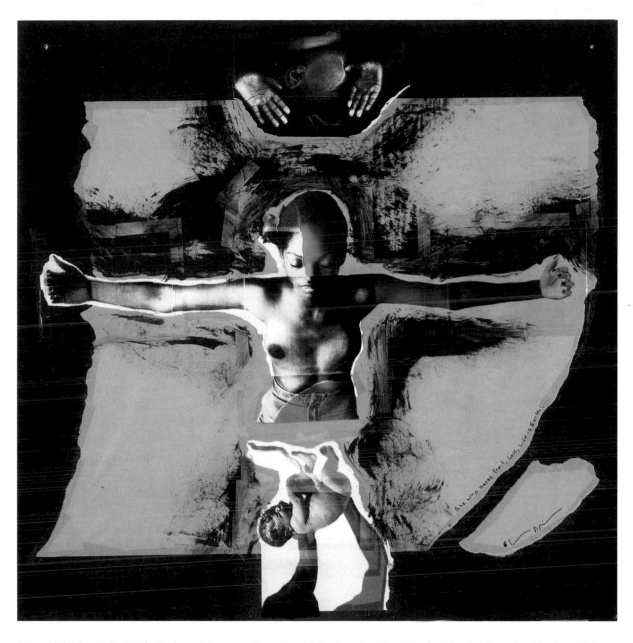

Willie Middlebrook (b. 1957). *The God Suite, Pomp No. 628*, n.d. Mixed media, 48 x 48 in. (121.9 x 121.9 cm). Lent by the artist.

Photography is the tool I use to communicate my feelings. My social and aesthetic convictions come from my parents, who endowed me with strong feelings about the ideals and integrity of being Black. I direct my focus to produce great images of my people, not necessarily in a positive light but always in a true light.—W.M.

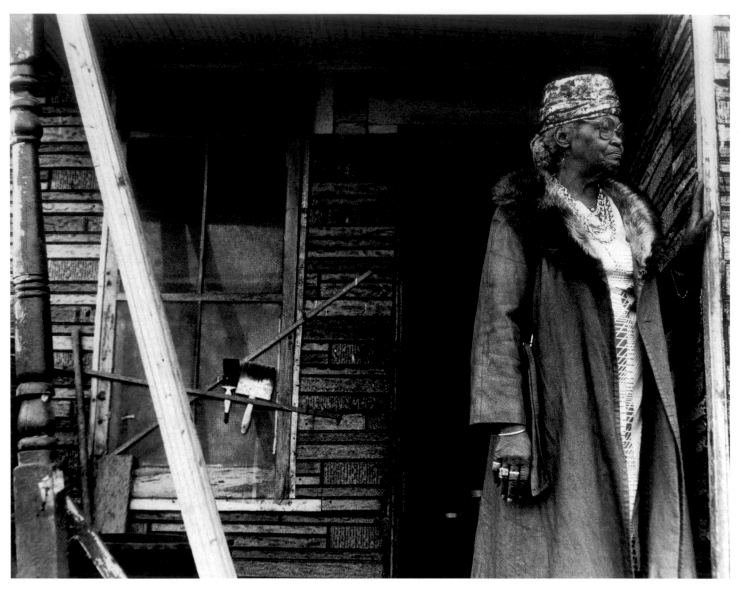

Cheryl Miller (b. 1953). *Thelma Jones*, 1988. Gelatin silver print, 11 x 14 in. (27.9 x 35.6 cm). Lent by the artist.

I work to honor who we are and the foundation of strength built for us by our ancestors. My work celebrates the African rites and rituals they passed on to us and their presence in our everyday lives in urban America. I hope that identifying traditions that speak to our African spirit will continue to substantiate / reaffirm the richness of our culture.—C.M.

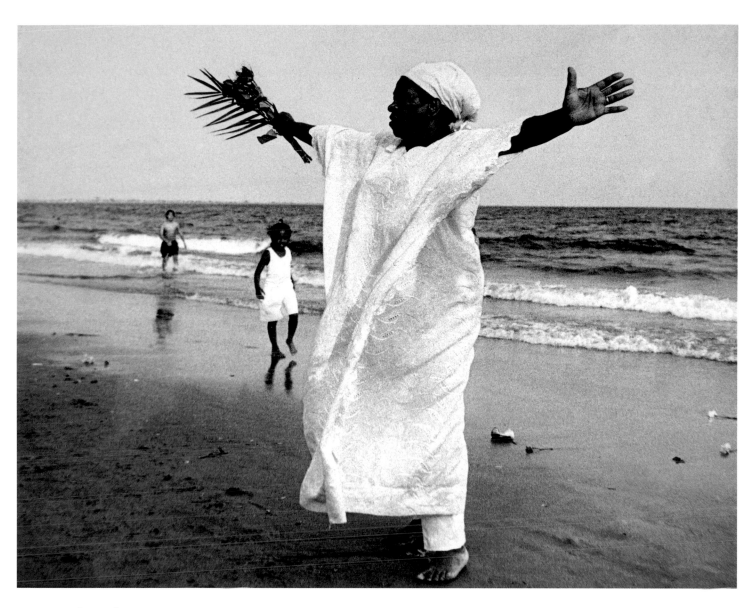

Cheryl Miller (b. 1953). *Tribute to the Ancestors of the Middle Passage—"Juneteenth,"* 1995. Gelatin silver print, 11 x 14 in. (27.9 x 35.6 cm). Lent by the artist.

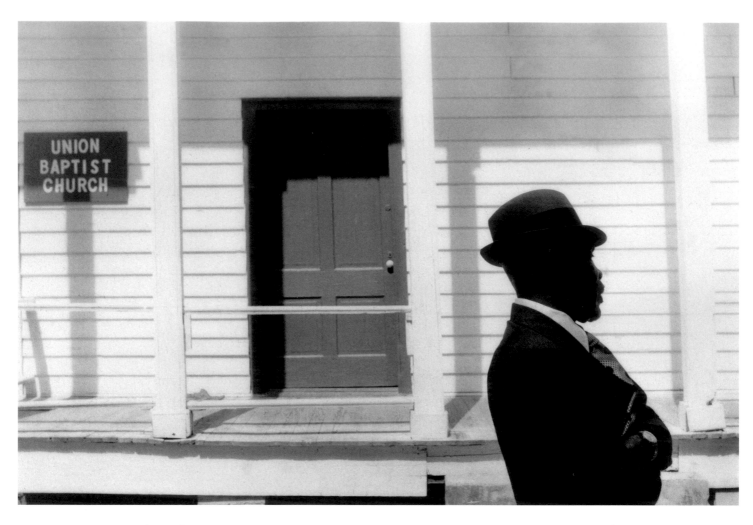

Jeanne Moutoussamy-Ashe (b. 1951). *Man in Front of Union Baptist Church*, 1977. Black-and-white fiber-based print, 11 x 14 in. (27.9 x 35.6 cm). Lent by the artist.

There is nothing more mysterious than a well-defined fact. The camera, as no other artistic tool, can convey one as truthfully as possible. Whether we choose to accept that fact—the photograph—or not is an individual choice. . . . Photography should force us to question ourselves and to question the environment in which we live.
—Excerpt from *Viewfinders: Black Women Photographers* by Jeanne Moutoussamy-Ashe (New York: Dodd, Mead & Company, 1986), p. xvii

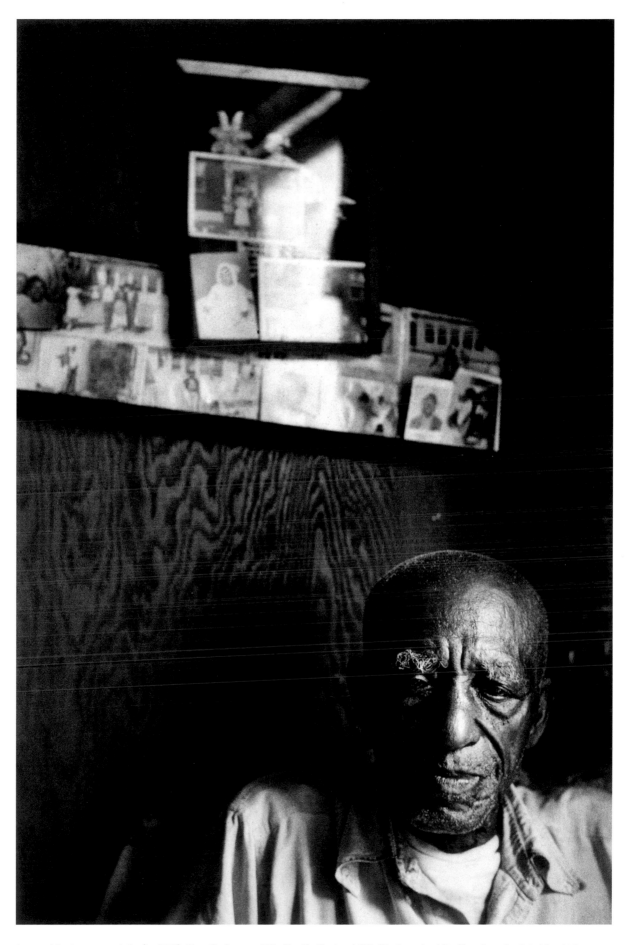

Jeanne Moutoussamy-Ashe (b. 1951). *Sam Gadsen and His Family Photos*, 1977. Black-and-white fiber-based print, 14 x 11 in. (35.6 x 27.9 cm). Lent by the artist.

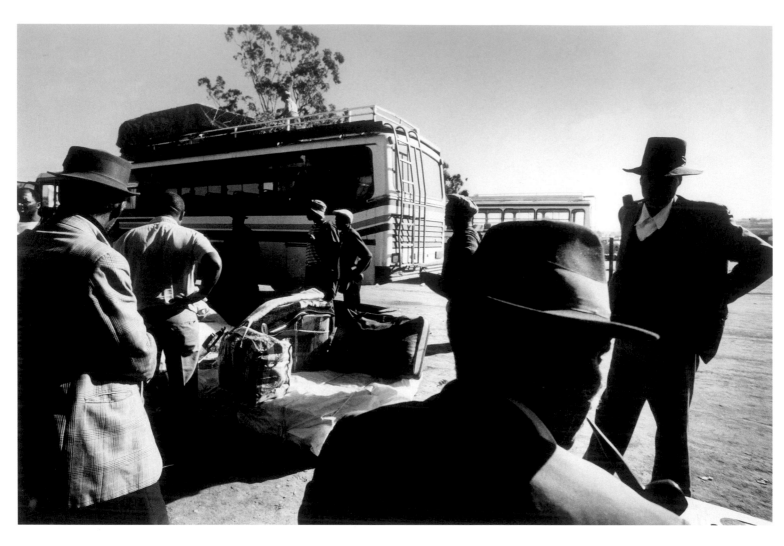

Ozier Muhammad (b. 1950). *Men Smoking at Bus Stop*, 1989. Gelatin silver print, 16 x 20 in. (40.6 x 50.8 cm). Lent by the artist.

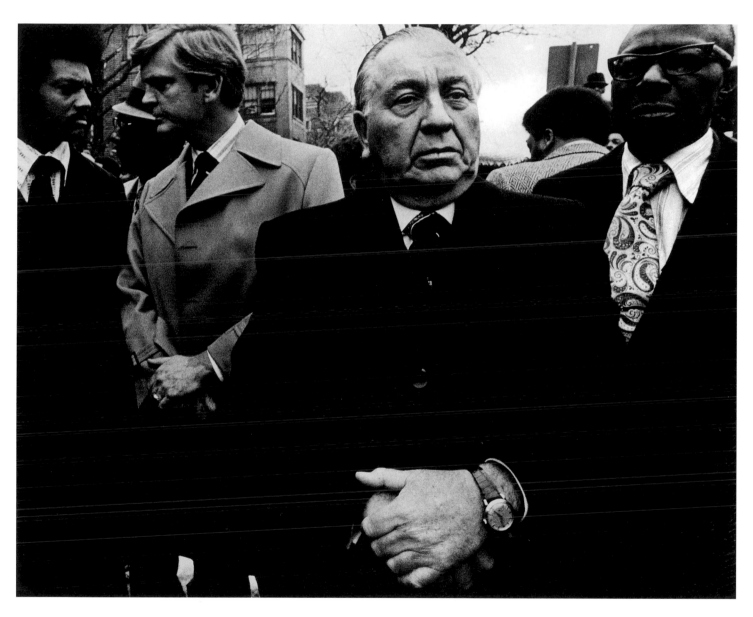

Ozier Muhammad (b. 1950). *Mayor Richard Daley and His Enemies*, 1971. Laser print, 16 x 20 in. (40.6 x 50.8 cm). Lent by the artist.

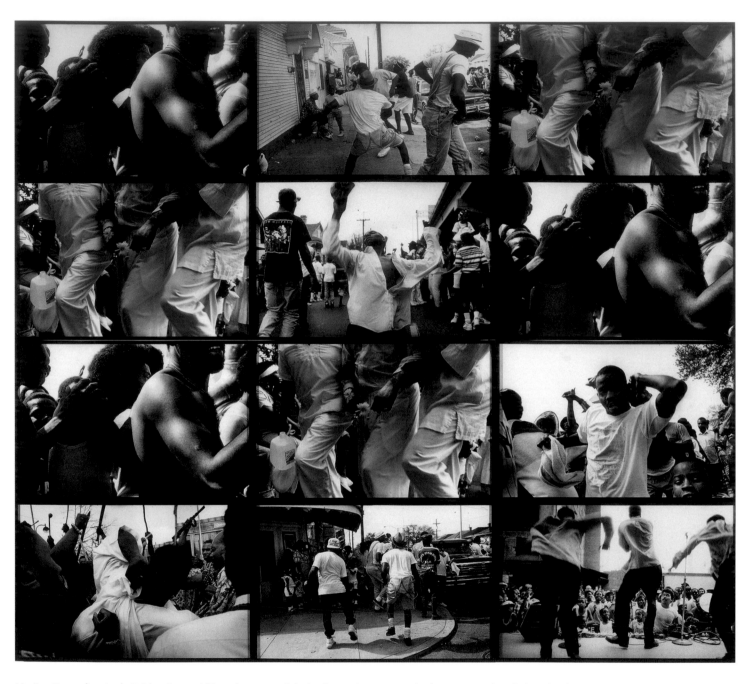

Marilyn Nance (b. 1953). *Celebration and Mourning*, 1994. Gelatin silver prints, 25 x 37 in. (63.5 x 94 cm) each. Lent by the artist.

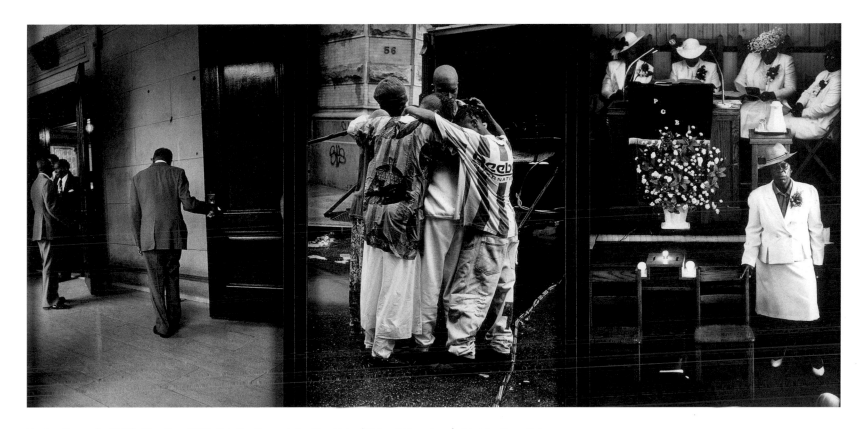

Marilyn Nance (b. 1953). *Standing*, 1997. Gelatin silver prints, 14 x 11 in. (35.6 x 27.9 cm) each. Lent by the artist.

When photographing, I am dancing
and mourning with "my subjects."
I photograph out of a need to
commune with others.—M.N.

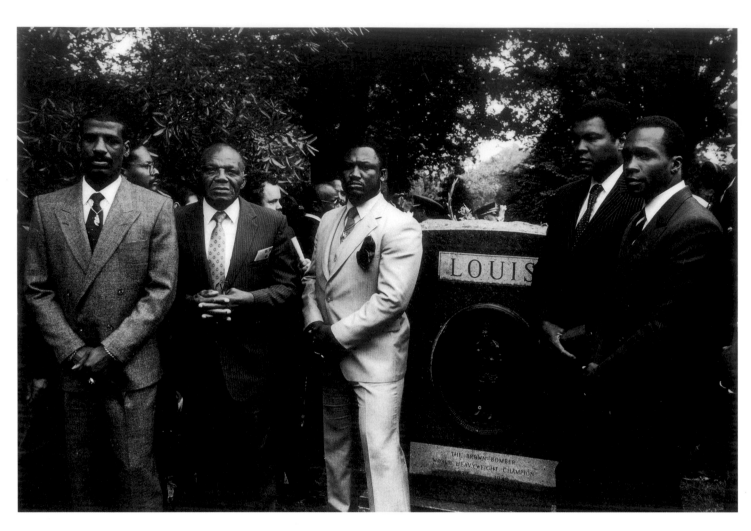

Oggi Ogburn (b. 1942). *World Champions* (Joe Louis's Grave in Arlington National Cemetery: Michael Spinks, Jersey Joe Walcott, Smokin' Joe Frazier, Muhammad Ali, Sugar Ray Leonard), 1986. Gelatin silver print, 16 x 20 in. (40.6 x 50.8 cm). Lent by the artist.

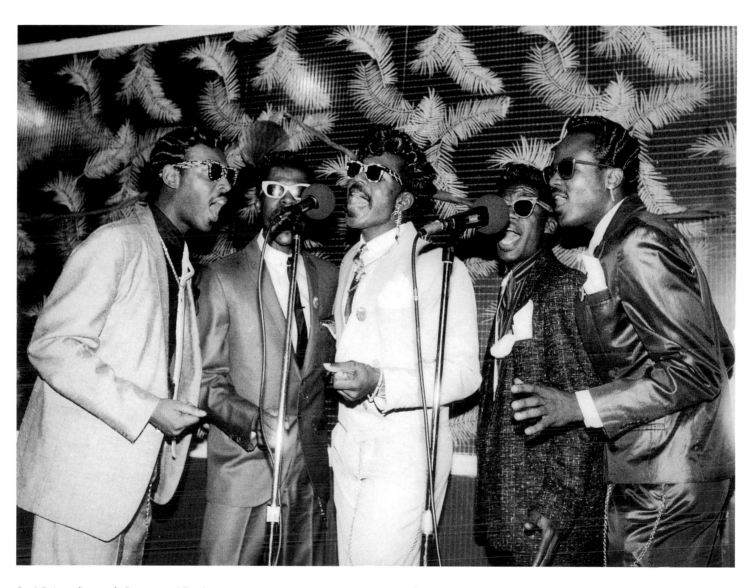

Oggi Ogburn (b. 1942). *Process and The Doorags*, 1985. Gelatin silver print, 16 x 20 in. (40.6 x 50.8 cm). Lent by the artist.

To be a freelance photographer is the greatest job in the world. As I am working mainly for my friends, every day is like a holiday. My goal is to preserve music history through traditional photography. Jazz is not played on the radio as much as it once was, and many of the artists are becoming forgotten. Similarly, the old methods of developing film and printing pictures are slowly becoming a lost art form.—O.O.

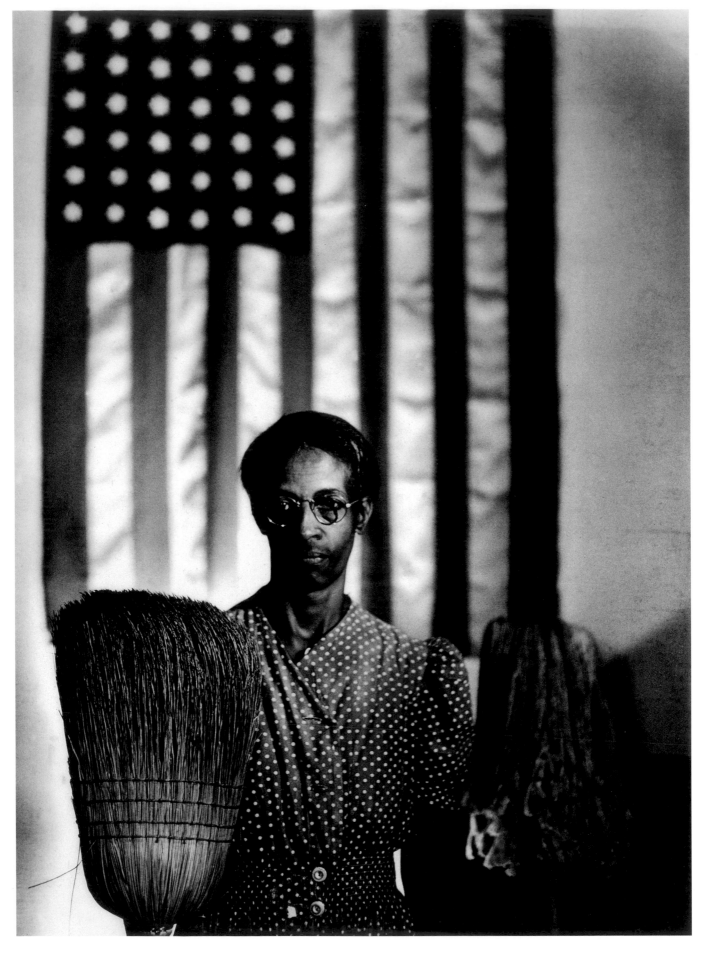

Gordon Parks (b. 1912). *American Gothic*, 1942. Gelatin silver print, 20 x 16 in. (50.8 x 40.6 cm). Lent by the artist.

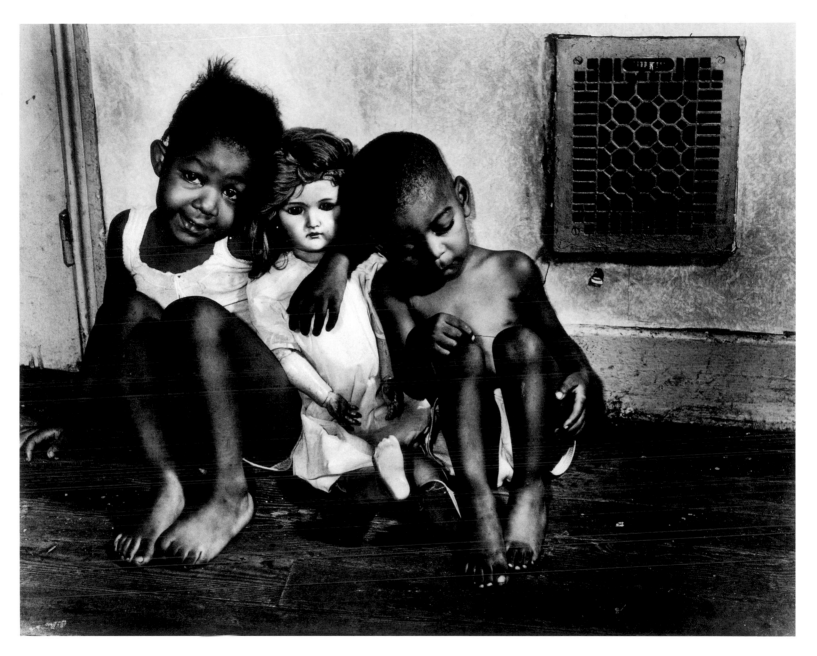

Gordon Parks (b. 1912). *Children with Doll*, 1942. Gelatin silver print, 16 x 20 in. (40.6 x 50.8 cm). Lent by the artist.

My experience—though I would never wish it upon anyone else—has helped make me whatever I am and still hope to be. . . . I have come to understand that hunger, hatred, and love are the same wherever you find them, and it is that understanding that now helps me escape the past that once imprisoned me.—G.P.

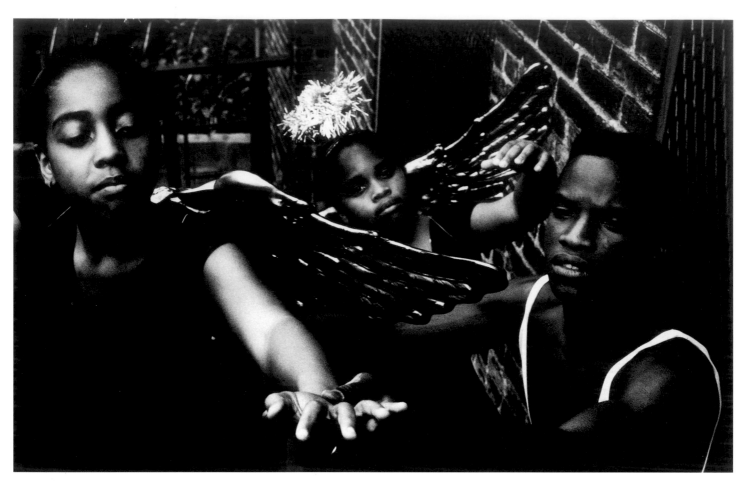

Toni Parks (b. 1940). *Dance Theatre of Harlem Students with Teacher*, 1990. Gelatin silver print, 16 x 20 in. (40.6 x 50.8 cm). Lent by the artist.

My father, Gordon Parks, flooded my life with music, literature, photography,
and painting. So there are many images, feelings, and thoughts stored
within me. I find that I release this knowledge through my photographs.
We are what we feed the brain, and one of my father's sayings I have
heard many times is, "Always be prepared for your luck."—T.P.

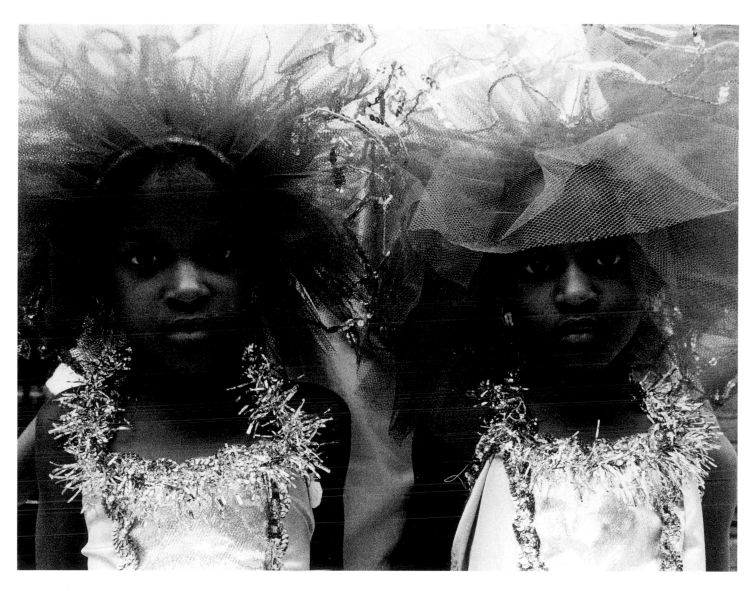

Toni Parks (b. 1940). *Twins*, 1988. Gelatin silver print, 16 x 20 in. (40.6 x 50.8 cm). Lent by the artist.

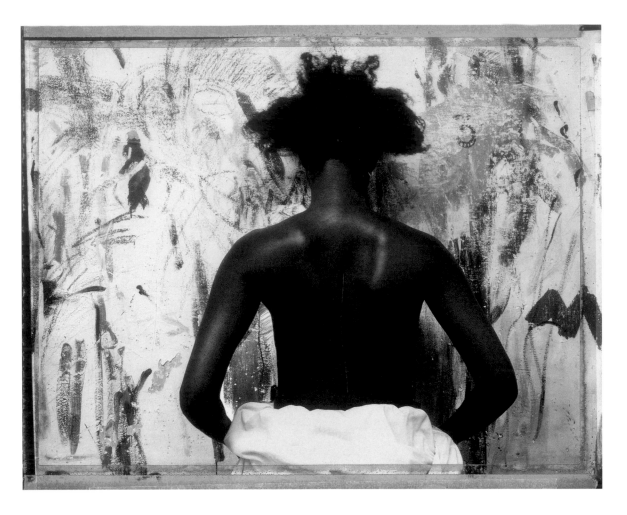

John Pinderhughes (b. 1946). *Untitled*, 1998, from the Pretty for a Black
Girl series (four images total). Iris print on Somerset velvet, 11⁷⁄₈ x 28 in.
(30.2 x 71.1 cm). Lent by the artist.

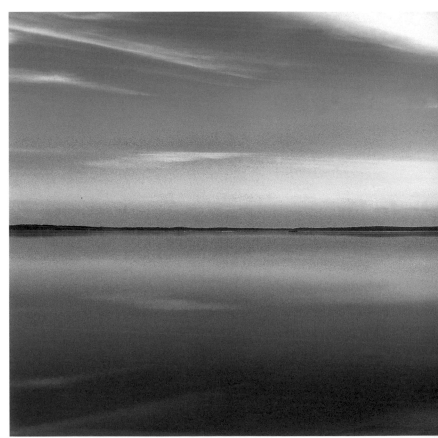

I tend to work in series. Sometimes the relationship within a group is straightforward. The works are usually connected by time and place, and by the distinct quality of the light. I also like to work with images that are related in a more oblique way, such as scenes with a suggested narrative.—J.P.

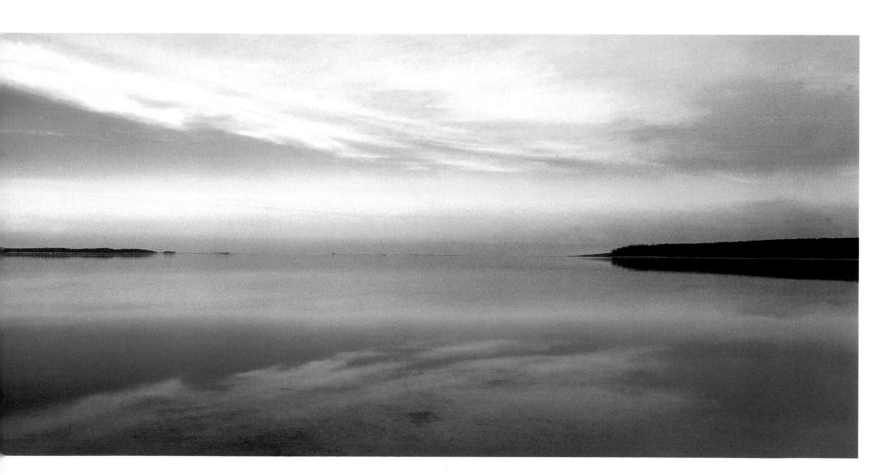

John Pinderhughes (b. 1946). *Untitled*, 1998, from the Majestic Vistas series. Iris print on Somerset velvet, 19 x 21 5/8 in. (48.3 x 54.9 cm). Lent by the artist.

Since 1996, I have photographed gay communities in the cities I travel through. I have discovered that certain objects, gestures, and landscapes exist in a surreal, twilight world of double meaning. My latest photographs explore these junctures of the mainstream and the spheres of Black queerness.—C.P., Jr.

Carl Pope, Jr. (b. 1961). *Untitled*, 1999. C-print, 42 x 20 in. (105.7 x 50.8 cm). Lent by the artist.

Carl Pope, Jr. (b. 1961). *Divine*, 1998. C-print, 20 x 38 in. (50.8 x 96.5 cm). Lent by the artist.

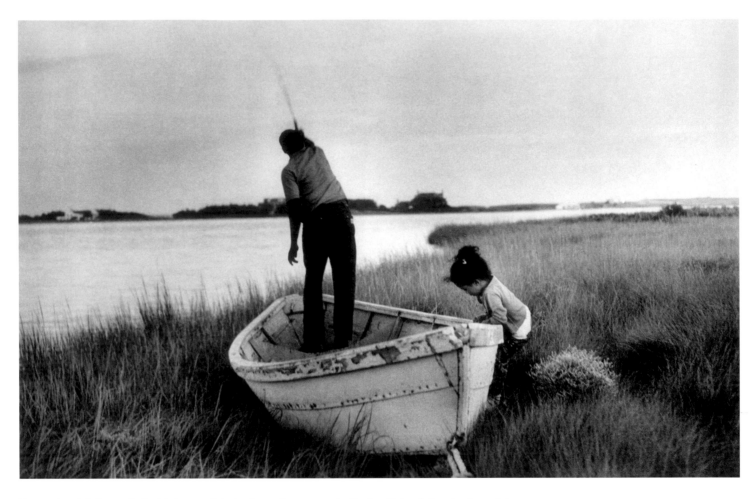

Herbert Randall (b. 1936). *Untitled*, 1964. Gelatin silver print, 11 x 14 in. (27.9 x 35.6 cm). Lent by the artist.

I am sometimes asked to describe my work. This is asking me to put into words something I conveyed best through photography—my hopes, limitations, fantasies, and ideas. My work expresses who I am and how I view the world.—H.R.

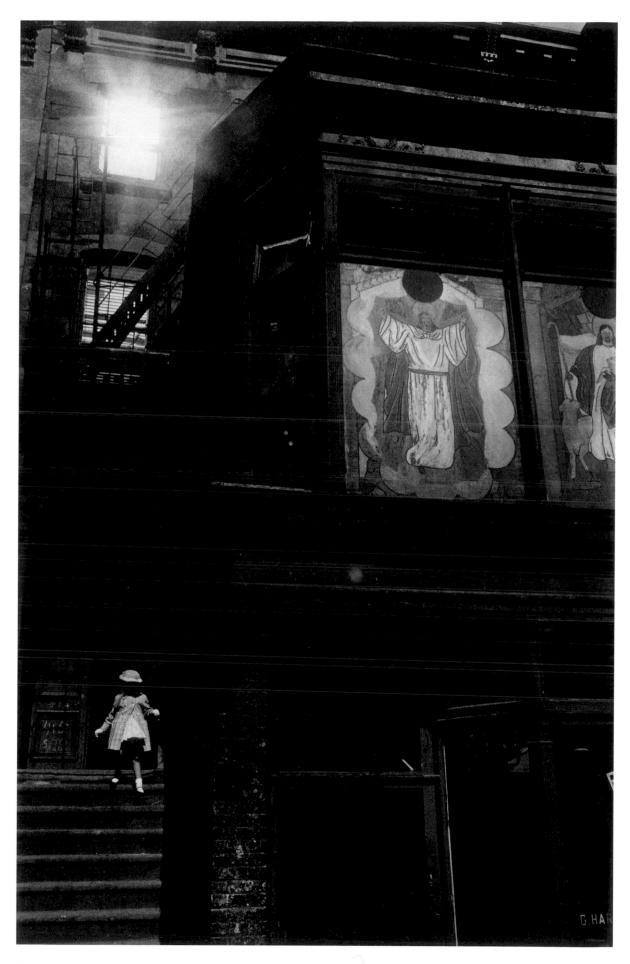

Herbert Randall (b. 1936). *Untitled*, 1963. Gelatin silver print, 14 x 11 in. (35.6 x 27.9 cm). Lent by the artist.

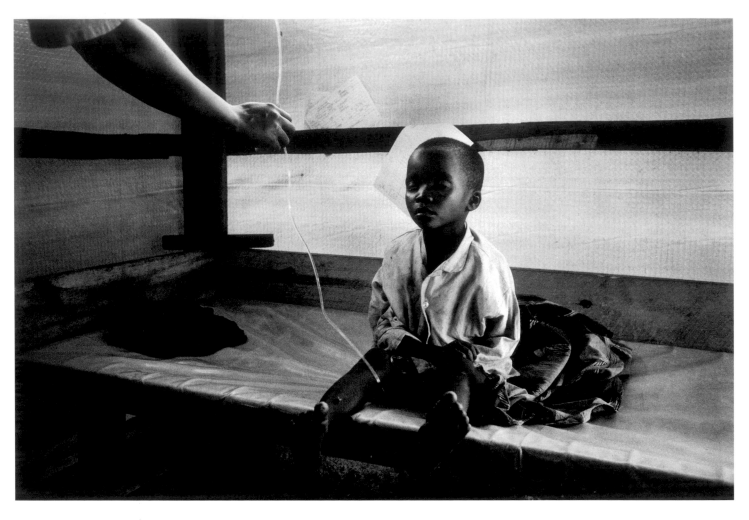

Eli Reed (b. 1946). *Cholera Dorm, Benaco Refugee Camp in Tanzania*, 1995. Gelatin silver print, 16 x 20 in. (40.6 x 50.8 cm). Lent by the artist.

The camera goes first to the head and then hopefully the heart. It tells the truth of the matter with compassion, showing warts and all. Raising issues of right and wrong is almost a necessary by-product of photography. The "art" develops when you allow the photograph to take the artist.—E.R.

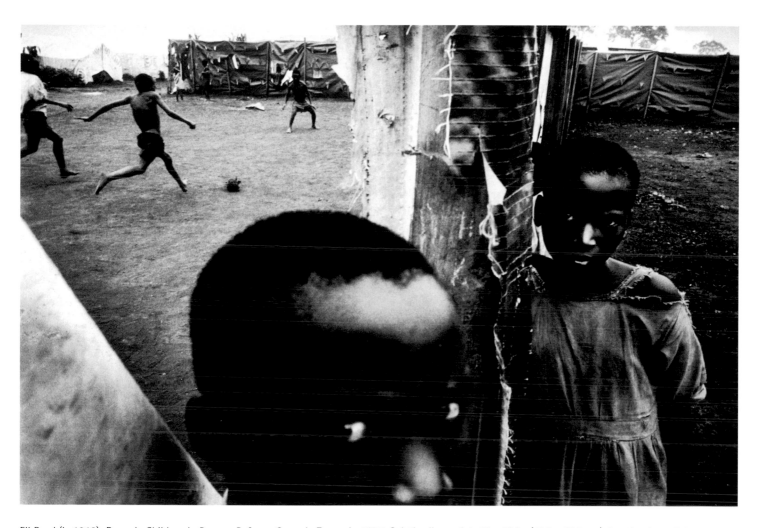

Eli Reed (b. 1946). *Rwanda Children in Benaco Refugee Camp in Tanzania*, 1995. Gelatin silver print, 16 x 20 in. (40.6 x 50.8 cm). Lent by the artist.

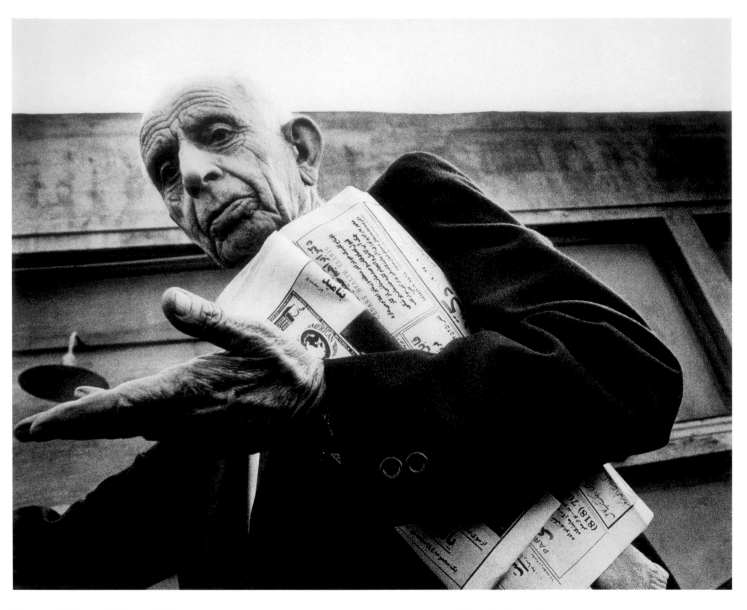

Vernon Reid (b. 1958). *Man with Newspaper*, 1990. Gelatin silver print, 16 x 20 in. (40.6 x 50.8 cm). Lent by the artist.

While in L.A., I pulled my convertible over to get my bearings, and saw the melancholic gentleman portrayed in *Man with Newspaper*; I grabbed my Canon and took one shot. I photographed *Two Figures with Gold Bar* when I was wandering about Paris and happened on an antique-shop window with a curious arrangement. Such luck still puzzles me.—V.R.

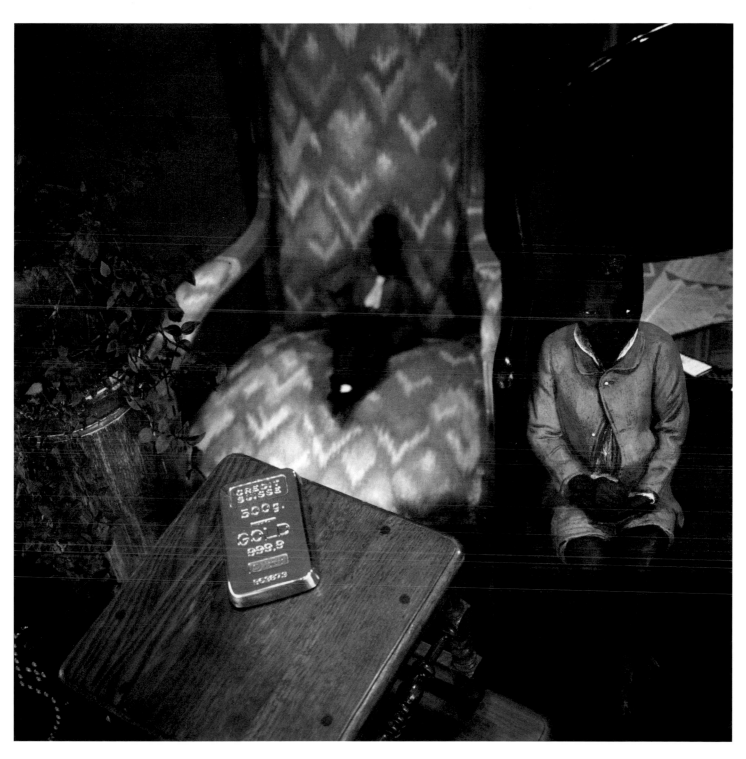

Vernon Reid (b. 1958). *Two Figures with Gold Bar*, 1993. Ektachrome print, 16 x 20 in. (40.6 x 50.8 cm). Lent by the artist.

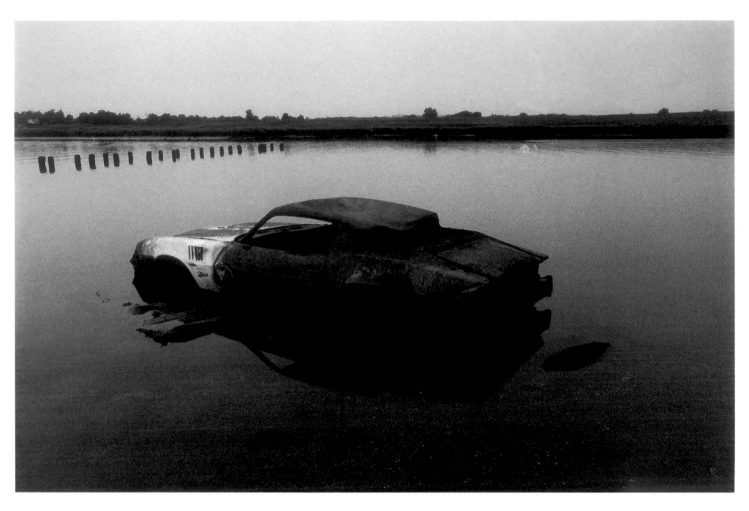

Orville Robertson (b. 1957). *Abandoned Car, Marine Park, Brooklyn*, 1987/2000. Gelatin silver print, 16 x 20 in. (40.6 x 50.8 cm). Lent by the artist.

My images have been shaped by my street-photography aesthetic. This involves balancing a child's curiosity and informality with an adult's need for structure and purpose. Passersby in their self-contained worlds create dynamic relationships, giving the streets a wonderful energy.—O.R.

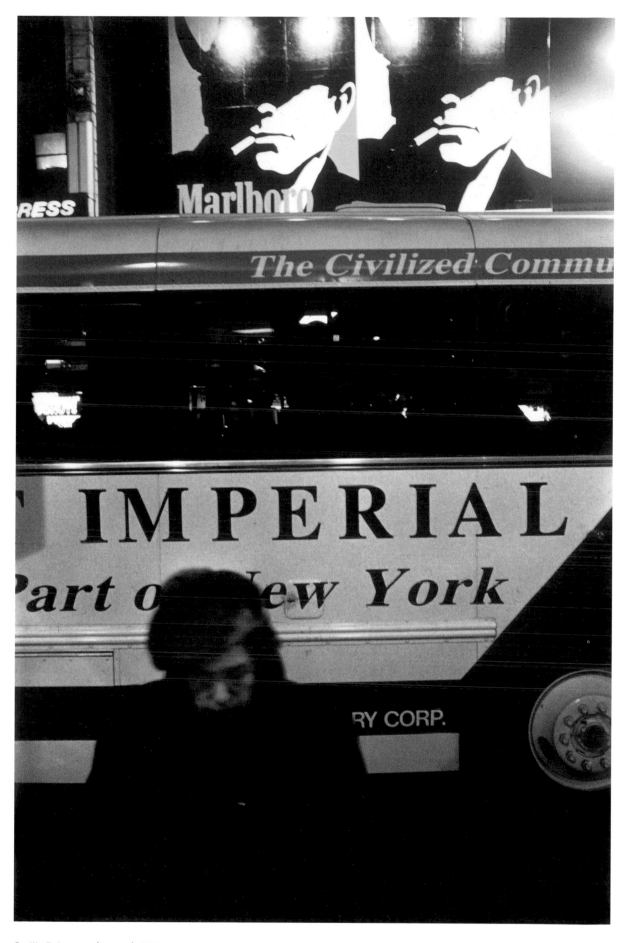

Orville Robertson (b. 1957). *Woman in Front of Macy's, Manhattan*, 1992/2000. Gelatin silver print, 20 x 16 in. (50.8 x 40.6 cm).
Lent by the artist.

Herb Robinson (b. 1942). *Etude No. 1*, 1992. Digital C-print, 20 x 16 in. (50.8 x 40.6 cm). Lent by the artist.

Herb Robinson (b. 1942). *Etude No. 3*, 1992. Digital C-print, 16 x 20 in. (40.6 x 50.8 cm). Lent by the artist.

My photographs are the products of my most meditative moments. They reflect my need to have a voice, to share visions that I cannot explain. I have been deeply influenced by still-life painters such as Jean-Baptiste-Siméon Chardin and photographic masters such as Roy DeCarava and W. Eugene Smith.—H.R.

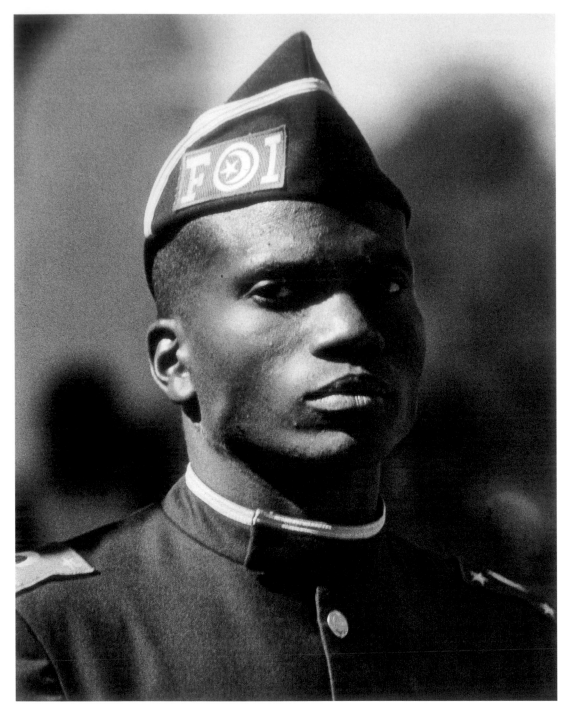

Richard Howard Rose (b. 1973). *Intense Moment*, 1995. Iris print, 25 1/4 x 20 1/8 in. (64.1 x 51.1 cm). Lent by the artist.

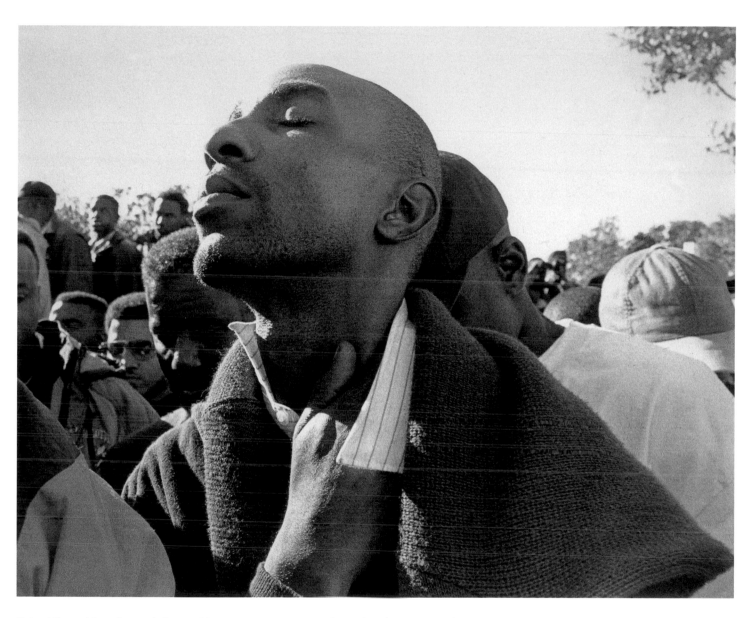

Richard Howard Rose (b. 1973). *Prayers Moment*, 1995. Iris print, 20 1/8 x 25 1/4 in. (51.1 x 64.1 cm). Lent by the artist.

The Million Man March in Washington, D.C., in October of 1995 was an opportunity to elevate and exchange energy. It was a celebration of the strong Black man and a moment of unifying to free the spirit. When I'm photographing, imagining certain music helps me see better. In *Prayers Moment*, I see "A Love Supreme" by John Coltrane.—R.H.R.

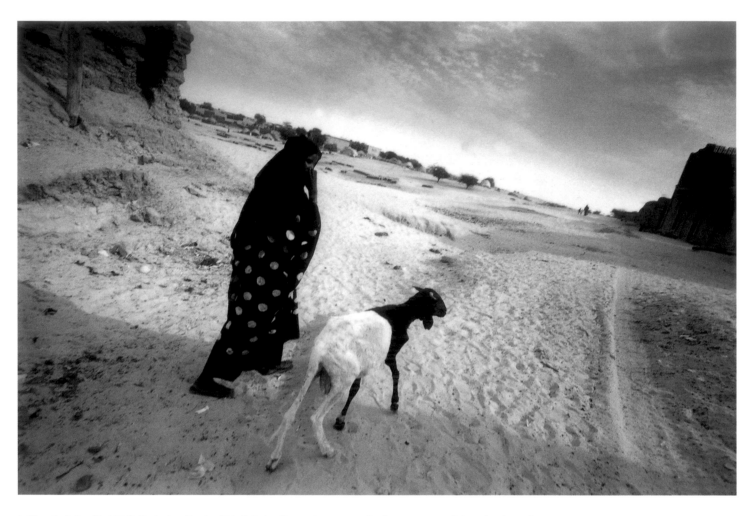

Jeffery A. Salter (b. 1961). *Timbuktu No. 2*, 1998. Gelatin silver print, 16 x 20 in. (40.6 x 50.8 cm). Lent by the artist.

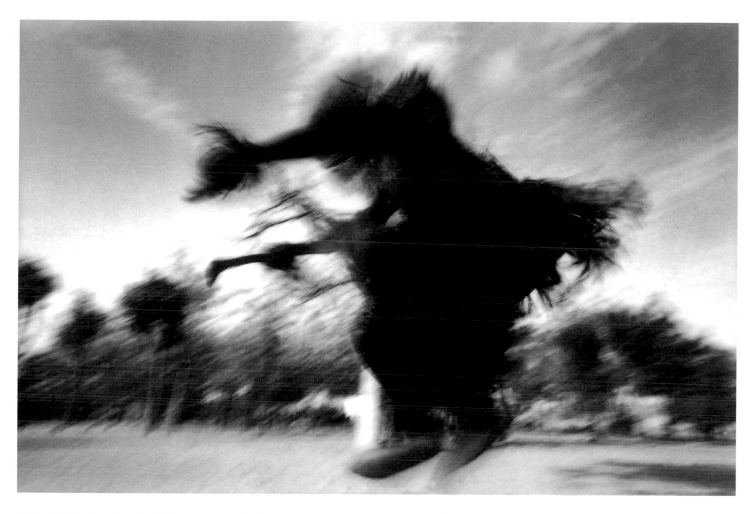

Jeffery A. Salter (b. 1961). *Spirit Dancer*, 1998. Gelatin silver print, 16 x 20 in. (40.6 x 50.8 cm). Lent by the artist.

My two pictures are selected from a travelogue on Timbuktu. As seen here, I photograph only people. I capture the beautiful unseen moments of life by clicking when others blink. My influences—aside from the sky or the fresh air or the way a woman smiles at me—are the Dutch painter Jan Vermeer, the photographer Anthony Barboza, and the poet Langston Hughes.—J.A.S.

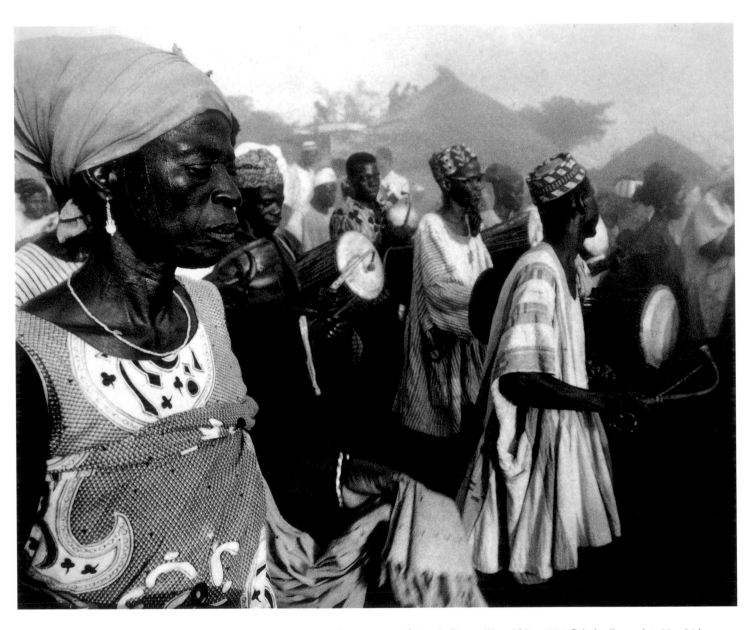

Dr. Juma Santos (b. 1947). *Enskinment, or Inauguration, of a "Ya Na" (Dagomba Chief), Yendi, Ghana, West Africa*, 1974. Gelatin silver print, 20 x 24 in. (50.8 x 61 cm). Lent by the artist.

I use the camera like a drum or a paintbrush, as a tool to express moods and energy, and to create compositions of space and rhythm. My objectives are to investigate, interpret, and document the many aesthetic expressions of the African Diaspora.—J.S.

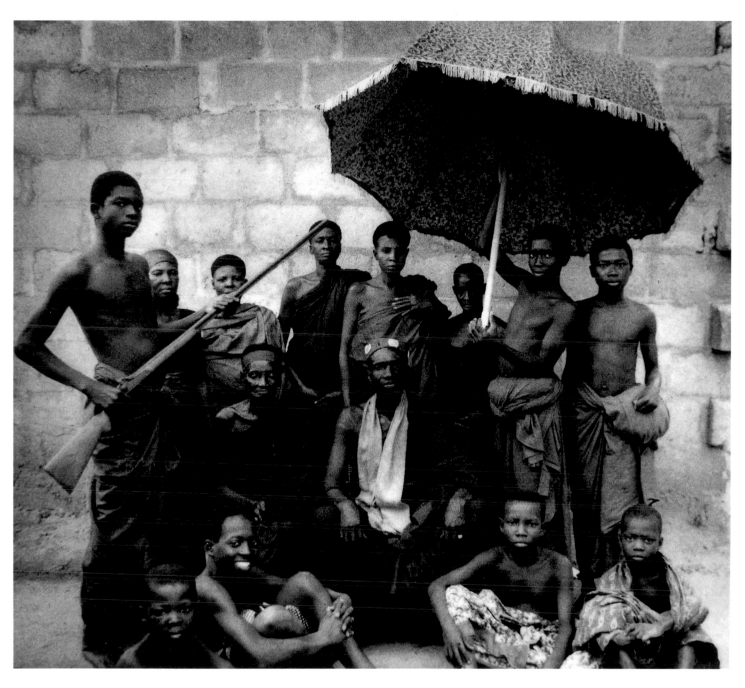

Dr. Juma Santos (b. 1947). *The Funeral of an Ashanti Paramount Chief, Kumau, Ghana, West Africa*, 1974. Gelatin silver print, 20 x 24 in. (50.8 x 61 cm). Lent by the artist.

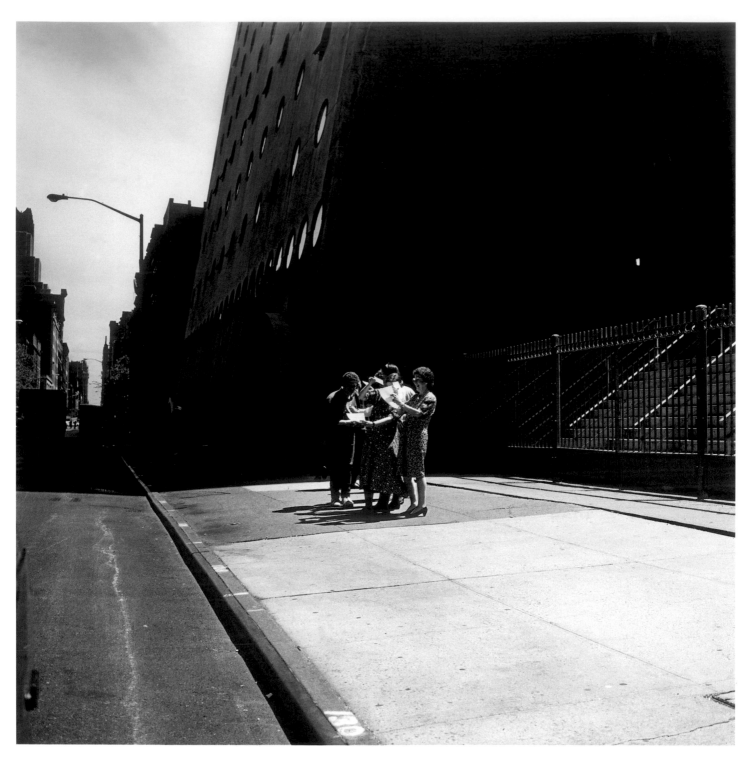

Jeffrey Henson Scales (b. 1954). *West 17th Street, NYC*, 1993. C-print, 30 x 39 ¹/₂ in. (76.2 x 100.3 cm). Lent by the artist.

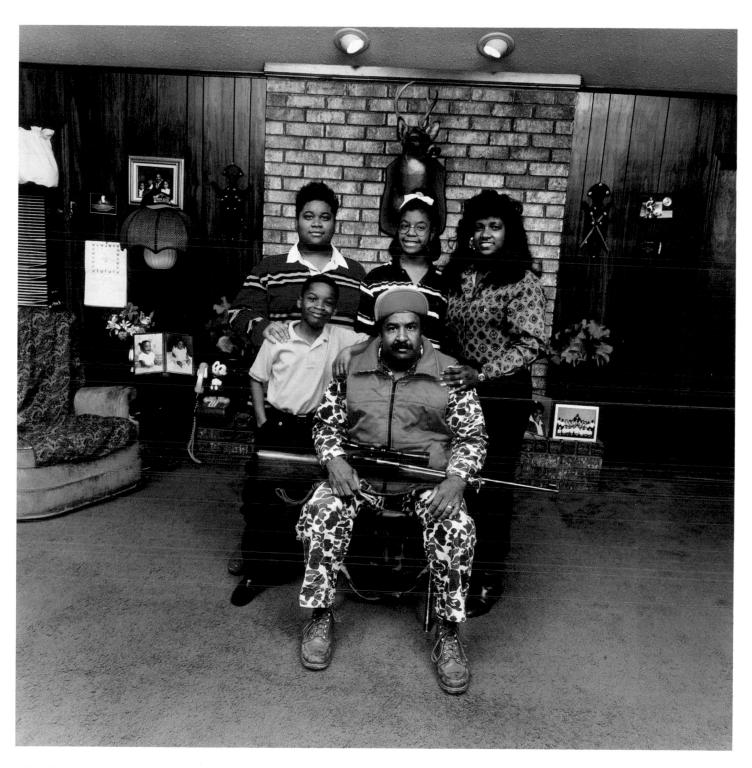

Jeffrey Henson Scales (b. 1954). *American Gothic*, 1993. C-print, 30 x 39³/₈ in. (76.2 x 100 cm). Lent by the artist.

Making a photograph is like pointing at something and defining it as clearly as I can. My subjects are often unexpected, or difficult to explain. While a photograph describes the subject formally, the content always remains just a little bit ambiguous.—J.H.S.

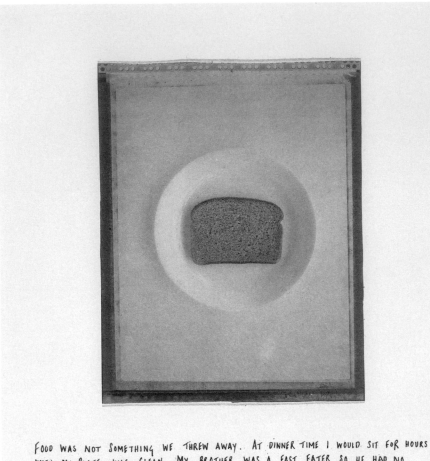

FOOD WAS NOT SOMETHING WE THREW AWAY. AT DINNER TIME I WOULD SIT FOR HOURS UNTIL MY PLATE WAS CLEAN. MY BROTHER WAS A FAST EATER SO HE HAD NO PROBLEMS. "BRANOLA" WHEAT BREAD WAS THE ONLY TYPE OF BREAD WE ATE. ONCE I MADE SOME TOAST, TOOK A COUPLE OF BITES AND THREW IT AWAY. MY FATHER CAME HOME AND A COUPLE OF MINUTES LATER HE CALLED ME INTO THE KITCHEN. HE PULLED THE BREAD OUT OF THE TRASH GAVE IT TO ME AND SAID, "EAT".

BREAD

Keisha Scarville (b. 1975). *I Grew Up . . . Bread*, 1997. Van Dyke brown on watercolor paper, 14 x 11 in. (35.6 x 27.9 cm). Lent by the artist.

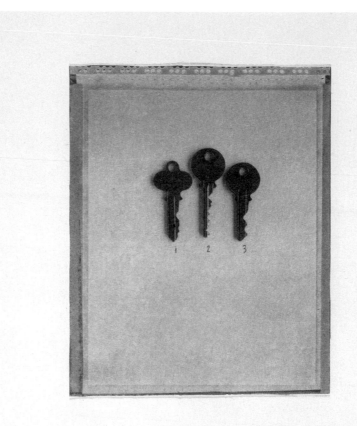

WHEN I GOT MY FIRST SET OF KEYS I FELT FREE I THOUGHT I COULD LEAVE THE HOUSE WHENEVER I WANTED (WHICH WASN'T TRUE). THE FIRST TIME I USED THEM I COULDN'T FIGURE OUT WHICH KEY WENT TO WHAT DOOR. EVEN THOUGH I HAD KEYS, I DIDN'T KNOW HOW TO GET IN. LATER MY DAD TAPED NUMBERS TO MY KEYS. EACH NUMBER REPRESENTED A DOOR.

KEYS

Keisha Scarville (b. 1975). *I Grew Up . . . Keys*, 1997. Van Dyke brown on watercolor paper, 14 x 11 in. (35.6 x 27.9 cm). Lent by the artist.

The purpose of my work is to reveal the simple beauty within people and the objects around them. With my portraits, I bring to the surface an instance of peace in a person— a moment of introspection for both viewer and subject. With my still lifes, I challenge the viewer to reflect on memories.—K.S.

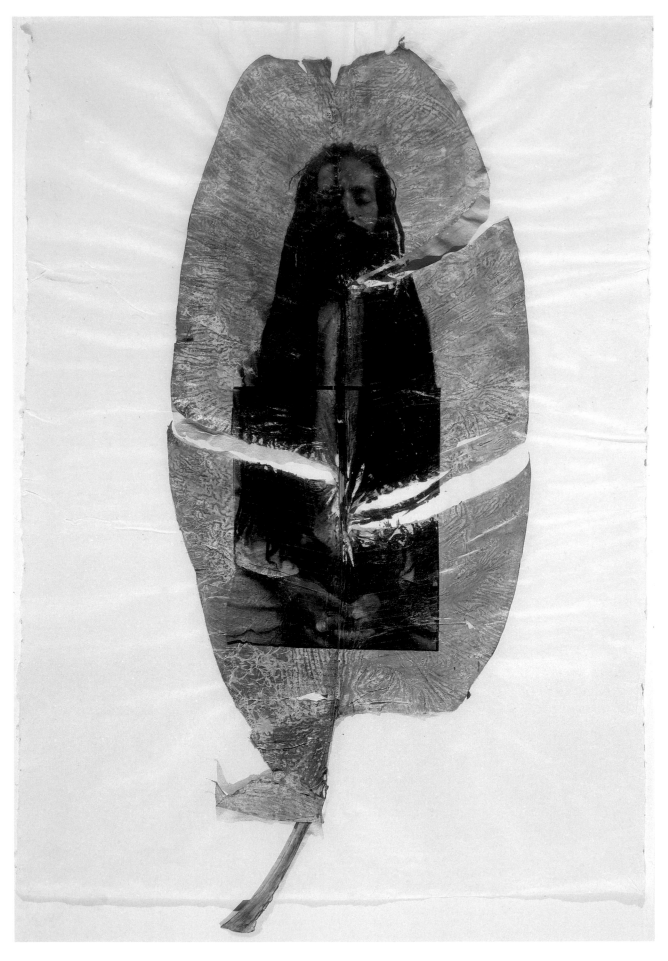

Accra Shepp (b. 1962). *Eric (Version III)*, 1993. Gelatin silver emulsion on leaf paper, 34 x 24 $\frac{1}{2}$ in. (86.4 x 62.3 cm). Lent by the artist.

As I gather leaves, I gather the faces and hands and arms of people— equally unique and miraculous. The human image is then fitted to a specific leaf. The result brings together the separate histories of the natural object and the figure. The fragile and transitory leaf becomes the token through which we view ourselves and our relationship with nature.– A.S.

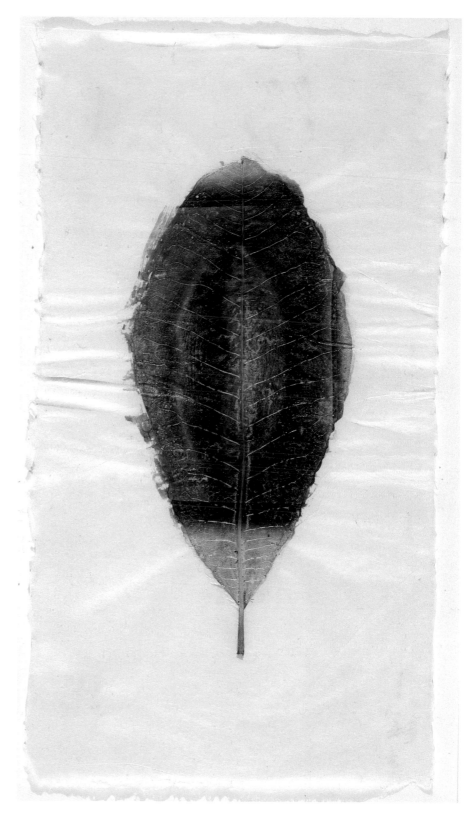

Accra Shepp (b. 1962). *Untitled*, 1992. Gelatin silver emulsion on leaf paper, 12 x 6$\frac{1}{2}$ in. (30.5 x 16.5 cm). Lent by the artist.

My work is an exploration of self-adornment, self-presentation, and identity. I believe that individuals empower themselves through adornment when they are limited by society in many other ways. Such ornamentation can also result in a person always presenting a mask to the world, never revealing his or her true identity.—C.S.

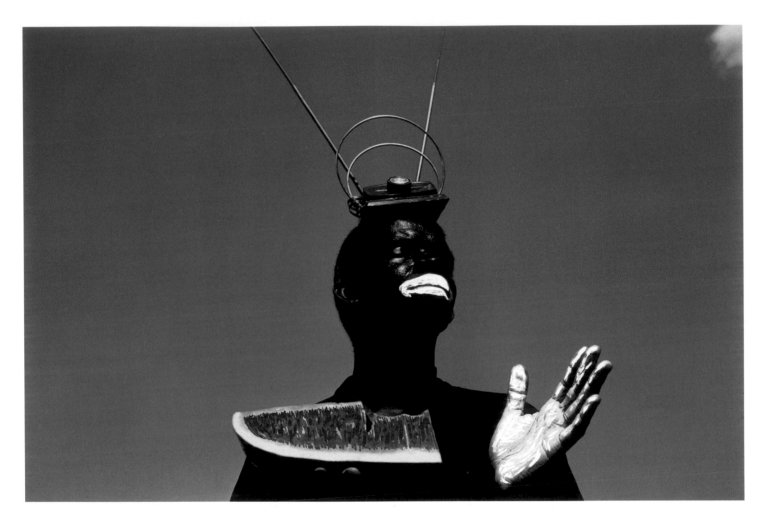

Coreen Simpson (b. 1942). *Untitled*, 1985, from the Sky Portrait series. Hand-painted C-print, 34 x 44 1/2 in. (86.4 x 113 cm). Lent by the artist.

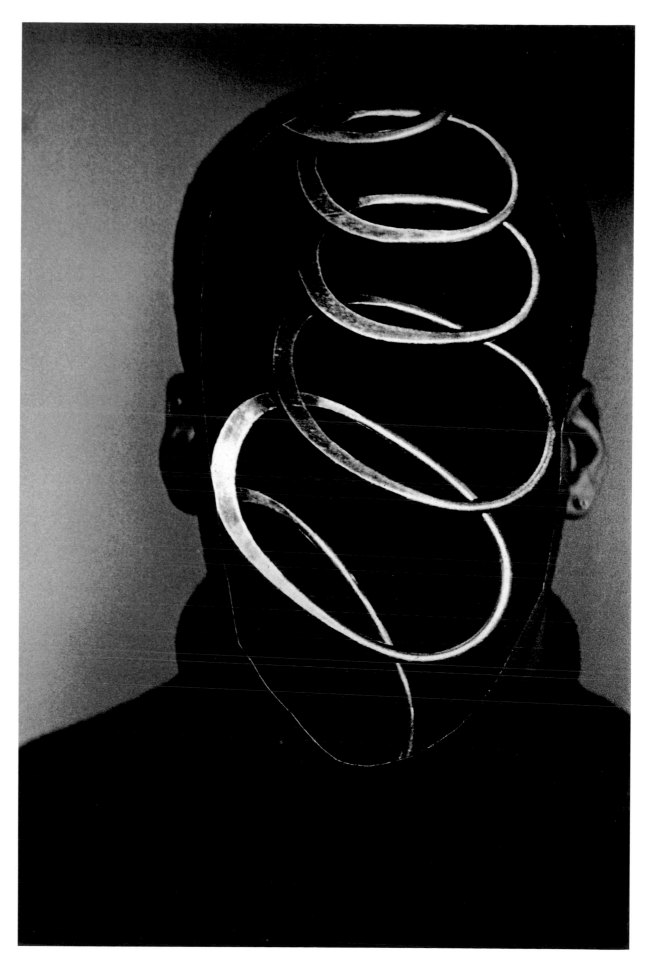

Coreen Simpson (b. 1942). *Untitled*, 1991, from the About Face series. Gelatin silver print, 34⁵/₈ x 24¹/₂ in. (87.9 x 62.2 cm). Lent by the artist.

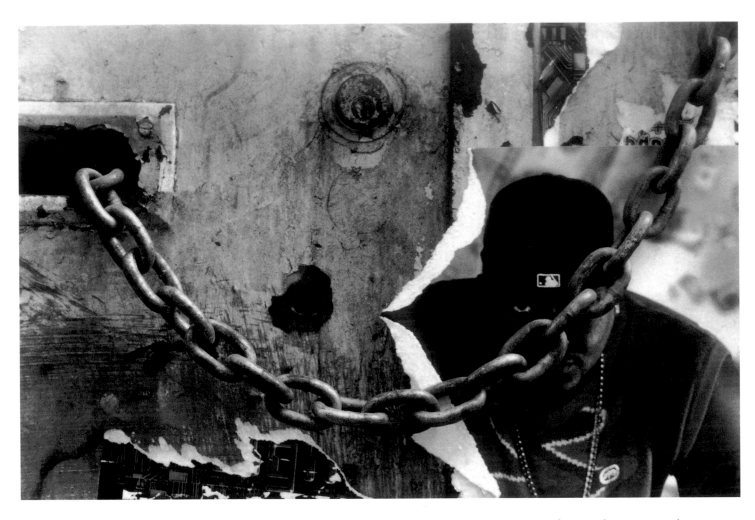

Beuford Smith (b. 1941). *From Jamestown to New York*, 1999, from the Hip-Hop Poster series. Gelatin silver print, 25 $\frac{1}{2}$ x 40 in. (64.8 x 101.6 cm).
Lent by the artist / Césaire.

I photograph images that reflect our daily encounters with each other, to heighten people's awareness of themselves. I capture these interactions as truthfully and humanely as possible, and try to have a sense of humor in my photographs.—B.S.

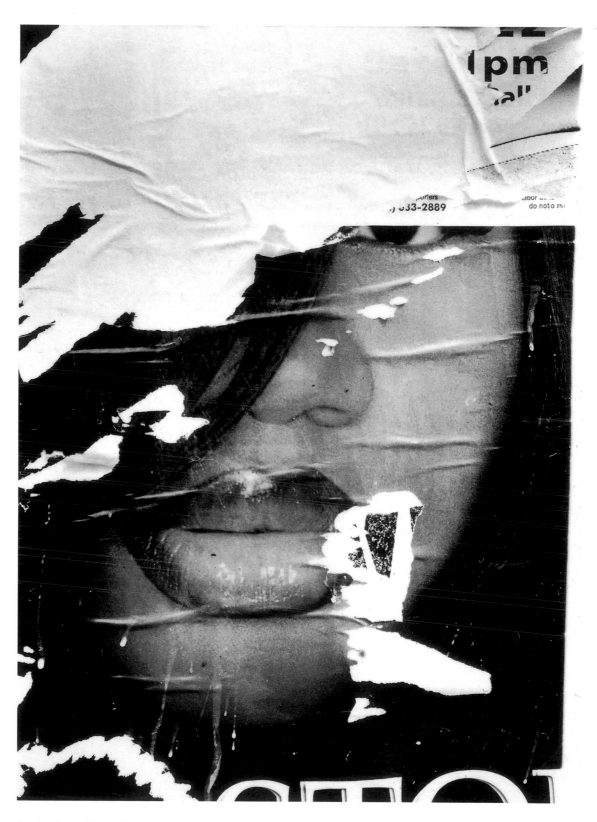

Beuford Smith (b. 1941). *Kelly-P*, 1999, from the Hip-Hop Poster series. Gelatin silver print, 40 x 28 ½ in. (101.6 x 72.4 cm). Lent by the artist / Césaire.

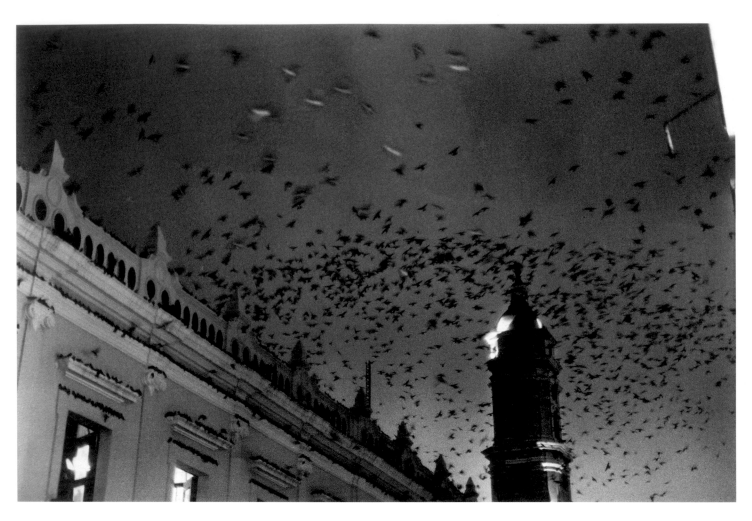

Jamyl Oboong Smith (b. 1954). *End of the Day*, 1986. Gelatin silver print, 20 x 24 in. (50.8 x 61 cm). Lent by the artist.

Both of my images are panoramic views that move through a series of moments due to their long exposures.

You see the same image in two or three different positions. For me the continuity of these soft images works.—J.O.S.

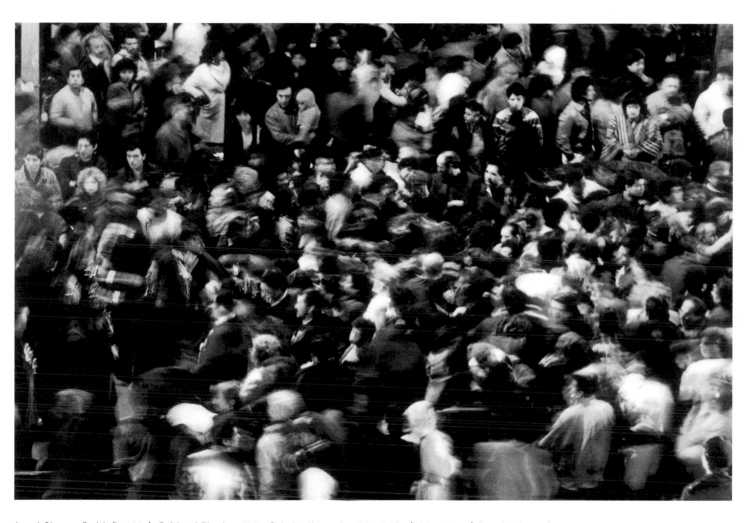

Jamyl Oboong Smith (b. 1954). *Spiritual Rhythm*, 1989. Gelatin silver print, 20 x 24 in. (50.8 x 61 cm). Lent by the artist.

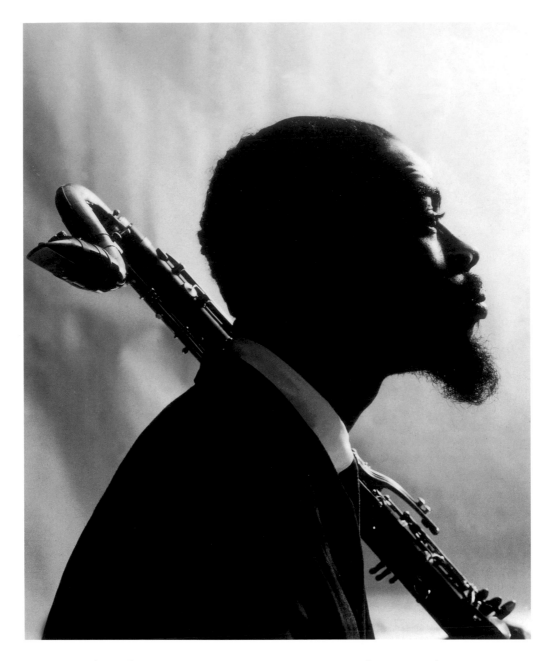

Chuck Stewart (b. 1927). *Eric Dolphy*, 1964. Gelatin silver print, 20 x 16 in. (50.8 x 40.6 cm). Lent by the artist.

I am best known for my work with jazz musicians. I try to make beautiful images of people who perform music I wish I could play.—C.S.

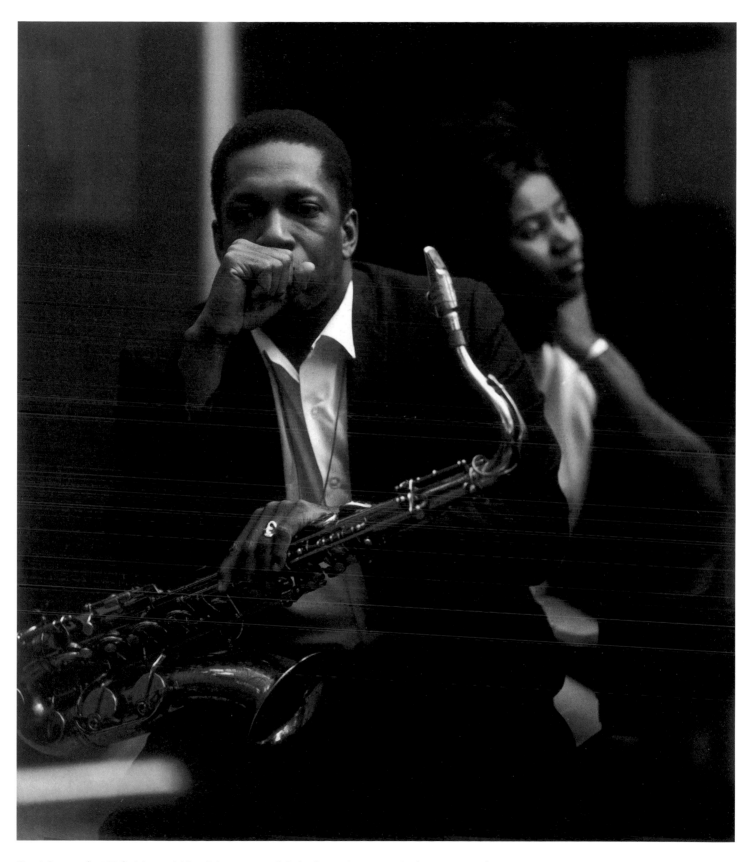

Chuck Stewart (b. 1927). *John and Alice Coltrane*, 1966. Gelatin silver print, 20 x 16 in. (50.8 x 40.6 cm). Lent by the artist.

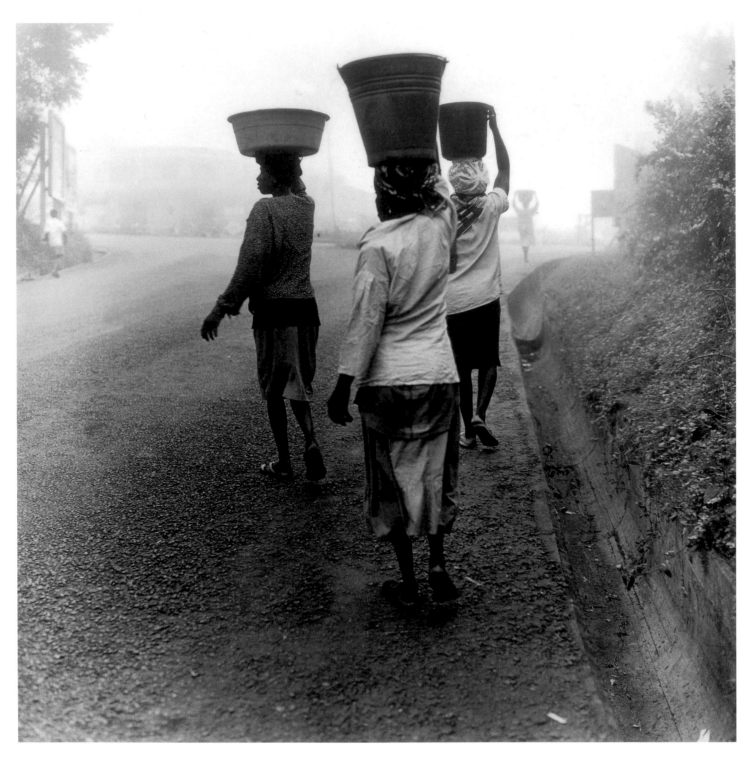

Frank Stewart (b. 1949). *Clock of the Earth, Ghana*, 1998. Gelatin silver print, 16 x 20 in. (40.6 x 50.8 cm). Lent by the artist.

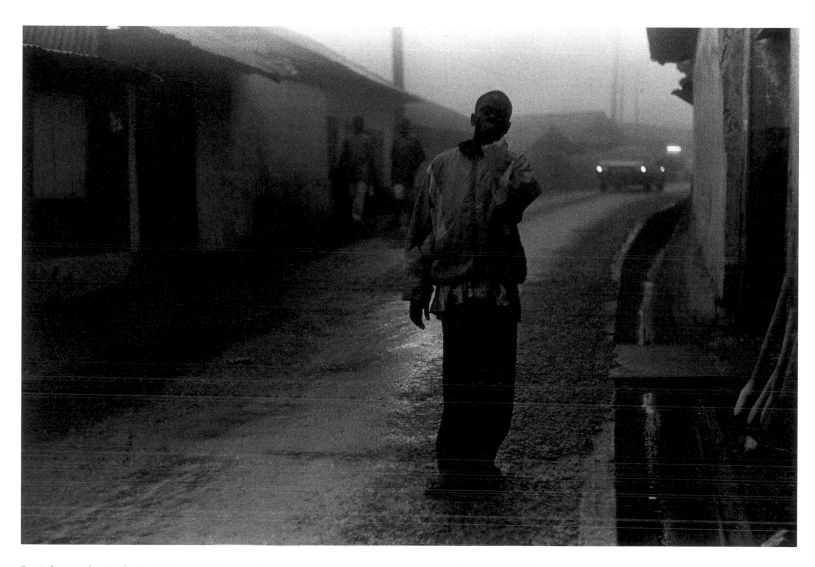

Frank Stewart (b. 1949). *Mamfe Street in Evening, Ghana*, 1998. Gelatin silver print, 16 x 20 in. (40.6 x 50.8 cm). Lent by the artist.

These two works are part of a much larger, ongoing piece called *The Clock of the Earth*, the goal of which is to find the similarities and differences between Africans and African Americans. I have recently taken photographs in Ghana, on the West Coast of Africa.—F.S.

Gerald Straw (b. 1943). *Untitled*, 1982. Black-and-white selenium print, 11 ³/₄ x 14 in. (29.8 x 35.6 cm). Lent by the artist.

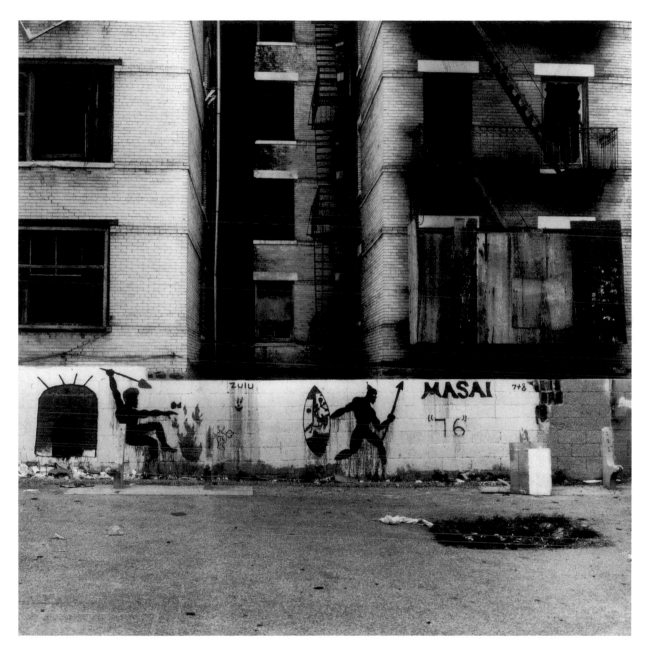

Gerald Straw (b. 1943). *Untitled*, 1982. Black-and-white selenium print, 11 ³/₄ x 14 in. (29.8 x 35.6 cm). Lent by the artist.

My photographs are designed to elicit a response, whether like or dislike. I do not manipulate my images, but I do create them in the best light available. The story of each photograph gets communicated according to each viewer's understanding and experience.—G.S.

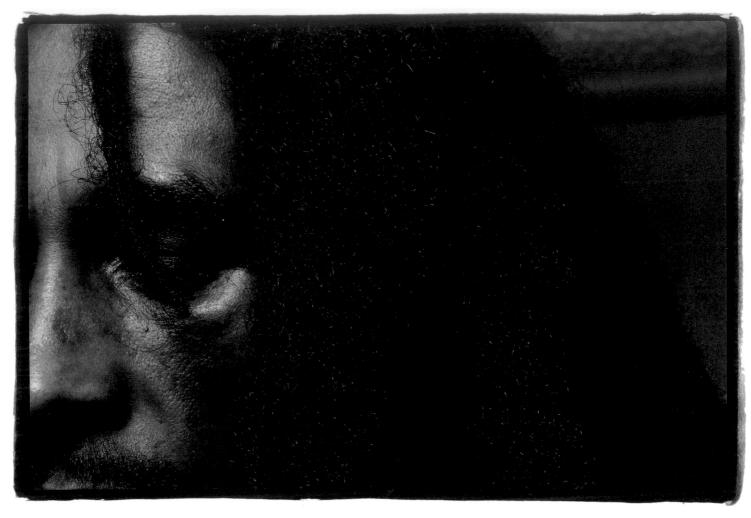

Bruce W. Talamon (b. 1949). *Bob Marley No. 1*, 1978, from the L'Ermitage Hotel Portrait Session series. Selenium-toned print, 16 x 20 in. (40.6 x 50.8 cm). Lent by the artist.

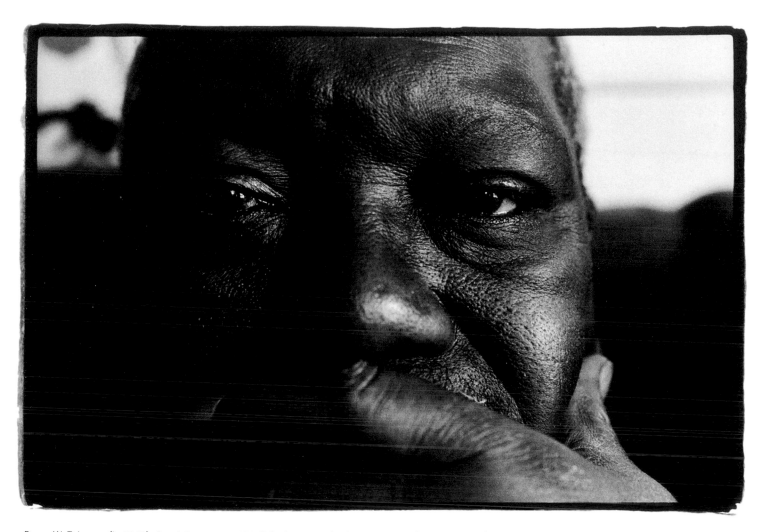

Bruce W. Talamon (b. 1949). *Jacob Lawrence*, 1992. Selenium-toned print, 16 x 20 in. (40.6 x 50.8 cm). Lent by the artist.

I enjoy the documentary quality of photography and consider myself a visual historian, continuing the mission of the *griot* (storyteller) of keeping the historical record in African society. We photographers can't accept the word "no," because there is no excuse for not coming back with the shot.—B.W.T.

Ron Tarver (b. 1957). *Rail and Clouds*, 1997, from the Conrail Train Yard series. Toned gelatin silver print, 19³/₄ x 24 in. (50.2 x 61 cm). Lent by the artist.

Since moving to Philadelphia from the Midwest in 1983, I have been fascinated with the city and its people. I explore its poetry and wonders. I want to photograph the city's soul. To create art, you must belong to a place; through these photographs I offer up this city, of which I have become a part. —R.T.

Ron Tarver (b. 1957). *Water Tower*, 1997, from the Conrail Train Yard series. Toned gelatin silver print, 19³/₄ x 24 in. (50.2 x 61 cm). Lent by the artist.

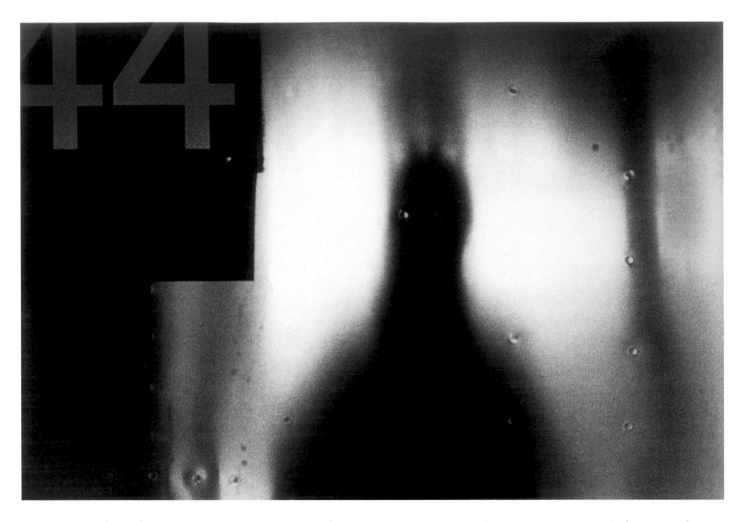

Shawn W. Walker (b. 1940). *Untitled*, 1990s, from the Self-Portraits / Shadows and Reflections series. Gelatin silver print, 20 x 24 in. (50.8 x 61 cm). Lent by the artist.

Shawn W. Walker (b. 1940). *Untitled*, 1990s, from the Self-Portraits/Shadows and Reflections series. Gelatin silver print, 20 x 24 in. (50.8 x 61 cm). Lent by the artist.

These photographs are from an ongoing series called Self-Portraits/Shadows and Reflections. I am a modernist working from an African aesthetic. I combine social documentary, cultural anthropology, and fine art to make a statement about who I am as an African American in early twenty-first-century America.—S.W.W.

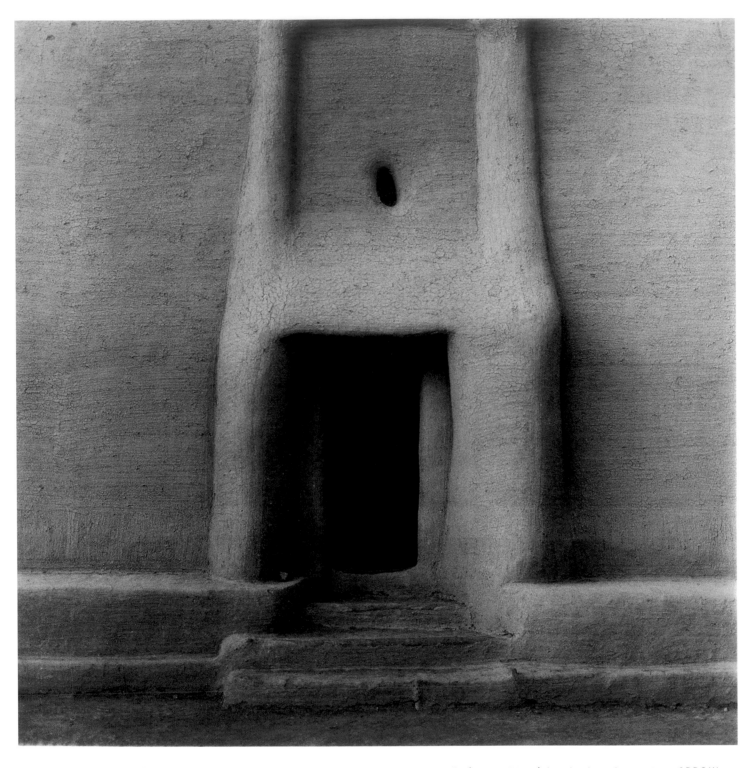

Carrie Mae Weems (b. 1953). *Untitled*, 1993, from the Africa series. Gelatin silver print, 30 x 30 in. (76.2 x 76.2 cm). Lent by the artist, courtesy of P.P.O.W. Gallery, New York.

I'm interested in the idea of forging a very different kind of democracy, one with a highly developed sense of how to serve our different needs, desires, and aspirations. How do we take care of our own? How do we take care of other constituencies? We are involved in the process of change.—C.M.W.

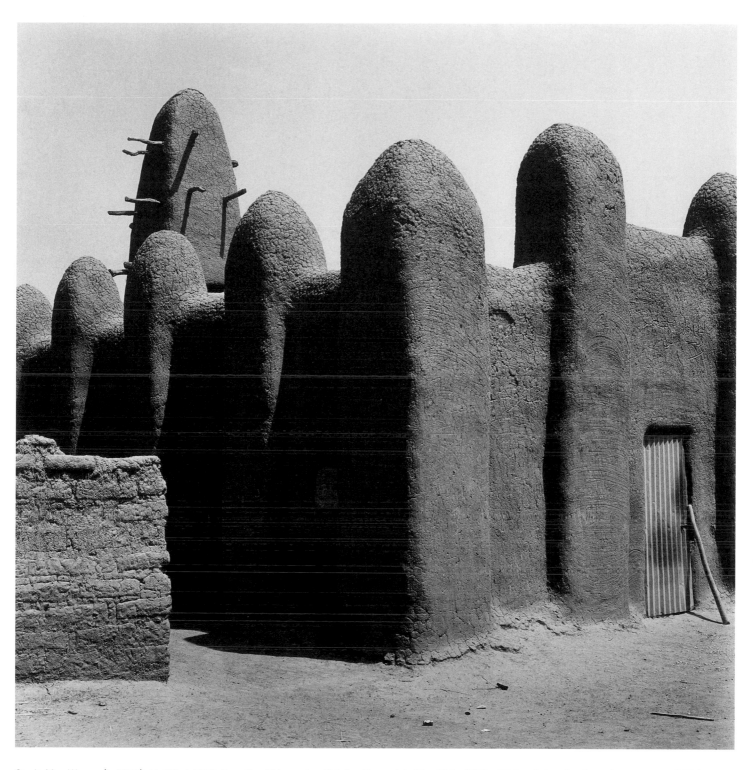

Carrie Mae Weems (b. 1953). *Untitled*, 1993, from the Africa series. Gelatin silver print, 30 x 30 in. (76.2 x 76.2 cm). Lent by the artist, courtesy of P.P.O.W. Gallery, New York.

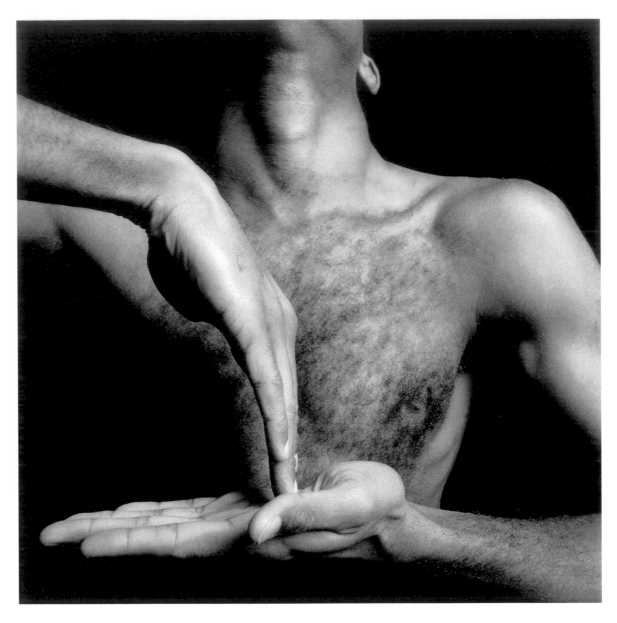

Edward West (b. 1949). *Poonie*, 1985. Giclée print, 22 ³/₄ x 22 ³/₄ in. (57.8 x 57.8 cm). Lent by the artist.

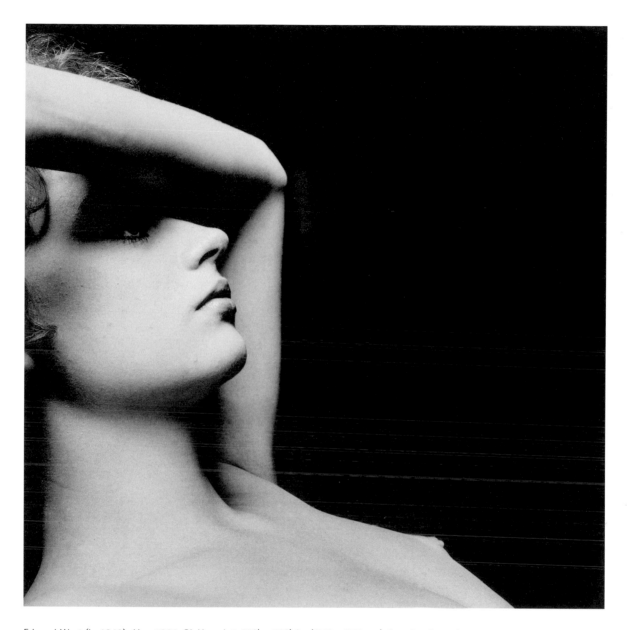

Edward West (b. 1949). *Lisa*, 1984. Giclée print, 22³/₄ x 22³/₄ in. (57.8 x 57.8 cm). Lent by the artist.

The relationship between the figure and its context, both literally and culturally, has remained a consistent focus in my work throughout my career. These two pieces utilize a vocabulary drawn from my biracial heritage—the duality of Black and White. I construct identities, perpetuate myths, and tell stories.—E.W.

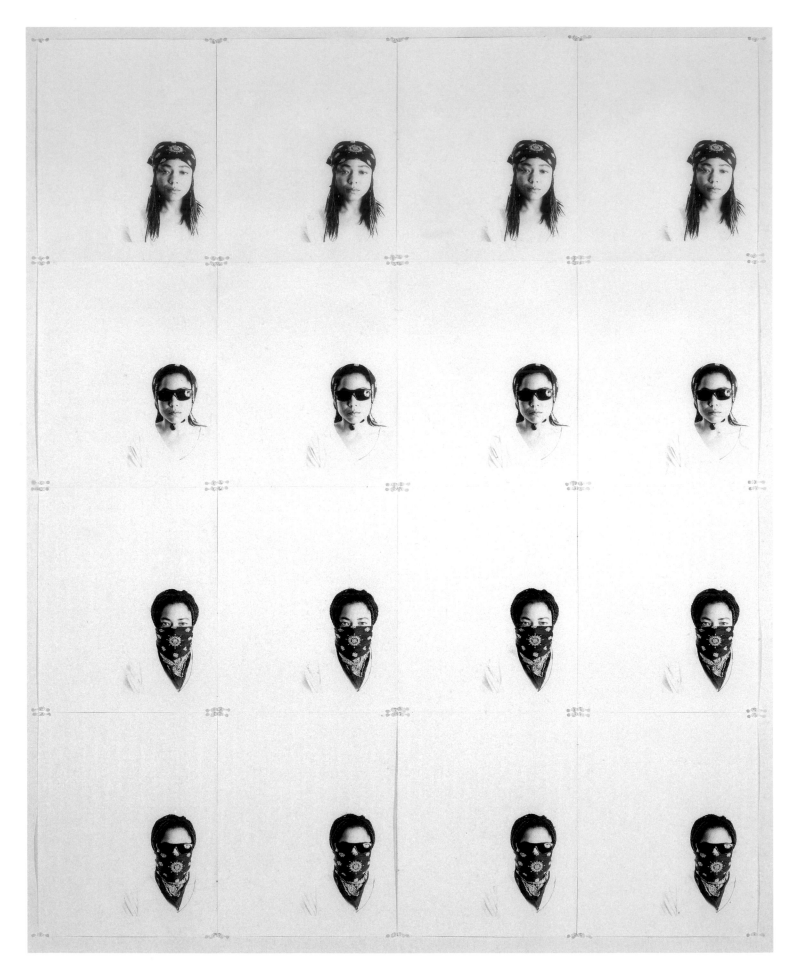

Cynthia Wiggins. *perception No. 11* (detail), 1994. Gelatin silver prints, pushpins, 128 x 80 in. (325.1 x 203.2 cm) overall. Lent by the artist.